Master Drawings and
Watercolours
in the British Museum

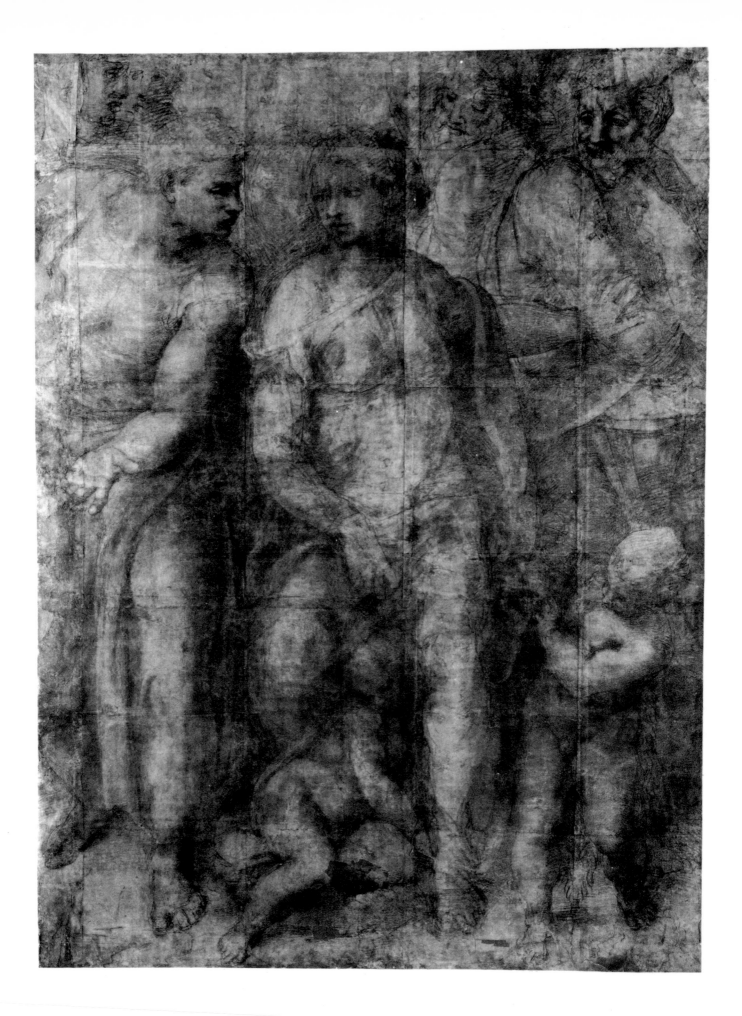

Master Drawings and Watercolours in the British Museum

EDITED BY JOHN ROWLANDS

PUBLISHED FOR THE
TRUSTEES OF THE BRITISH MUSEUM BY
BRITISH MUSEUM PUBLICATIONS LTD

© 1984 Trustees of the British Museum
Published by British Museum Publications Ltd
46 Bloomsbury Street, London WC1B 3QQ

British Library Cataloguing in Publication Data
British Museum
 Master drawings and watercolours in the
 British Museum.
 1. Art, European—Catalogs
 I. Title II. Rowlands, John, 1931-
 760'.094'074 N6750

ISBN 0-7141-0797-2

Designed by Sebastian Carter
Set in Palatino
and printed in Great Britain by
W. S. Cowell Ltd, Ipswich, Suffolk

Frontispiece

MICHELANGELO BUONARROTI
1475-1564
Epifania
Black chalk; 232.7 × 165.6 cm
1895-9-15-518* Presented by John Wingfield Malcolm, 1893

The only known complete large-scale cartoon by
Michelangelo, probably executed between 1546 and 1550. It
served as a basis for a painting, now in the Casa Buonarroti
in Florence, by the artist's friend and biographer, Ascanio
Condivi (c.1525-74). The subject is thought to show the
Virgin and St Joseph with the brothers and sisters of Christ;
the traditional title alludes to the fourteenth-century
theologian St Epiphanias, who held that these were the
children not of the Virgin, but of St Joseph by a previous
marriage.

Acknowledgments

My colleagues in the Department have played a vital part in the process of selecting the drawings that are included in this book and by assisting in all stages of its preparation. Valuable contributions have been made by Miss Giulia Bartrum, Miss Jenny Bell, Miss Frances Carey, Paul Goldman, Miss Sheila O'Connell, Peter Rea, Martin Royalton-Kisch, Miss Lindsay Stainton and Nicholas Turner, making this book a reflection of the tastes and predilections of the Department as a whole.

Contents

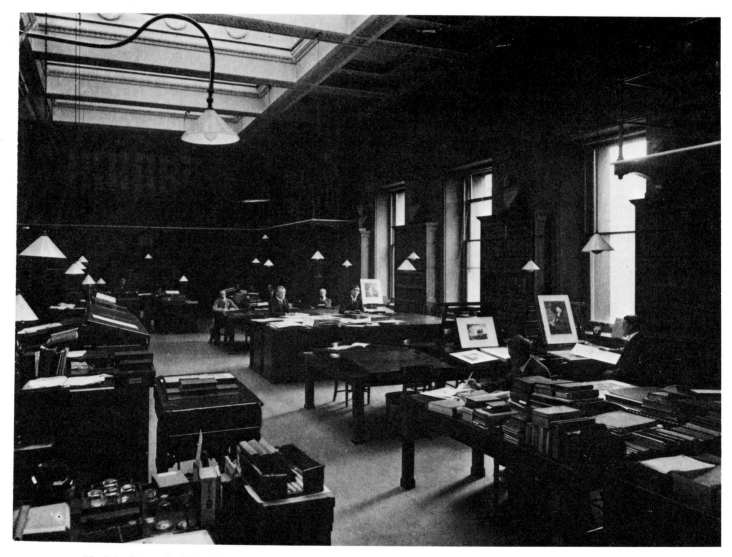

The Print Room, the White Wing
Photograph taken shortly before the Department moved to the King Edward Building in 1914. Seated at the centre table are Campbell Dodgson (1867-1948), Keeper 1912-1932, and Arthur Waley (1899-1966), the eminent Oriental scholar, at this date Assistant Keeper in the Department. In the foreground is Laurence Binyon (1869-1943), later Keeper of the Department 1932-1933.

Introduction

In tourist guides to London the British Museum and its world-famous collections are always given a prominent place, but the Department of Prints and Drawings, unlike other parts of the Museum, usually only receives a passing reference in such books, if it is mentioned at all. This mainly arises from the fact that apart from the large-scale cartoon by Michelangelo, called *Epifania* (see Frontispiece), the Department has no permanent display that can be described by compilers, and which visitors can count on seeing. The reason for this is quite simple. Drawings, especially watercolours, can only be exhibited with safety for limited periods without damage from over-exposure. In any case, the contents of the Department, the national collection of Western graphic art, are so large that a programme of exhibitions, often drawn entirely from the Museum's own reserves, ordinarily changed thrice a year, is the means whereby the public may most easily appreciate the diversity and beauty of its drawings and prints. Sometimes the subject is a particular artist like Claude Lorrain, whose work is richly represented in the Collection, or the works of a school are assembled, or, again, themes or techniques represented in graphic art are shown. Apart from this, the facilities of the Students' Room are available to ticket holders who may examine the full range of material housed in the Department during the regular opening hours.

This aspect of the Department's work may be fairly likened to that of a reference library of graphic material. For its contents range from the greatest heights of artistic achievement, drawings by the masters of the Renaissance, Michelangelo, Raphael and others, to sets of playing cards and prints of purely social or documentary interest – in all somewhere between two and a half and three million sheets of paper, on which something has been drawn or printed.

This book is intended to make reproductions of a selection of some of the finest drawings and watercolours in the Museum available to a wider public in a convenient form. The choice is made not only from among the drawings by the leading masters but also from the many outstanding works by less well-known artists. All the main West European schools are represented, and examples are included ranging from the early fifteenth century to recent times where works from different nations are grouped for convenience as those of 'Modern Masters'.

It is no accident that the British Museum has such a fine collection of drawings,

especially of those by the Old Masters. The distinguished, mostly British, collectors, whose drawings have formed the basis of the Collection, were only the latest in a succession of owners to possess them. Although certain important continental collections have, of course, been the source of many of the finest acquisitions, notably those which formerly belonged to Pierre-Jean Mariette (1694-1774), the British Museum has benefited from the long tradition of enthusiastic and discriminating collecting of drawings in these islands.

The first, and subsequently the leading connoisseurs with a predilection for drawings, were artists. Starting with Sir Peter Lely (1618-90) a line was maintained from one generation of artists to the next, through Jonathan Richardson, Senior (1665-1745) and Junior (1694-1771), and Sir Joshua Reynolds (1723-92), down to Sir Thomas Lawrence (1769-1830).

A matchless collection had been formed by Lawrence, which, if it had been acquired when it was offered, at a fraction of its current value, to the Nation in 1830, would have turned the British Museum's collection at once into the greatest depository of drawings in the world. Instead, the character of the Collection, which, unlike several of the greater continental collections, does not rest on royal or princely foundations, has been determined, like those in other departments of the Museum, largely by the exertions and expertise of successive Keepers.

When the Museum was founded in 1753, the first drawings in the Collection were naturally those which had belonged to its founder, Sir Hans Sloane (1660-1753), President of the Royal Society, man of science, physician, antiquary and prodigious collector in many fields, as well as owner of a very large library of books and manuscripts. Within this vast whole, the collection of drawings, although diverse, included many acquired as a record of the appearance of animals and plants and contained much of indifferent artistic quality; however, this was more than redeemed by the inclusion of a volume of drawings by Albrecht Dürer (1471-1528) and his followers, which, together with another containing a great part of all the surviving designs done in England by Hans Holbein the Younger (1497/8-1543), has been the basis of the subsequent great importance of the collection of German drawings (see nos 41-73). Among these, perhaps the greatest treasures are the small but unrivalled group of watercolour landscapes by Dürer (see no. 50).

The Print Room, as the Department is commonly called, was at first merely a part of the Museum's Library, only being constituted as a separate entity in 1808. This independence, which would no doubt have come anyway at a later date, was precipitated through the detection by a leading dealer of prints and drawings, Samuel Woodburn (1786-1853), in 1806 of a succession of thefts from the collection of etchings by Rembrandt. The culprit was Richard Dighton (c.1752-1814) the portrait painter and caricaturist, described by a contemporary as 'a bipedical serpent'. By gifts and favours he had wormed his way into the con-

fidence of the obliging curator of prints and drawings, William Beloe. At the discovery of the robbery the Trustees sacked the unfortunate Beloe and constituted the new Department, appointing as its first head the artist William Alexander (1767-1816), best known for his watercolours of China painted as a result of his being part of Lord Macartney's entourage on his embassy to Peking in 1793.

Perhaps because the Collection had functioned as an appendage of the Library its expansion had lacked any clear direction in the intervening years since 1753. There had been only two substantial accessions, the bequests of William Fawkener in 1769, and the Rev. C. M. Cracherode in 1799. Neither of these were

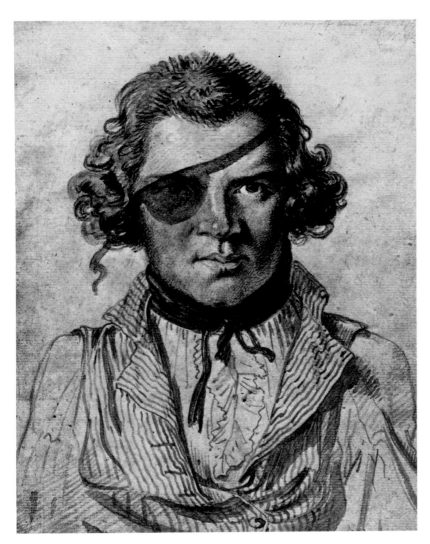

William Alexander (1767-1816)
Grey wash and watercolour over pencil
Self portrait
William Alexander was the first Keeper to be appointed to the new department in 1808. The inscription (top right) reads *from myself done at Sea 179 . . .W.A.*

11

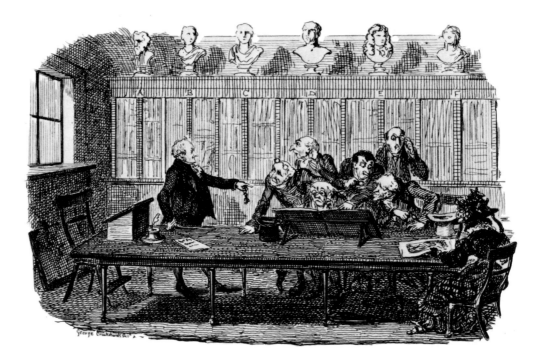

The Print Room, Montagu House
Etching by George Cruickshank, 1828
John Thomas Smith (1766-1833), Keeper of the Department 1816-1833, showing prints to a group of visitors.

collections of drawings of all-pervasive quality, but certainly included some outstanding examples by the great masters. This was more so with the second of these, in which there were superb drawings by Rubens (see no. 88) and Rembrandt (see no. 94). It was only in 1824, when the Department received the bequest of a Trustee, Richard Payne Knight (1750-1824), that it became a first-rate collection, still however one which was small by European standards. Indeed, even today, although comprising one of the most representative collections of Old Master drawings extant it remains relatively small beside some of the great continental collections like those in Paris and Florence. Payne Knight, a leader of taste and dilettante in the eighteenth-century mould, wrote on the picturesque in art and nature, and on their reinterpretation in garden design. The chief fount of inspiration for their arrangement was the landscape compositions of Claude Lorrain. Payne Knight's collection of drawings, as well as containing very impressive Rembrandts and Rubens', and many great Italian works, not surpris-

ingly included an unrivalled group of landscape drawings by Claude. These formed the nucleus of the Museum's incomparable collection of Claude's work which was finally crowned in 1957 with the acquisition from Chatsworth of the *Liber Veritatis*, the artist's drawn record of his paintings, done as a safeguard against forgery (see no. 120, a record of the painting, now in the National Gallery, popularly called *The Enchanted Castle*). In 1836, representation of the work of the seventeenth-century draughtsmen was greatly enhanced by the purchase of the Sheepshanks collection which, besides prints of magnificent quality, included over 600 drawings mainly of the Dutch school (see nos 89, 100, 105, 108 and 112).

Despite the failure of the Government to acquire the Lawrence collection, throughout the nineteenth century the Museum's collection of drawings gradually expanded with a steady flow of important gifts, bequests and purchases. Of these the purchase of twenty-nine drawings by Michelangelo in 1859, and of drawings from the Lawrence collection at the sale of Samuel Woodburn in the following year are the most important in a very disjointed series of acquisitions. It was not, however, until 1895 that the Print Room was enriched by a single complete collection of inestimable importance, that of John Malcolm of Poltalloch (1805-93). It had been put together with the advice of Sir J. C. Robinson, an eminent collector, whose discernment and experience made possible the formation of a collection of incomparable quality. It consisted of 970 drawings of the major schools of European art ranging from memorable works of the fifteenth century by Netherlandish and Italian masters to first-class drawings by Rembrandt, Watteau and Zurbarán (see nos 95, 124 and 149). Such was the richness of the Malcolm collection that its purchase transformed the Museum's collection into one of the world's finest. Its importance, not unexpectedly, is reflected in this book by the number of drawings of outstanding quality selected that have come from this source. They can be readily identified from their register numbers which begin 1895-9-15- . . .

The Department has been the happy recipient of much support from private and public sources and this fortunately has been maintained despite two World Wars and increased taxation in this century. Especially important has been the rôle of the National Art-Collections Fund which either gives remarkable drawings itself (see nos 23, 29, 75, 131, 136, 147, 184 and 192) or acts as the channel for the munificence of others (see nos 18, 22, 47, 59, 78 and 138). Among the many private benefactions since 1900 one should mention particularly the varied bequest of George Salting (see nos 38, 62, 96, 106, 123, 125, 164, 181 and 183), and the gift made anonymously by a long-standing friend of the Department in 1946 of the Phillipps-Fenwick collection of more than 1500 drawings, the largest part, mostly Italian, still remaining of the Lawrence collection. Over the same period some important drawings by leading modern draughtsmen have entered the Collection, but as yet efforts in this field have not been crowned by the

acquisition or presentation of a large comprehensive collection of modern drawings of quality. But unquestionably, judging from past history, we can look forward to the future full of hope. This has been given substance through the bequest of the gems in the César Mange de Hauke collection in 1968, drawings by leading artists, almost all French, of the last century, Delacroix, Degas, Renoir, Van Gogh, and others.

For the future, the building-up of a representative collection of modern drawings, illustrating as broad a cross-section of taste as possible must continue to be an important task, even though there are not the resources available to indulge in the pursuit of every trend; nor indeed is this desirable in a department which does not form a part of a Museum of Modern Art. In my view, our aim should be to examine critically the drawings of the recent and not too distant past, picking out what appears worthy and if possible, avoiding the meretricious. In this quest we are being greatly helped on our way by the generous presentation of fine works of leading artists of our own day, often by the artists themselves, or their families and friends. Such gifts sustain the purpose of the Print Room as they vividly demonstrate the continuing value of the collections for successive generations. Especially important among such benefactions must be counted the bequest by the late Lady Clark of Henry Moore's *First Shelter Sketchbook* (1940), two sheets from which are included in the present selection (see nos 205 and 206).

Since the last war the function of the State as a patron and supporter of the Arts has been a significant factor in the cultural life of the country and in the maintenance of its heritage. Like other national institutions the Museum has benefited from this and specifically in the present context. For instance, the tax provisions available have made it possible for key works to enter the Collection. The most famous of these is undoubtedly the *Liber Veritatis* of Claude Lorrain. From the Devonshire Collection at Chatsworth, it was accepted in 1957 in lieu of Estate Duty and allocated to the Museum (see no. 120). In 1983 one of the finest sheets of studies from early in Dürer's career (c.1490/1) entered the Collection after being accepted by HM Treasury in lieu of tax (see no. 48). In the future such support will be ever more vital in keeping the most significant part of the remaining heritage of fine drawings, fortunately still in private hands, in this country. A determined stance will, however, be necessary to achieve this.

Although the occasion for the production of this book of plates has been the staging of an exhibition in which all these drawings have been displayed, it is hoped that the publication will continue to be of interest to visitors and also serve as a strong reminder of the great treasures that abound in the Print Room.

John Rowlands

The Plates

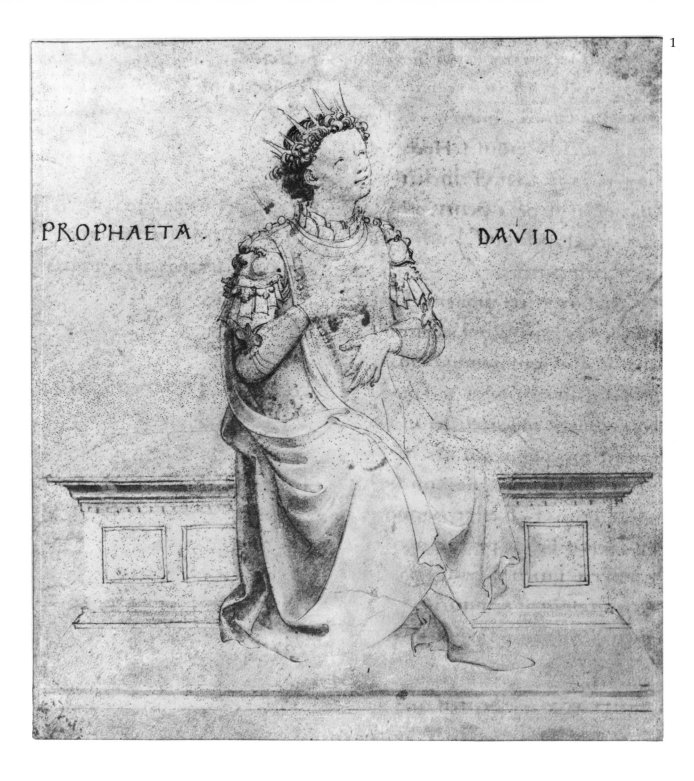

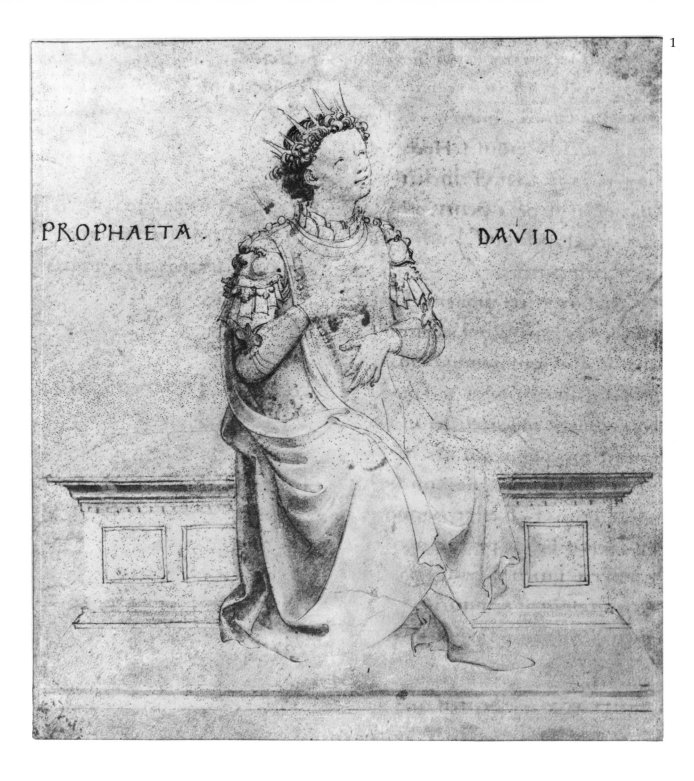

PROPHAETA. DAVID.

FRA ANGELICO
1387-1455

1 *King David playing a Psaltery*

Pen and brown ink with purple wash on parchment;
19.7×17.9 cm
1895-9-15-437

This is one of the very few drawings certainly by the artist. It
is drawn on a piece of waste parchment, with script on the
verso, and is therefore almost certainly not a manuscript
illumination but a drawing made in its own right.

ANDREA MANTEGNA
1431-1506

2 *Madonna and Child with an Angel*

Pen and brown ink; 19.6×14 cm
1858-7-24-3

A brilliant example of Mantegna's drawing in pen and ink in
which the artist used a system of close hatching to denote
shadow, thereby creating forms which appear convincingly
plastic. It has been dated in the artist's middle period, but
shows many analogies with the *Madonna della Vittoria* of
*c.*1495.

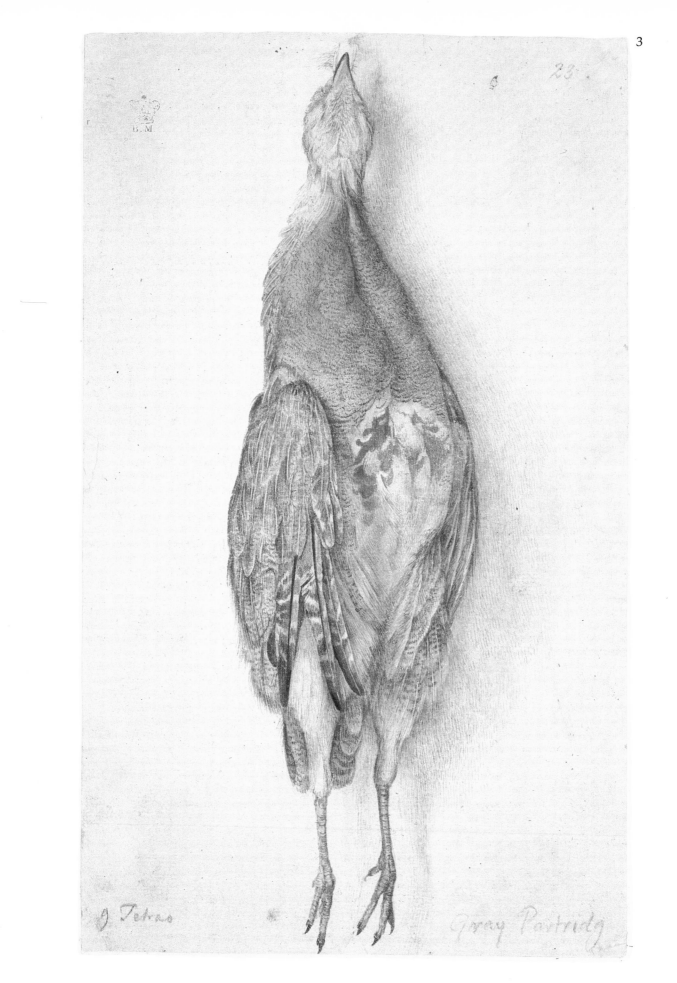

Tetrao

Gray Partridg

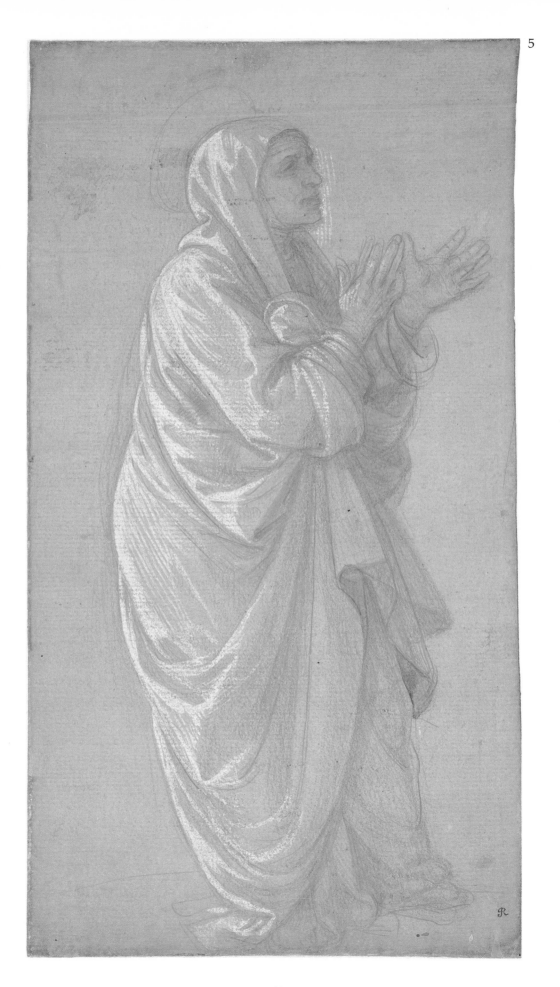

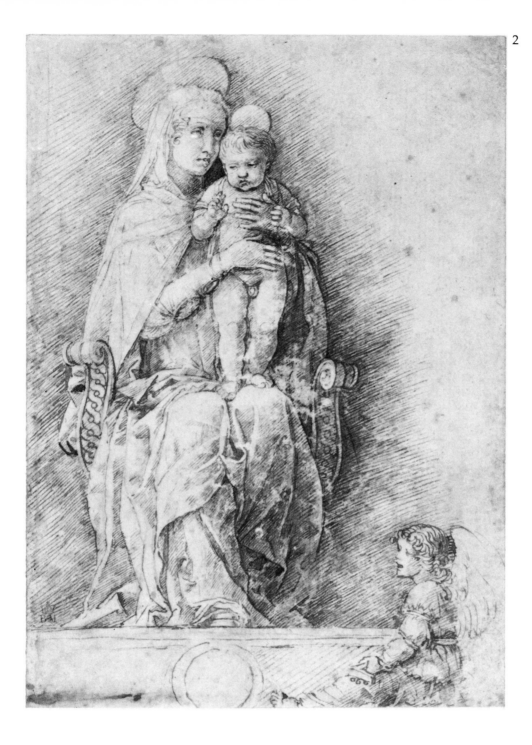

JACOPO DE' BARBARI
*c.*1440/50-1515

3 *Study of a dead grey Partridge,* 1511
Watercolour; 25.7×15.3 cm
5264-23. 1928-3-10-103 Sloane Bequest, 1753
This drawing, the only known still-life study in watercolour
by this artist, is remarkable for its realism. Not only has the
artist taken infinite pains in the rendering of the detail of the
plumage, but he has also succeeded in portraying the bird's
lifelessness.

GENTILE BELLINI
1429-1507

4 *A Turkish Woman*
Pen and brown ink; 21.5×17.7 cm
Pp. 1-20 Richard Payne Knight Bequest, 1824
Gentile was the son of Jacopo and the brother of Giovanni.
This and a pendant drawing, a *Turkish Janissary,* are perhaps
the most important drawings by the artist to have survived.
They are thought to have been made during the artist's visit
to Constantinople in 1479-81. It is inscribed with colour
notes.

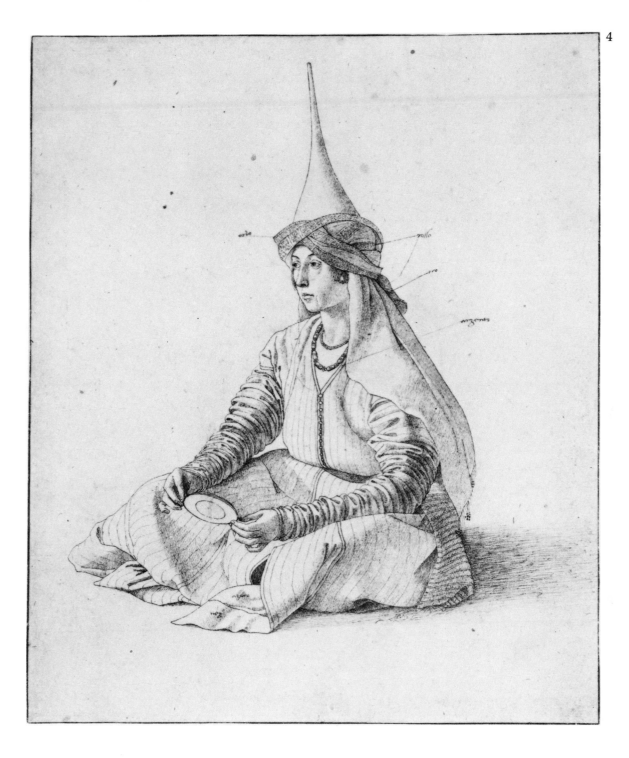

FRA FILIPPO LIPPI
c.1406-1469

5 *A Standing Female Saint*

Metalpoint and brown wash over black chalk, heightened
with white bodycolour, on salmon-pink prepared paper; the
outlines indented; 30.9×16.6 cm
1895-9-15-442

One critic, who considered the figure to be that of the Virgin
in a *Crucifixion*, judged this drawing as one of Filippo Lippi's
finest conceptions in his later years.

SANDRO BOTTICELLI
1444/5-1510

6 *Abundance*

Pen and brown ink and brown wash over black chalk,
heightened with white bodycolour, on paper tinted pink;
31.7×25.5 cm
1895-9-15-447

Probably one of the most beautiful drawings of the Italian
Quattrocento and certainly the finest of Botticelli's extant
drawings. It may have been made a few years after his
painting of *Primavera* in the Uffizi, which is generally dated
c.1478. The *cornucopia* carried by the woman and the bunch
of grapes and fruit by the two accompanying *putti* could well
be a reference to the season of Autumn.

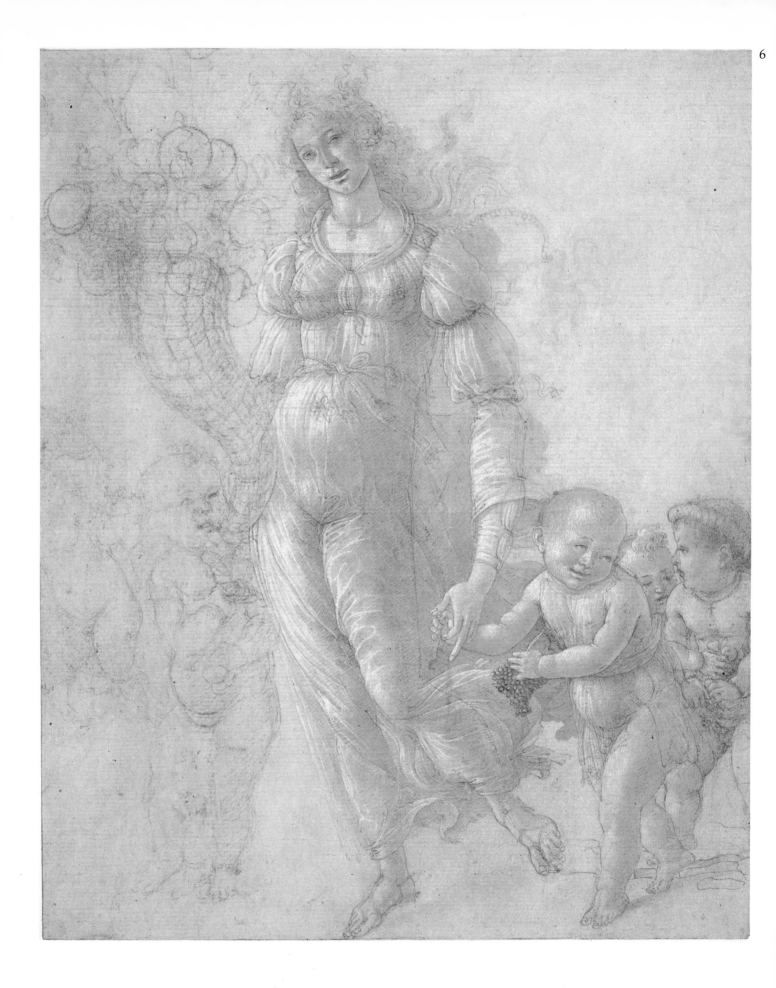

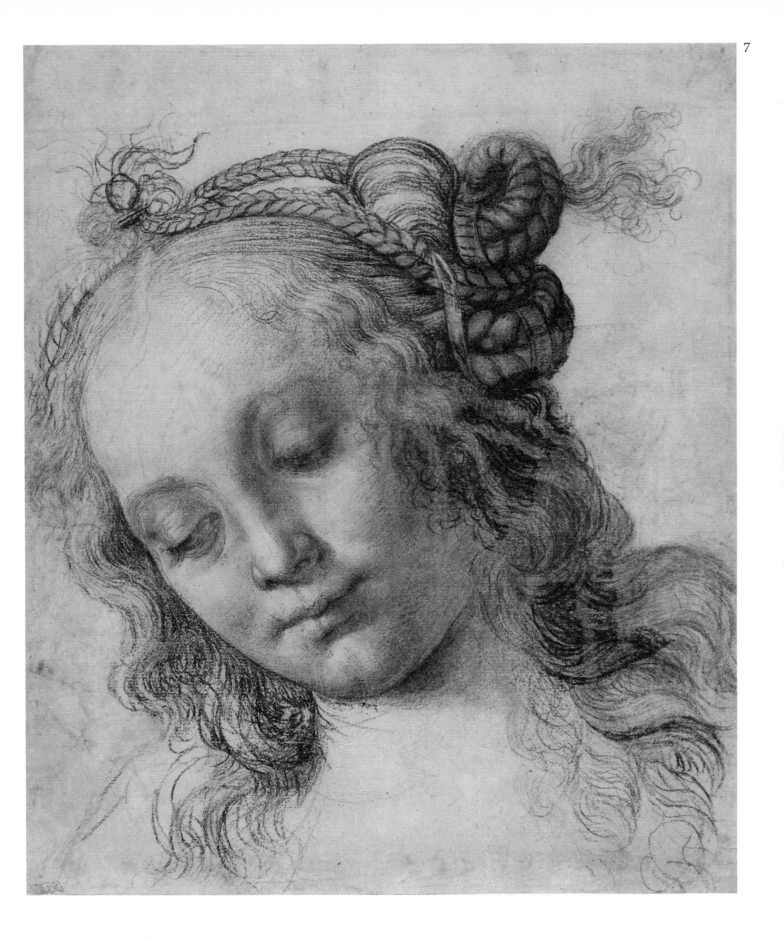

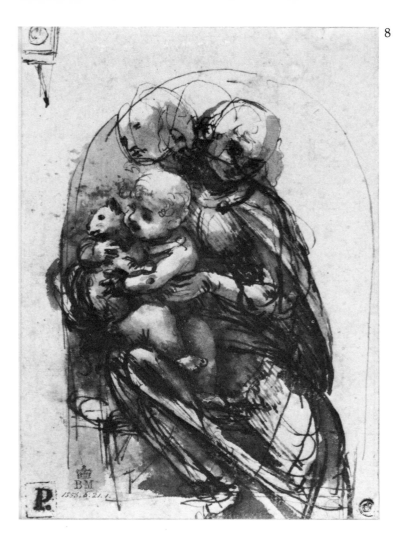

ANDREA DEL VERROCCHIO
1435-1488

7 *Head of a Woman with an elaborate Coiffure*

Black chalk heightened with white bodycolour;
32.5×27.3 cm
1895-9-15-785

Possibly a study for the head of the Madonna in an altarpiece at Pistoia of *c*.1475. Giorgio Vasari, the painter, art historiographer and collector, described such drawings by Verrocchio of heads of women in his own collection as having *'bell'arie ed acconciature di capelli'* (beautiful expressions and hair styles), and he added that Verrocchio's pupil, Leonardo da Vinci (*q.v.*), frequently imitated such drawings.

LEONARDO DA VINCI
1452-1519

8 *Studies for the Virgin and Child with a Cat*

Pen and brown ink and brown wash over a sketch with the stylus; 13.1×9.5 cm
1856-6-21-1 *verso*

One of several studies for a composition of the Virgin and Child with a cat for which no corresponding picture is known. These studies are generally dated *c*.1478. They show the rapid style Leonardo employed in his working drawings and his habit of making frequent corrections in apparent disregard for the final appearance of the sheet.

RAFFAELLINO DEL GARBO
c.1466-1524

9 *Studies for Christ rising from the Tomb, and of Hands*

Metalpoint heightened with white bodycolour on bluish-grey prepared paper; 38×25.6 cm
Pp. 1-32 Richard Payne Knight Bequest, 1824

The figure is a study for that of Christ in the *Resurrection*, now in the Uffizi, but formerly in the Capponi Chapel in S. Bartolomeo a Monte Oliveto; this picture has been variously dated between 1496 and 1505. The drawing belonged to Vasari, and is on his mount which he decorated and inscribed.

LEONARDO DA VINCI
1452-1519

10 *Bust of a Warrior in profile*

Metalpoint on cream-coloured prepared paper;
28.5×21 cm
1895-9-15-474

This famous drawing shows Leonardo working in the style of his master Verrocchio and surpassing him. The figure's presence, its severity of expression and the meticulous rendering of detail in the helmet and armour certainly leave a powerful impression. The warrior may have been intended to represent Darius since there is a loose resemblance in type to a copy of a Verrocchiesque profile-bust of Darius in Berlin.

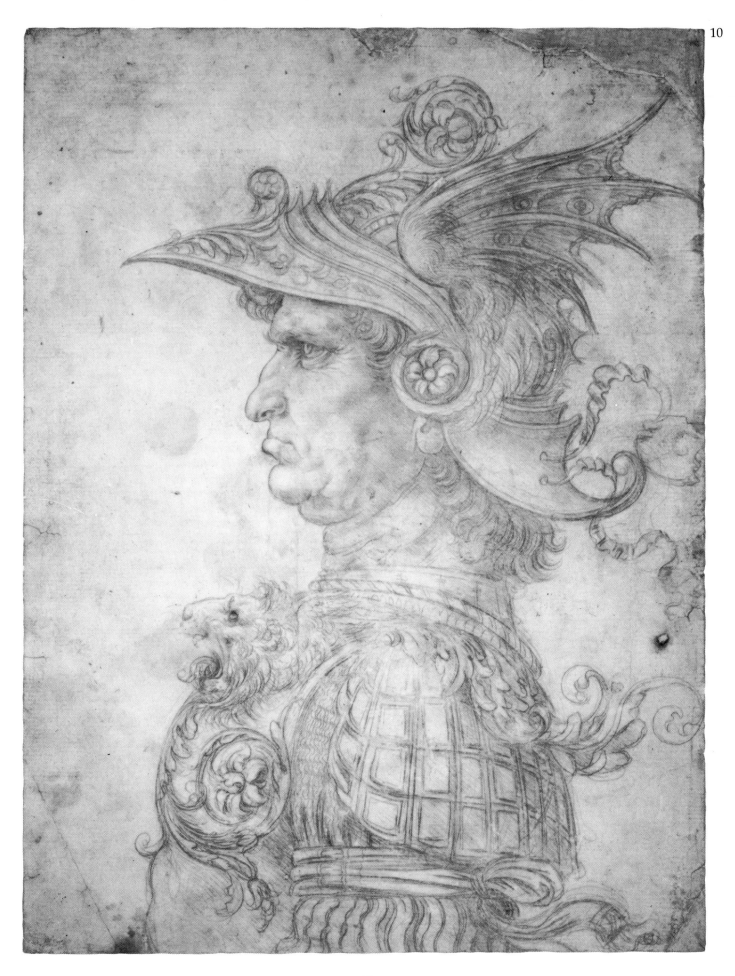

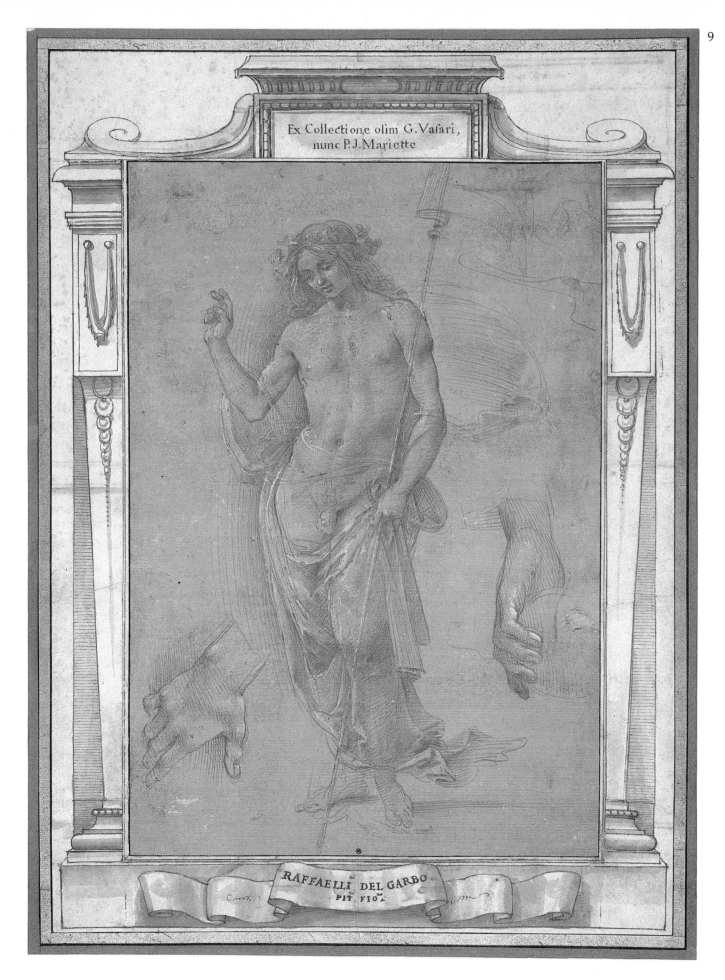

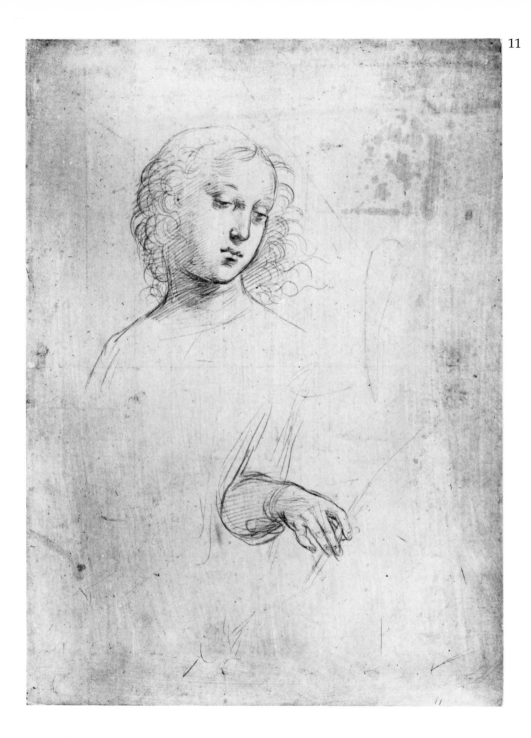

RAFFAELLO SANTI, called RAPHAEL
1483-1520

11 *Head and right forearm of an Angel*

Metalpoint on warm-white prepared paper; 27.6×19.6 cm
Pp. 1-67 Richard Payne Knight Bequest, 1824

A study for the angel on the extreme right of the *Coronation of the Virgin* painted in *c.*1502-3, and now in the Vatican Gallery. It was made from a studio model, but Raphael has deliberately idealised the features.

RAFFAELLO SANTI, called RAPHAEL
1483-1520

12 *Study for the left-hand side of the 'Disputa'*

Pen and brown ink and brown wash over stylus underdrawing, heightened with white bodycolour only on the figure with its back turned in the left foreground; 24.7×41 cm
1900-8-24-108 Henry Vaughan Bequest

A study, close to the final solution, for the lower left-hand part of the *Disputa*. It is probably the first of the surviving drawings to show the central motif of the lower part of the composition, the altar with the host.

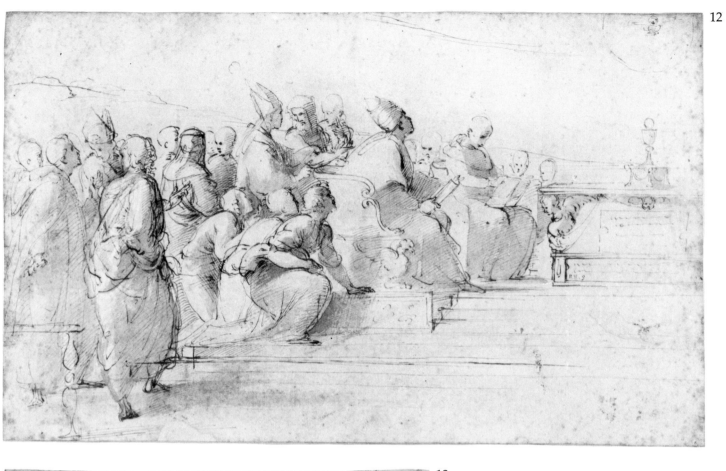

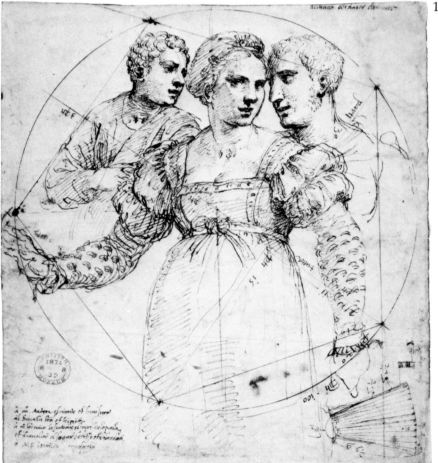

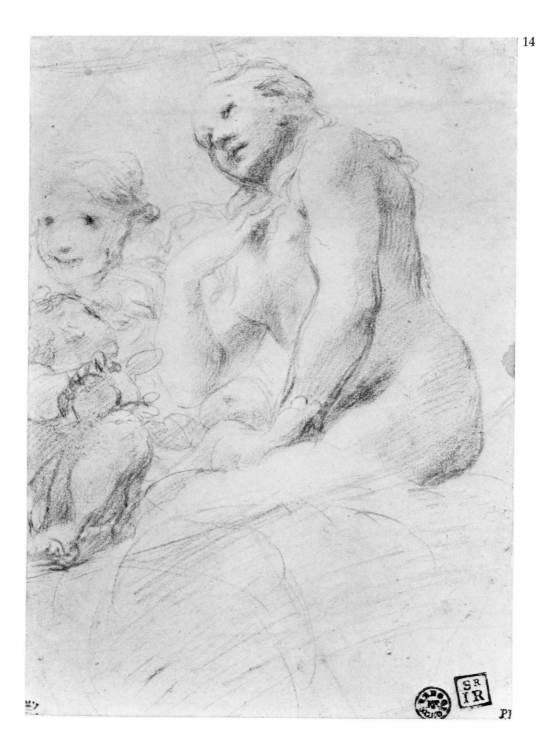

BALDASSARE PERUZZI
1481-1536

13 *Composition of a Woman and two Men*

Pen and brown ink; 23.4×21.7 cm
1874-8-8-32

The subject is of a courtesan with two lovers. A circle and pentagon inscribed with proportionate numbers has been drawn over the figures and the sheet is extensively inscribed in Peruzzi's hand with notes that may possibly refer to this diagram.

ANTONIO ALLEGRI, called CORREGGIO
1489/94-1534

14 *Eve and other Figures on Clouds*

Red chalk; 18.3×13 cm
1895-9-15-738

Correggio was one of the finest draughtsmen of the Italian High Renaissance. From the apple held in the hand of an attendant *putto*, the figure can be identified as that of Eve in the cupola of the Duomo at Parma, which Correggio painted in *c*.1526-29.

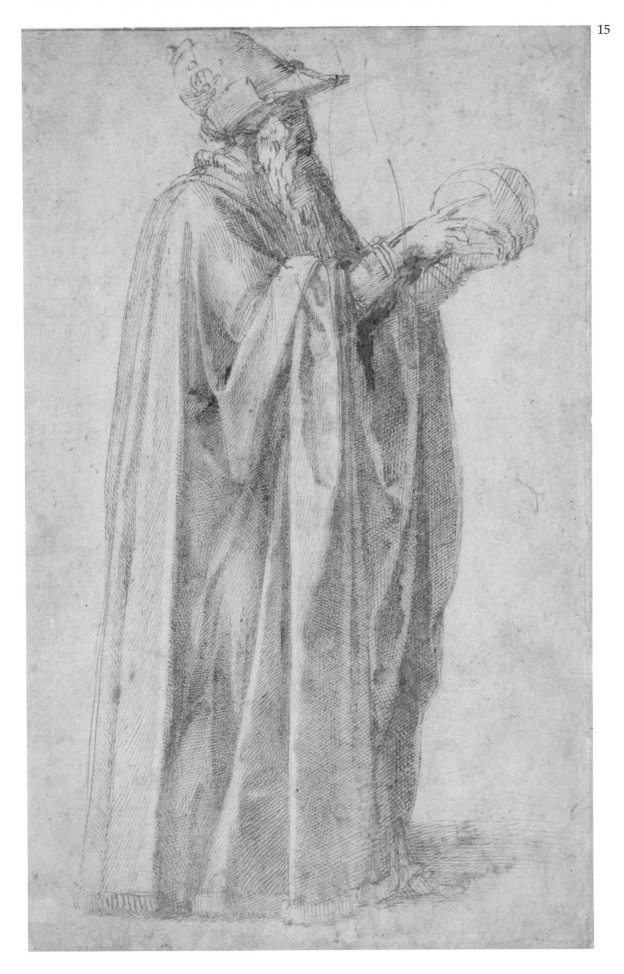

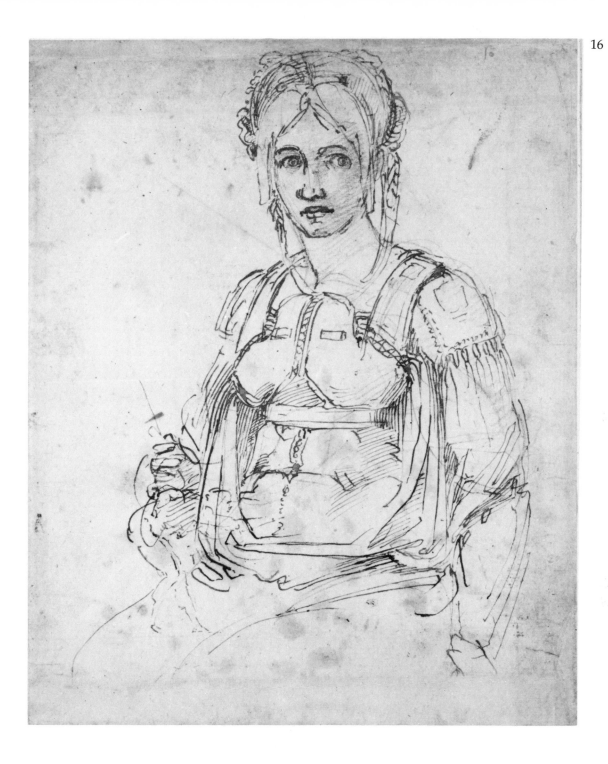

MICHELANGELO BUONARROTI
1475-1564

15 *A Philosopher*

Pen and pale yellow-brown and grey-brown ink;
33.1×21.5 cm
1895-9-15-498

The drawing is datable c.1501-3 and is a characteristic
example of Michelangelo's early drawing style. The hat is
derived from that worn by the Byzantine Emperor, John
Palaeologus, who visited Italy in 1438-9. The object in his
hand is a skull.

MICHELANGELO BUONARROTI
1475-1564

16 *Female half-length Figure*

Pen and brown ink over black and red chalk; 32.3×25.8 cm
1859-6-25-547

Beneath the woman's right hand and drawn in the same ink
as the principal study, is a small sketch of a nude man
bending forward in profile to the right. There seems to be no
connection between the two studies. Another half-length
figure of a female is on the *verso*. Both the half-lengths may
be identified as belonging to the type of drawing which
Vasari called *teste divine,* and which he stated Michelangelo
was in the habit of making as presents for friends.

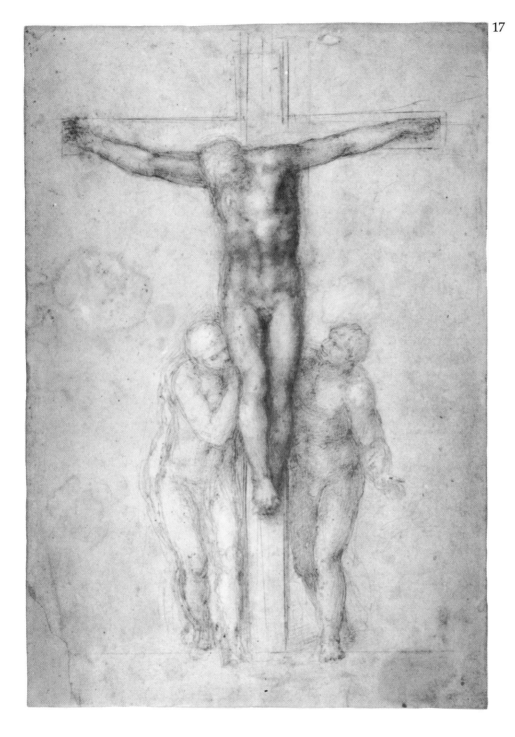

MICHELANGELO BUONARROTI
1475-1564

17 *Christ on the Cross between the Virgin and St John*

Black chalk; 41.2×27.9 cm

1895-9-15-510

Michelangelo's late period is frequently described as one of suffering and emotional anguish. A series of some seven drawings of the *Crucifixion* of which this is generally agreed to be the last shows how the artist gave vent to feelings of a deep religious mysticism. These *Crucifixion* drawings were probably not made with any particular painting or sculpture in mind; and it has been suggested that they were made as presentation drawings for his friends. The highly-wrought technique, with its many repetitions of outline, is characteristic of his late style.

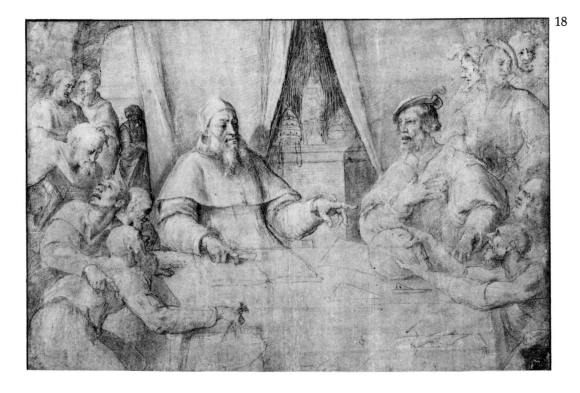

SEBASTIANO DEL PIOMBO
c.1485-1547

18 *Clement VII and the Emperor Charles V*

Black and white chalk on grey-washed paper; 31×46.2 cm
1955-2-12-1 Presented by the National Art-Collections Fund
(Campbell Dodgson Bequest Fund)

Sebastiano's style is a unique combination of the then current types of Venetian and Roman drawing. He was the protegé of Michelangelo by whom he was much influenced. The drawing represents the Pope and Emperor seated in council with their advisers: the divine basis of their authority being shown by the monstrance between the tiara and the crown. The drawing is datable c.1529-30.

GIROLAMO FRANCESCO MARIA MAZZOLA,
called PARMIGIANINO
1503-1540

19 *Study for the Virgin and Child with St John the Baptist and St Jerome*

Pen and brown wash over red chalk; 26×15.7 cm
1882-8-12-488

A study, with many variations, for the *Vision of St Jerome* in the National Gallery. According to Vasari, Parmigianino was working on this picture when the Constable of Bourbon's troops entered Rome in 1527.

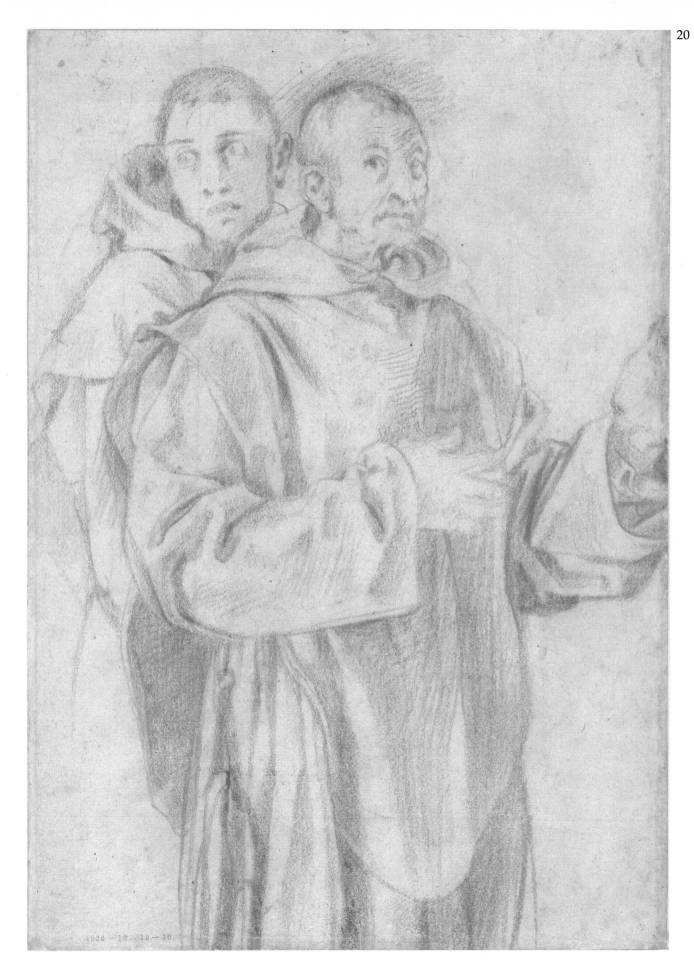

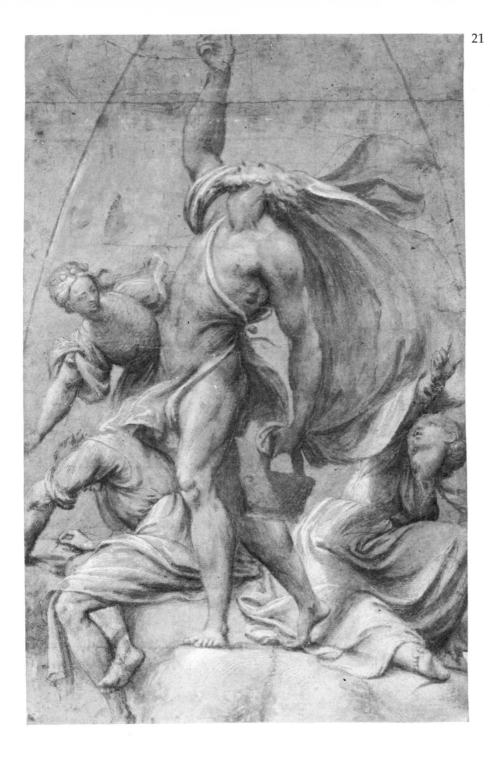

JACOPO CARUCCI, called PONTORMO
1494-1556

20 *Study for the Supper at Emmaus*

Red chalk; 28.4×20.2 cm
1936-10-10-10

Pontormo was one of the most eccentric of the Florentine sixteenth-century Mannerist artists. This is a study for the friars on the left in the *Supper at Emmaus* of 1525 in the Uffizi.

GIOVANNI ANTONIO PORDENONE
1483/4-1539

21 *Study for Prophets and Sibyls*

Pen and brown ink and grey and pink wash, heightened with white bodycolour over black chalk, on blue paper; 43.5×27.7 cm
5214-288 Sloane Bequest, 1753

A study for the figure of Habakkuk in the cupola of S. Maria di Campagna in Piacenza, the decoration of which is datable *c.*1530-32. The basket held by the Prophet is an allusion to the legend that he was transported by an angel to succour Daniel by giving him a bowl of food while he was in the lions' den.

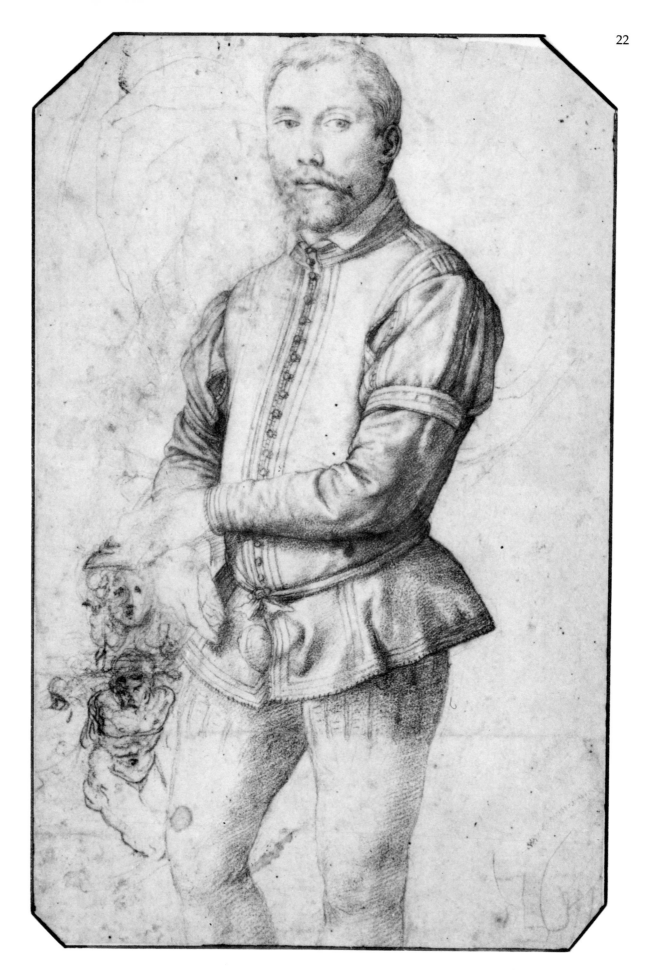

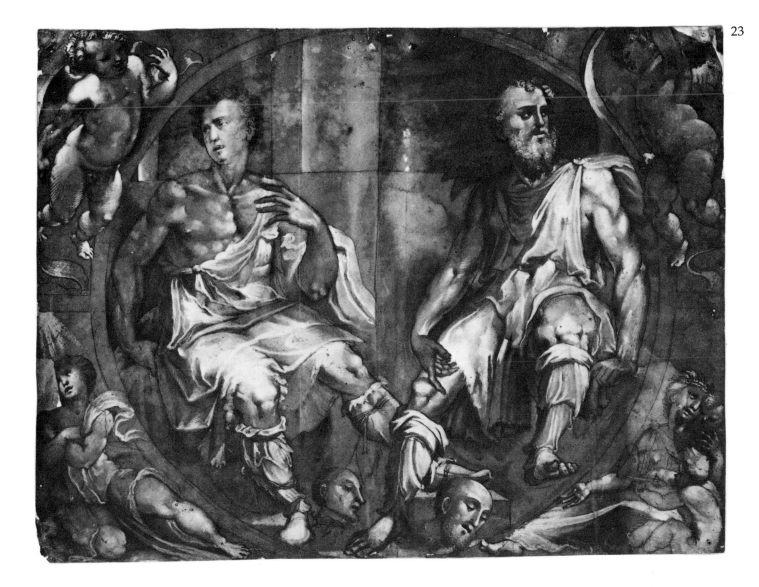

AGNOLO BRONZINO
1503-1572

22 *Portrait of a Man*

Black chalk, with touches of red chalk, on paper tinted pink;
39.2×24.9 cm
1958-12-13-1 Presented by the Holland Martin family and the
National Art-Collections Fund

Bronzino specialized as a portrait painter, but only a few of
his portrait-drawings survive.

DOMENICO BECCAFUMI
1486-1551

23 *Damon Pithagoricus and Lucius Brutus*

Pen and brown ink and brown wash over black chalk height-
ened with white bodycolour, on paper tinted brown;
37.5×48.5 cm
1952-4-5-8a Presented by the National Art-Collections Fund

A study for part of the fresco on the vault of the Sala del
Concistoro in the Palazzo Pubblico, Siena, which was
painted between 1529 and 1535. The fresco displays civic
virtues illustrated by exemplary Greek and Roman figures.
Damon Pithagoricus, as a representation of Friendship, is
seated to the left; on the right, as a symbol of Justice, is
Lucius Brutus, shown with the heads of his two sons whose
decapitation he had ordered because they conspired against
the state.

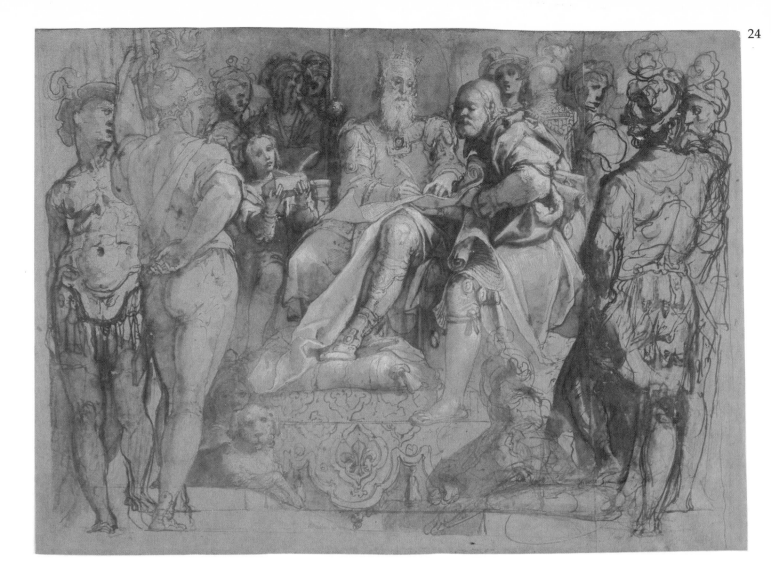

TADDEO ZUCCARO
1529-1566

24 *Charlemagne confirming the Donation of Ravenna*

Pen and brown wash over black chalk, heightened with
white bodycolour, on blue paper; 40×53.9 cm
1946-7-13-108 Presented anonymously (Phillipps-Fenwick
Collection)

Taddeo Zuccaro was perhaps the greatest exponent of the
Roman Mannerist style of drawing. This is a study for the
soprapporta fresco of *Charlemagne confirming his father Pepin's
gift of Ravenna to the States of the Church* in the Sala Regia in
the Vatican, a fresco painted in 1564.

FEDERICO BAROCCI
c.1535-1612

25 *Studies of a Man's left arm and right leg; an Archer*

Charcoal and red and white chalk on blue paper; 51.5×39 cm
Pp. 3-201 Richard Payne Knight Bequest, 1824

Barocci employed the medium of charcoal, red and white
chalk on blue paper with great vigour, to obtain a striking
effect. The studies of arms are for the hurdy-gurdy player in
the *Madonna del Popolo* in the Uffizi, dated 1579; the archer,
seen from behind, drawn with the sheet at right-angles, is for
an executioner in the *Martyrdom of St Sebastian* in Urbino
Cathedral, commissioned in 1557; the study of the leg in
profile could be for the right leg of Christ in the *Noli Me
Tangere* in the Allendale Collection, the date of which is not
recorded.

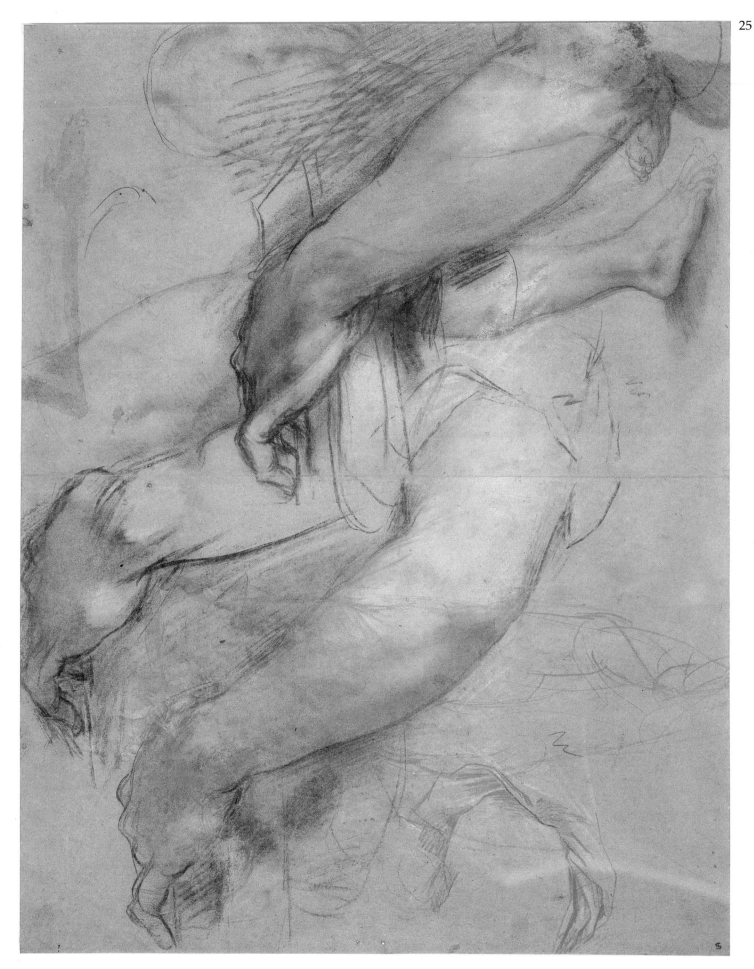

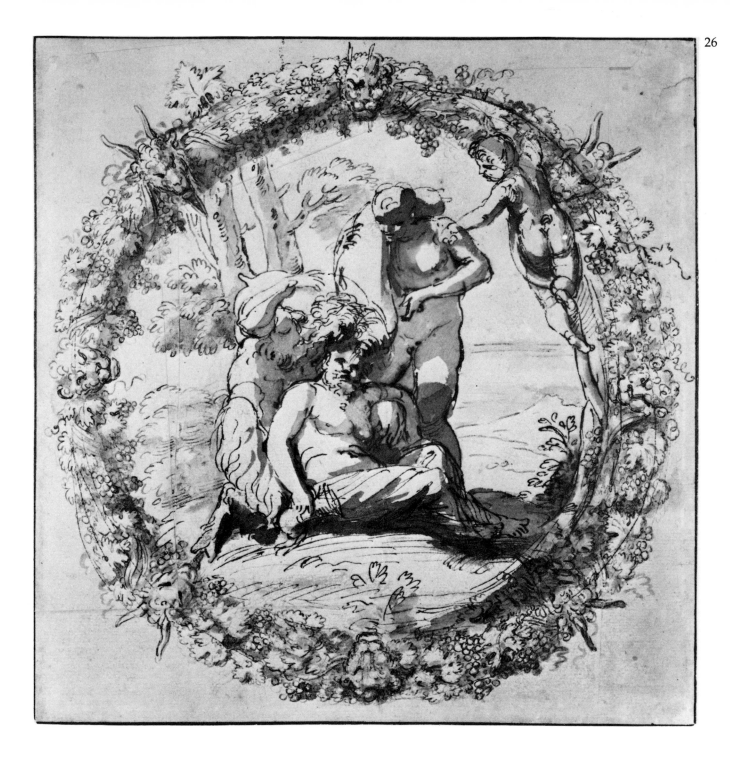

ANNIBALE CARRACCI
1560-1609

26 *The Drunken Silenus: design for the 'Tazza Farnese'*

Pen and brown ink with brown and grey wash over red
chalk; 28.6×27.5 cm
Pp. 3-20 Richard Payne Knight Bequest, 1824

In *c.*1598 Annibale Carracci made an engraving on silver of
this composition for Cardinal Odoardo Farnese to decorate a
silver cup known as the *Tazza Farnese*. The subject, Silenus
drinking, was clearly appropriate to the decoration of such a
vessel: Silenus, the oldest satyr, is associated with drunken-
ness, music and sleep.

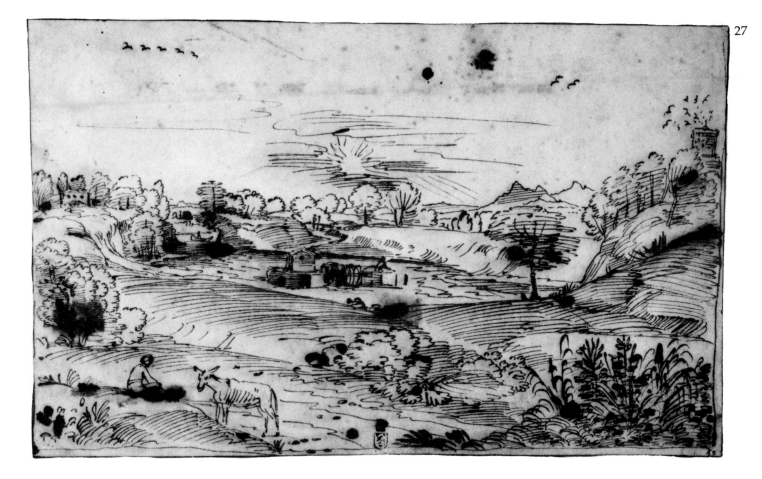

ANNIBALE CARRACCI
1560-1609

27 *Landscape with the setting Sun*

Pen and brown ink; 27.2×42.8 cm
1972-7-22-13

Annibale Carracci's style of landscape painting only became
fully developed after he had moved to Rome in 1595. He
brought to the *genre* a new, ideal conception of nature that
was basic to the formation of the classical landscape in
seventeenth-century Italian painting. A large number of his
drawings of landscape survive of which this is a particularly
fine example.

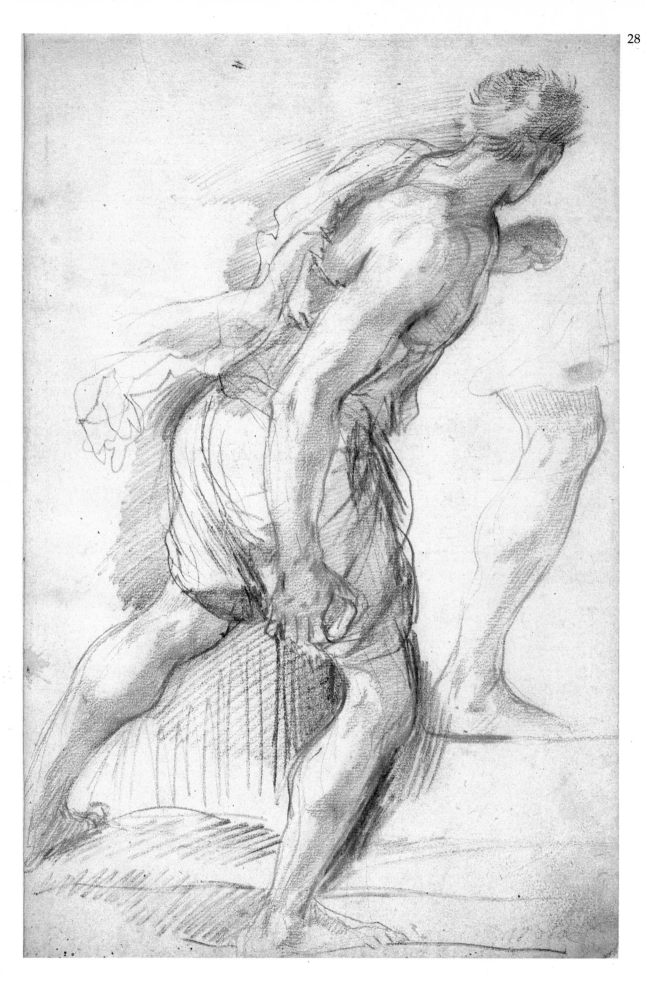

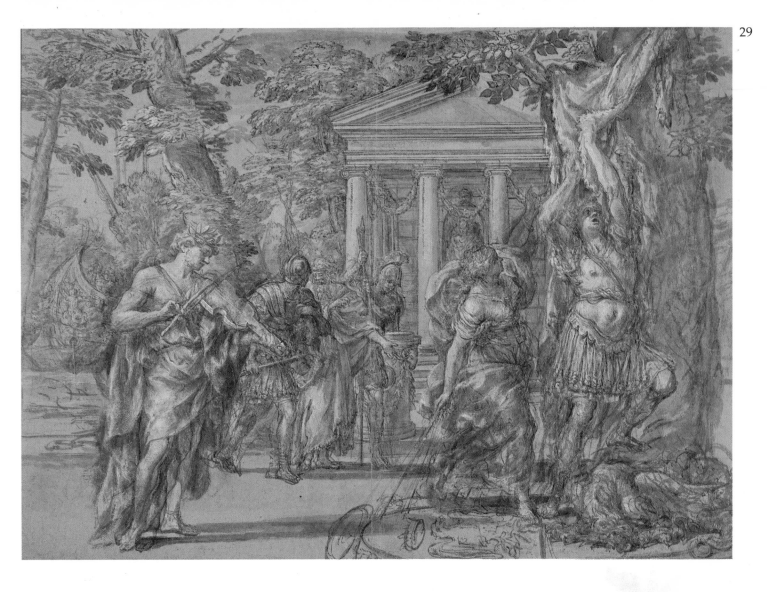

PIERFRANCESCO MOLA
1612-1666

28 *Figure running and clutching a Stone*

Black and red chalk; 41.2×26.5 cm
1946-7-13-89 Presented anonymously (Phillipps-Fenwick
Collection)

Traditionally attributed to Mola, a painter active in Rome in
the middle of the seventeenth century. The purpose of the
drawing is not known but it could be, for example, a study
for an executioner in a *Martyrdom of St Stephen*. The artist has
captured the figure's movement and has effectively exploited
the combination of red and black chalk.

PIETRO BERRETTINI, called PIETRO DA CORTONA
1596-1669

29 *Jason and the Golden Fleece*

Pen and brown ink, and brown and grey wash over black
chalk, heightened with white bodycolour on light brown
paper, the outlines indented; 39.7×53.3 cm
1941-11-8-16 Presented by the National Art-Collections
Fund

The drawing was presumably made for Cardinal Scipione
Borghese (1576-1633) whose coat-of-arms is displayed, and it
was engraved in 1658 by Charles Audran. The subject, from
Apollonius of Rhodes' *Argonautica*, shows Jason and Medea,
who with her magic has lulled the dragon to sleep, removing
the Golden Fleece from the tree on which it hangs. The
presence of Orpheus, the figure holding a musical instru-
ment, suggests that Cortona was aware of another, little-
known account of the Argonauts' adventures, thought to be
written by Orpheus himself.

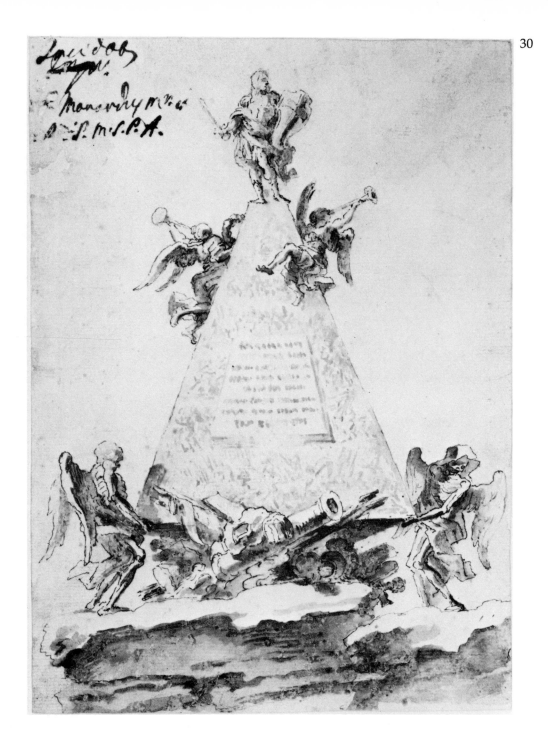

GIAN LORENZO BERNINI
1598-1680

30 *Design for the Catafalque of the duc de Beaufort*

Pen and brown ink with brown and grey wash;
25.2×17.9 cm
1874-8-8-11

A preparatory study for the print by Pietro Santi Bartoli in
the published account of the obsequies of the duc de Beau-
fort held in 1669 in the church of S. Maria d'Aracoeli in Rome.
Beaufort was killed while attempting unsuccessfully to break
the Turkish blockade of the island of Candia.

GIOVANNI FRANCESCO BARBIERI,
called GUERCINO
1591-1666

31 *A Theatrical Performance*

Pen and brown ink with brown wash; 35.8×46.2 cm
1937-10-8-1

Guercino was one of the most spirited and prolific draughts-
men of the seventeenth-century Bolognese School. Although
he was principally a painter of religious subjects, he was also
a shrewd and witty observer of scenes from everyday life.
Such scenes he recorded in his drawings rather than in his
paintings. This is an excellent example of the type and was
probably drawn before the artist's visit to Rome in 1621. It
may represent a theatrical performance at Cento in Emilia,
the town of his birth.

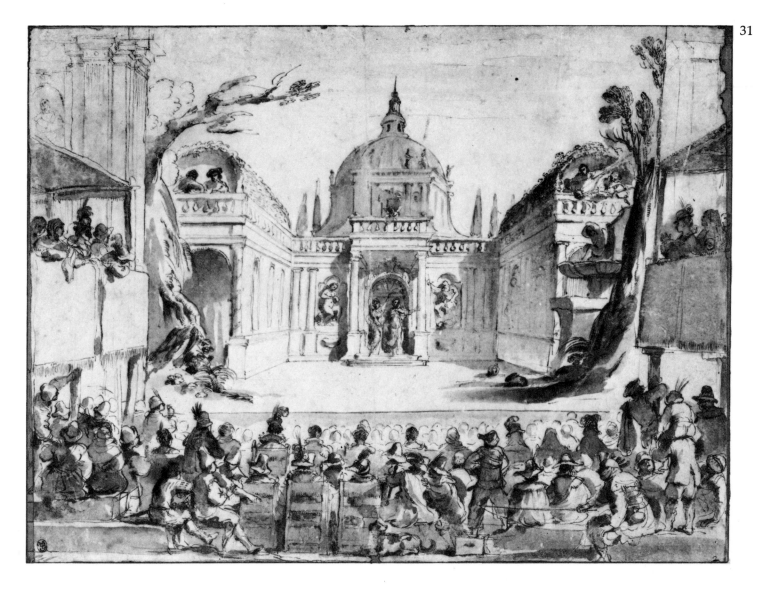

CARLO MARATTA
1625-1723

32 *The Adoration of the Shepherds*

Black chalk and brown wash heightened with white body-
colour; 16.9×30.4cm

1973-9-15-5

A study, corresponding closely but not exactly to the finished
painting, for a lunette-shaped fresco in the first chapel on the
right in the church of S. Isidoro in Rome. This decoration,
commissioned in 1652, was one of Maratta's earliest Roman
works. Maratta was the leading painter of the style known as
High Baroque Classicism which dominated Rome at the end
of the seventeenth century.

SALVATOR ROSA
1615-1673

33 *Philosophers in a Landscape*

Pen and brown ink with red and black chalk; 42.2×27.2 cm

1855-7-14-54

A fine example of Rosa's eccentric and energetic style of
drawing, which shows a proto-romantic interest in the
dynamism of invention, as if the creative process rather than
the drawing that resulted was for the artist the more import-
ant of the two. It is a preparatory study, in reverse and with
substantial differences, for the artist's etching of the subject
which can be dated *c.*1662.

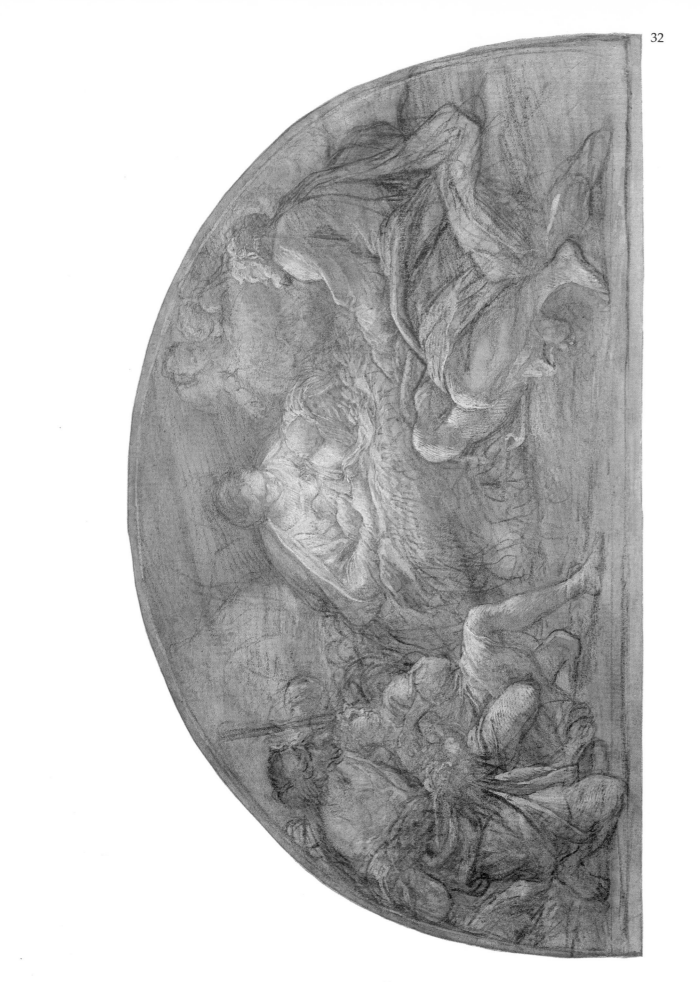

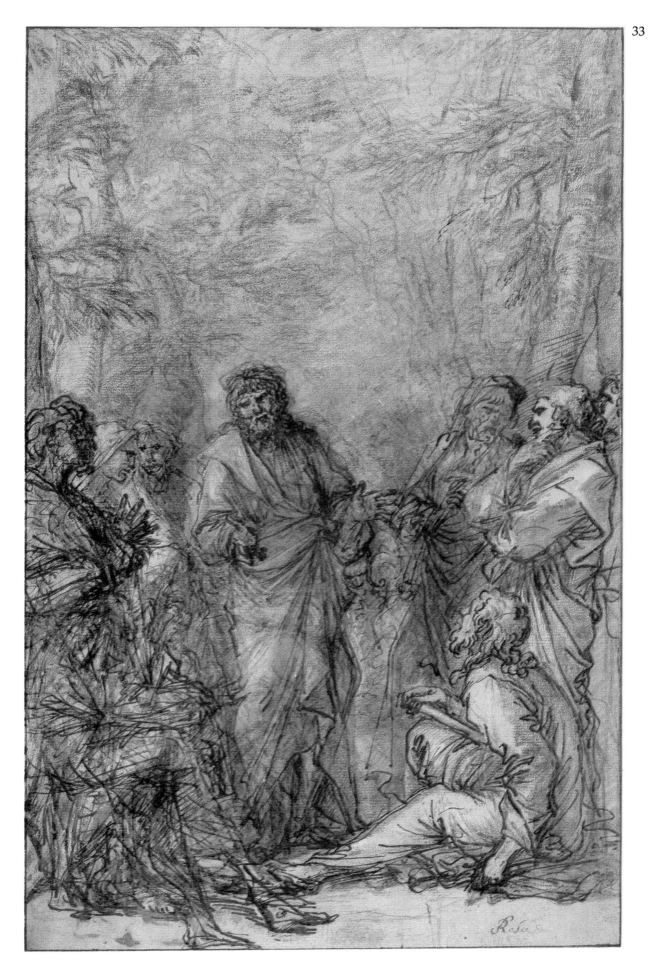

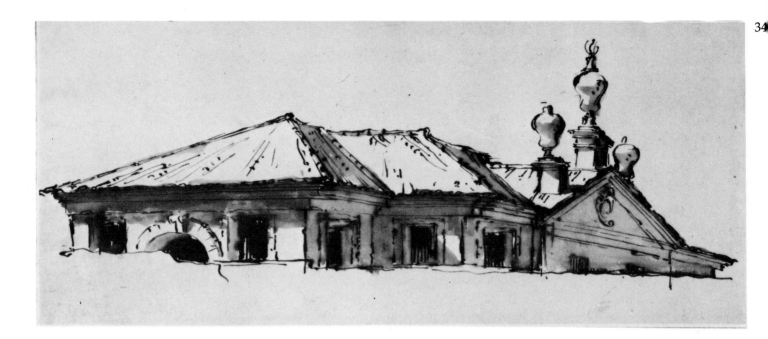

GIOVANNI BATTISTA TIEPOLO
1696-1770

34 *Roof of a Villa*

Pen and brown ink and brown wash; 9.9×23.2 cm
1903-11-26-2 Presented by Charles Ricketts

Tiepolo, the great exponent of the Rococo style in Italy,
occasionally drew landscapes, often with buildings. In these
he captured with particular flair the effect of bright sunlight
striking the hard surface of a wall or roof-top.

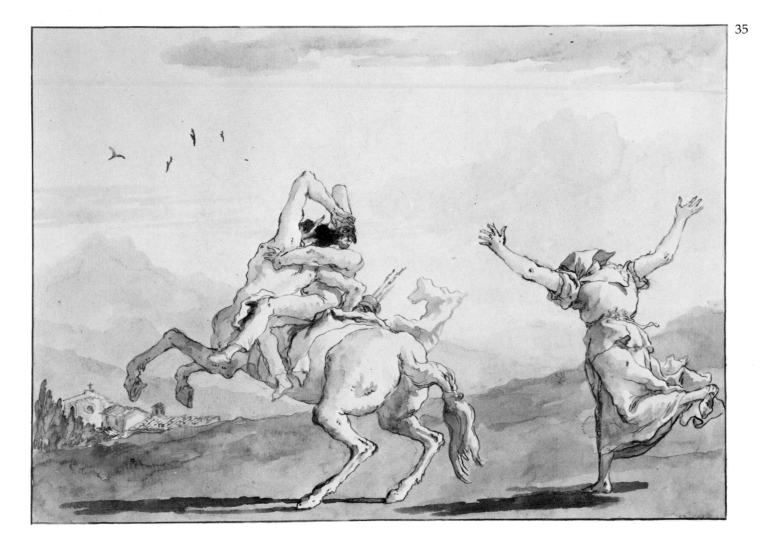

GIOVANNI DOMENICO TIEPOLO
1727-1804

35 *Punchinello carried off by a Centaur*

Pen and brown ink and brown wash; 35.6×51.2 cm
1925-4-6-1

One of the famous Punchinello series which apparently
numbers 104 drawings made towards the end of the artist's
life. They illustrate the antics of Punchinello, a burlesque
character of Neapolitan origin who was popularized in the
Commedia dell'Arte.

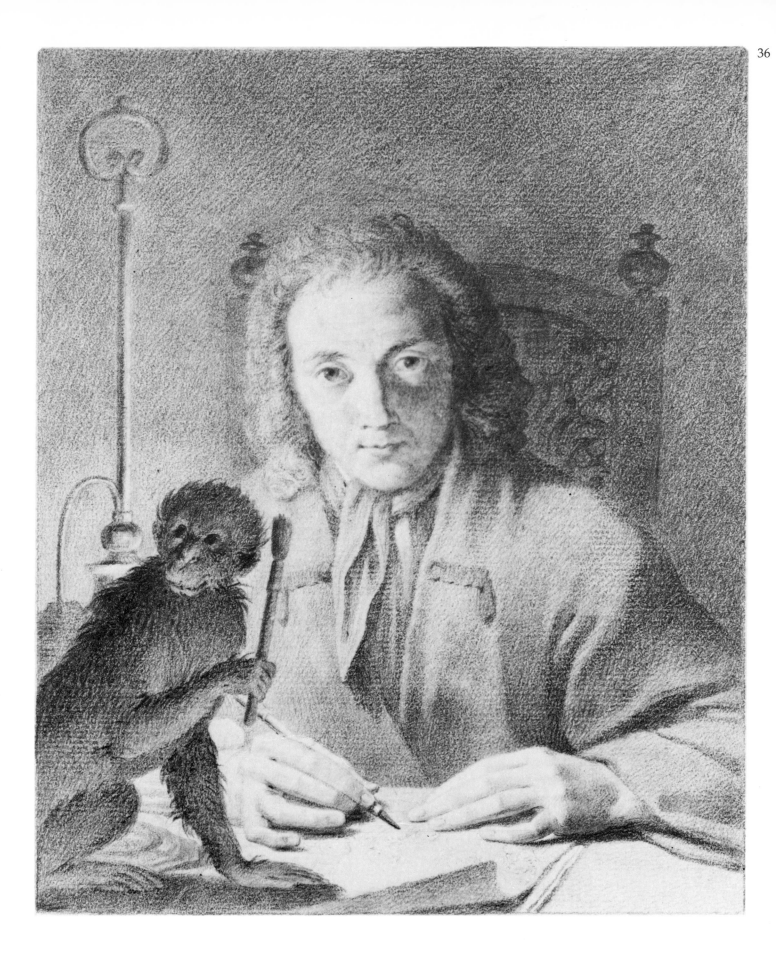

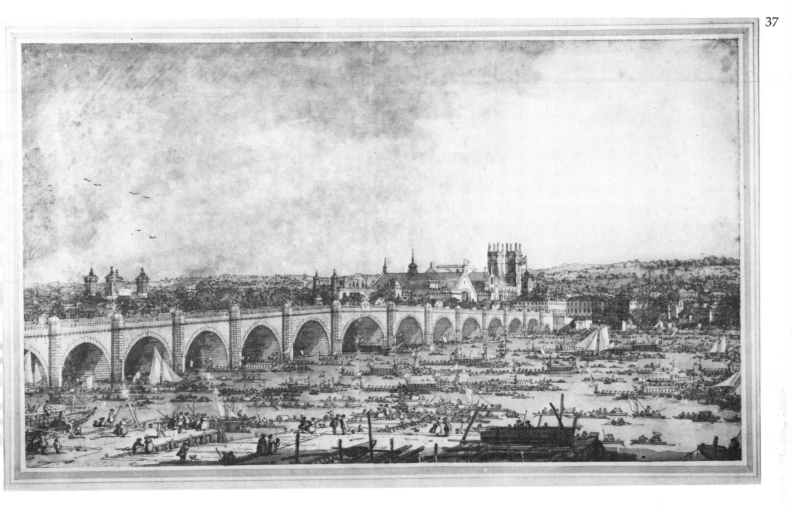

GIOVANNI DOMENICO CAMPIGLIA
1692-1768

36 *Self-portrait*

Black chalk; 41.8×26.2 cm
1865-1-14-820

Campiglia worked mainly in Florence and Rome, chiefly as an engraver and draughtsman. A blank space intended for an inscription below the drawing (covered by the mount) shows that it may have been intended to be engraved.

GIOVANNI ANTONIO CANALE,
called CANALETTO
1697-1768

37 *Westminster Bridge, London, with a Procession of civic Barges and other Boats*

Pen and brown ink with grey wash; 30.8×51.7 cm
1857-5-20-61

On the *verso* of the drawing is an inscription, possibly in Canaletto's hand: *Foncion de Lord Mayor a Londra*. Evidently the scene represented is the Lord Mayor's annual procession to Westminster, on 29 October 1747, when Canaletto was in London.

The view is taken from the Lambeth side of the Thames. Beyond the bridge, on the opposite bank, are visible, from left to right, the church of St John the Evangelist (now St John's Smith Square), St Stephen's Chapel, Westminster Hall, Westminster Abbey and St Margaret's (with a flag flying from the tower).

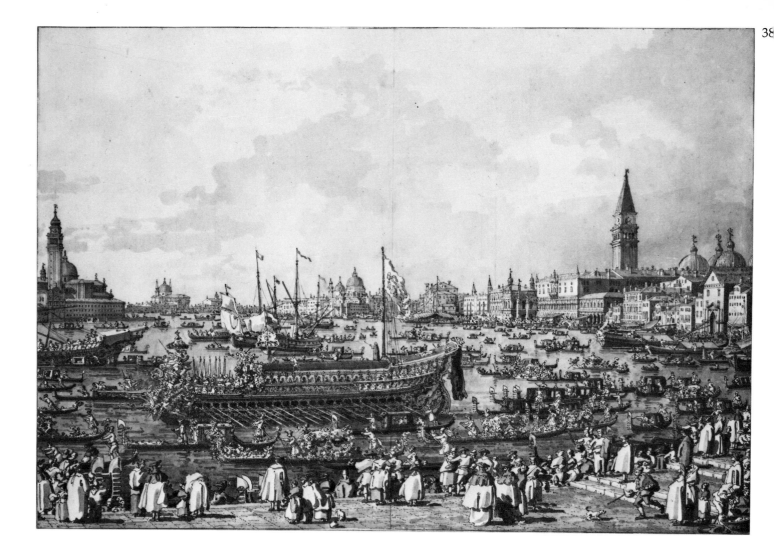

GIOVANNI ANTONIO CANALE,
called CANALETTO
1697-1768

38 *The Doge on Ascension Day departing for the Lido
in the Bucintoro*

Pen and light brown ink with grey wash, heightened with
white bodycolour; 39×60.4 cm
1910-2-12-19 George Salting Bequest

The scene represented is that of the *Bucintoro* (the Doge's
boat of state) departing for the Porto di Lido where the Doge
was to perform the ceremony of the *Sposalizio del Mare*
(Marriage with the Sea). The viewpoint is from the eastern
end of the Riva degli Schiavoni. Among the buildings seen
in the distance are, from the left: S. Giorgio Maggiore; the
church of Il Redentore; S. Maria della Salute (in the centre
background); and the Doge's Palace with the Campanile and
the domes of San Marco (on the right).

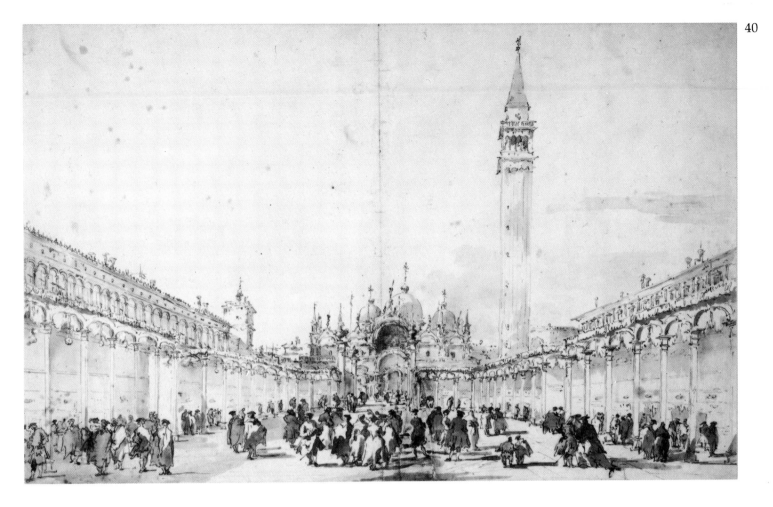

GIOVANNI BATTISTA PIRANESI
1720-1778

39 *View of the Capitol, Rome*

Pen and brown ink with red and black chalk; 40.3×70.1 cm
1908-6-16-45

Few working drawings survive for the *Vedute di Roma*,
Piranesi's famous series of topographical prints. The un-
finished state of the drawing shows how much of the detail
the artist supplied directly with the burin onto the surface of
the plate. The drawing is in the same direction and the same
size as the corresponding print.

FRANCESCO GUARDI
1712-1793

40 *Piazza S. Marco decorated for the 'Festa della Sensa'*
(Festival of the Ascension)

Pen and brown ink with brown wash over black chalk;
42.1×65.5 cm
1890-4-15-126

A good example of the large-scale drawings made by Fran-
cesco Guardi. Its composition corresponds with a painting of
*c.*1775 in the Gulbenkian Collection, Lisbon.

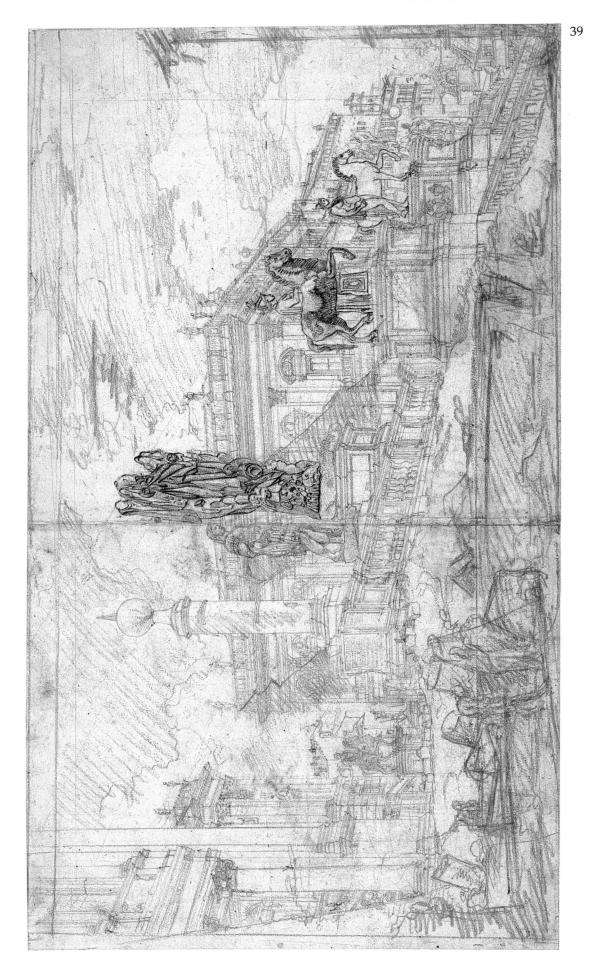

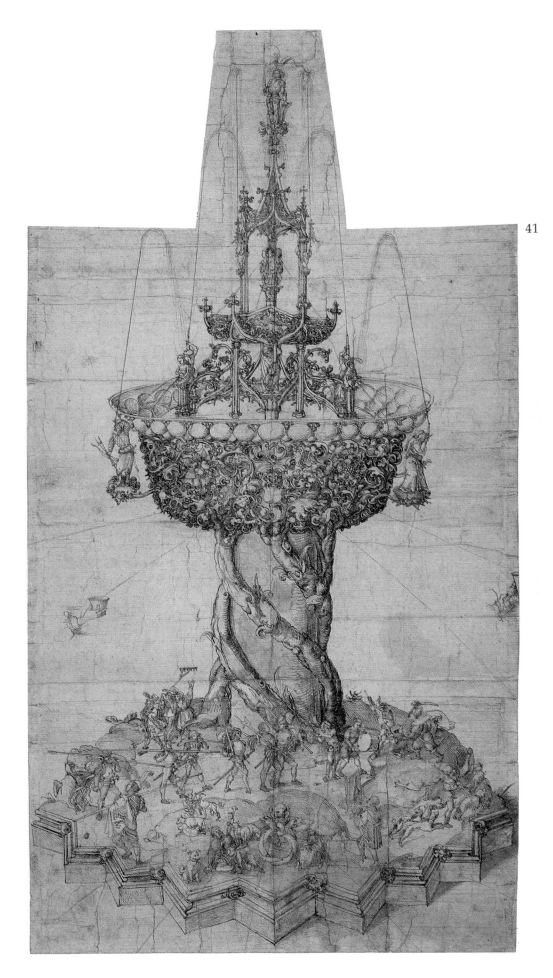

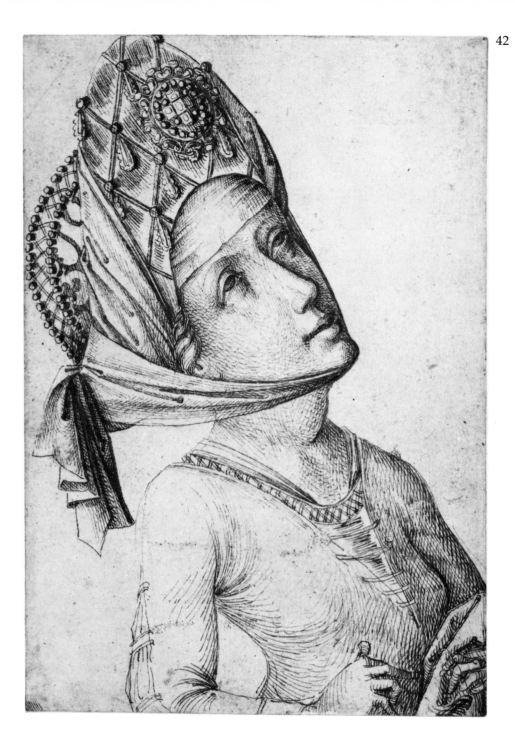

ALBRECHT DÜRER
1471-1528

41 *A Gothic Table Fountain*

Pen and brown ink, partly tinted with watercolour washes;
56×35.8 cm
5218-83 Sloane Bequest, 1753

The largest and most elaborate known metalwork design by
Dürer, probably executed about 1500. The artist's father-in-
law, Hans Frey, was a goldsmith who apparently made many
of these ornamental fountains, none of which survive, and it
could be that this design was executed for him.

UPPER RHINELAND
*c.*1440

42 *A Woman, probably a Sybil*

Pen and brown ink; 20.2×13.8 cm
1861-8-10-59

This richly dressed woman is strongly reminiscent of certain
female figures in the paintings of Conrad Witz (?*c.*1410-44/6)
which would suggest the draughtsman most probably
worked in Witz's immediate circle. The only drawings
usually associated with Witz himself are small-scale records
of compositions in pen touched with watercolour.

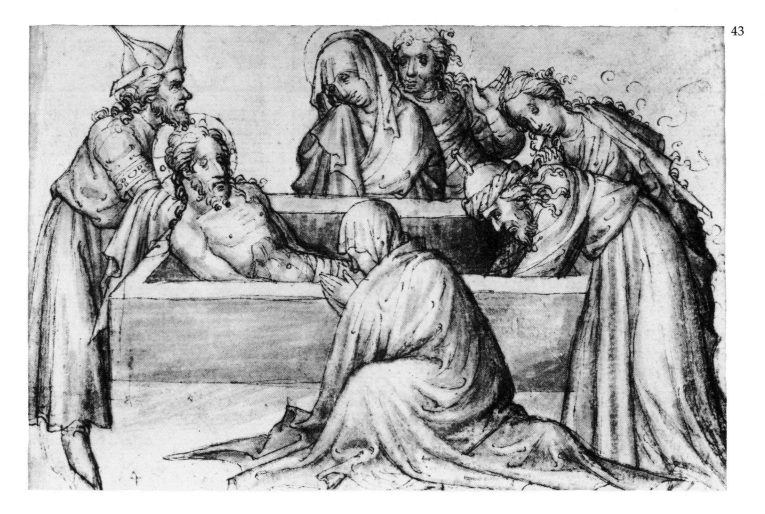

AUSTRIAN MASTER
*c.*1430

43 *The Entombment*

Pen and black ink with black and grey washes; 14×20.8 cm
5236-111 Sloane Bequest, 1753
This drawing has been specifically linked with the paintings
attributed to a leading artist of the time, called after his best
known surviving work 'the Master of the Votive Painting of
St Lambrecht'.

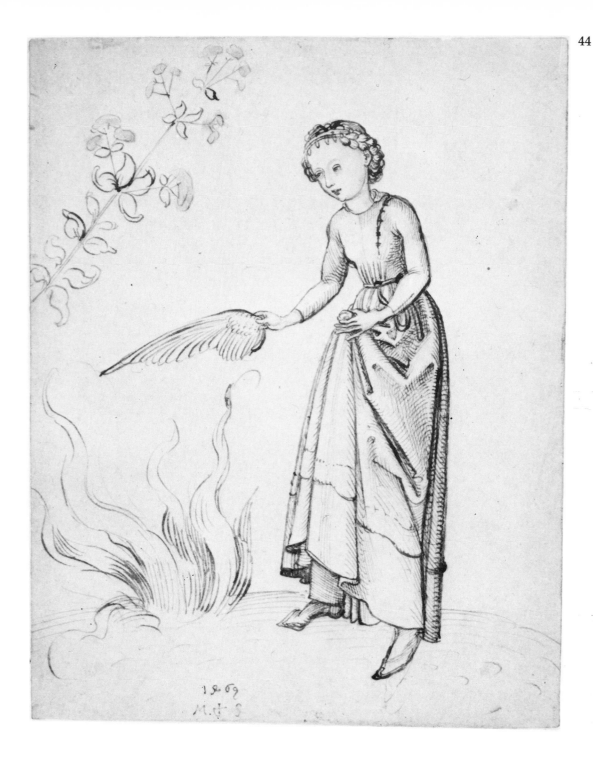

MARTIN SCHONGAUER
c.1453-1491

44 *A young Woman fanning a Fire with a Bird's Wing,*
probably 1469

Pen and brown ink with touches of pink wash; 18.3×14.2 cm
1884-9-13-14 Presented by Mrs W. Sharpe

This drawing belonged to the young Dürer who inscribed
the date, probably learnt from a reliable source, and Schon-
gauer's monogram on the sheet. It was almost certainly
acquired by him when he visited Schongauer's studio
shortly after his death. Dürer's earliest drawings strongly
reflect his admiration for this master's work (*q.v.* 48).

MICHAEL WOLGEMUT
1434-1519

45 *Design for the Title-Page of Hartmann Schedel's*
'Weltchronik' ('The Nuremberg Chronicle'), 1493

Pen and brown ink with watercolour washes and goldleaf on
the shields; 38.6×24.6 cm
1885-5-9-43

This is the only drawing of its kind by Wolgemut, Dürer's
master, to have survived connected with this famous book,
which was the first best-seller in the history of printing.

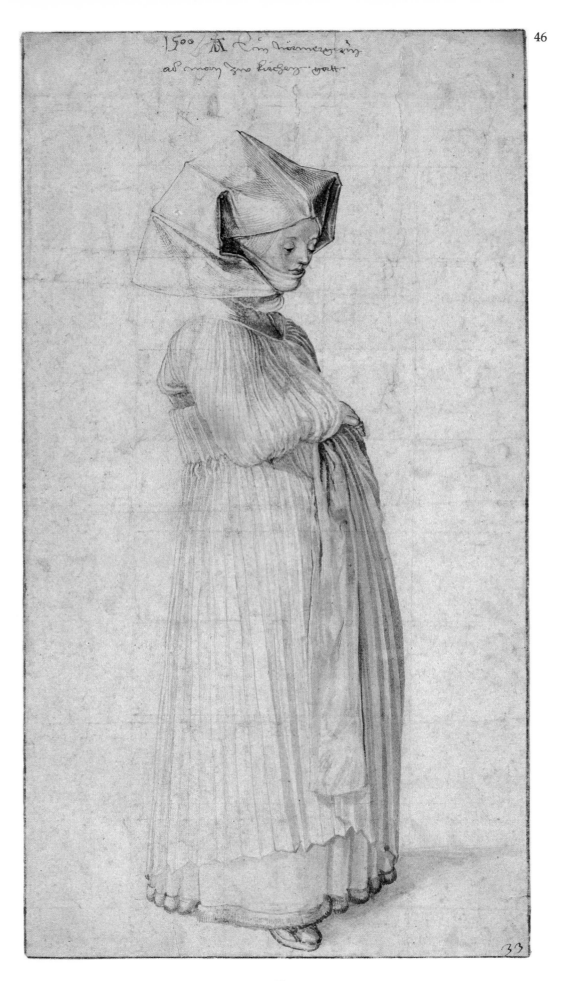

1500 / AD Ein nörmbergin
ab may zw kirchen gatt.

33

ALBRECHT DÜRER
1471-1528

46 *A Woman of Nuremberg going to Church,* 1500

Brush drawing in watercolour; 31.6×17.1 cm
1895-9-15-973

This was probably done prior to the better known version in Vienna, which was given a more finished appearance through the use of pen to define the outlines.

ALBRECHT DÜRER
1471-1528

47 *A Windisch Peasant Woman,* 1505

Pen and brown ink and brown wash; 41.6×28.1 cm
1930-3-24-1 Purchased with the aid of the National Art-Collections fund and of a private donor.

Perhaps the most striking characterisation of any of Dürer's portraits in pen. This peasant woman came from the Windisch Mark, the district around Gurk in Southern Austria, whom he evidently met somewhere *en route* to Italy or even in Venice itself.

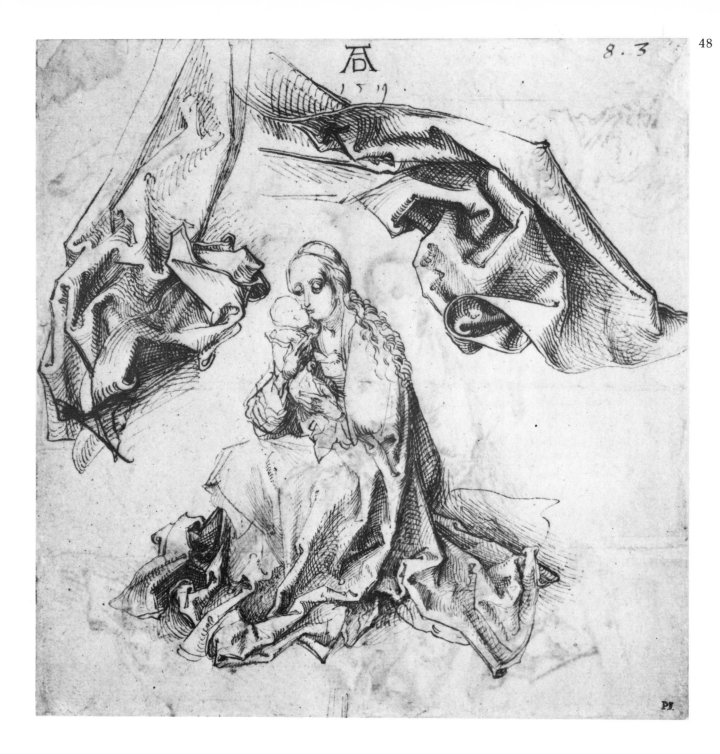

ALBRECHT DÜRER
1471-1528

48 *Virgin and Child, and study of a Hand and Drapery*

Pen and brown ink; 20.5×19.7 cm
1983-4-16-2*verso* Accepted by HM Treasury in lieu of tax and presented to the Museum.

Executed during his time as a journeyman from Easter 1490 to after Whitsun 1494, these studies, although inspired by the work of Martin Schongauer (*q.v.* 44), are among the first in which Dürer's own originality of expression is to be found.

HANS SUESS VON KULMBACH
1480-1522

49 *A Magus*

Pen and brown ink with grey wash and traces of an under-drawing in black chalk; 36×26.5 cm
1967-6-17-11

This is one of the surviving designs for parts of the Adoration of the Magi, the chief subject in the glass painting decorating the Ketzel family window, formerly in the Egidiuskirche at Nuremburg. Kulmbach was the most important of Dürer's followers who remained closely associated with the Master throughout his career.

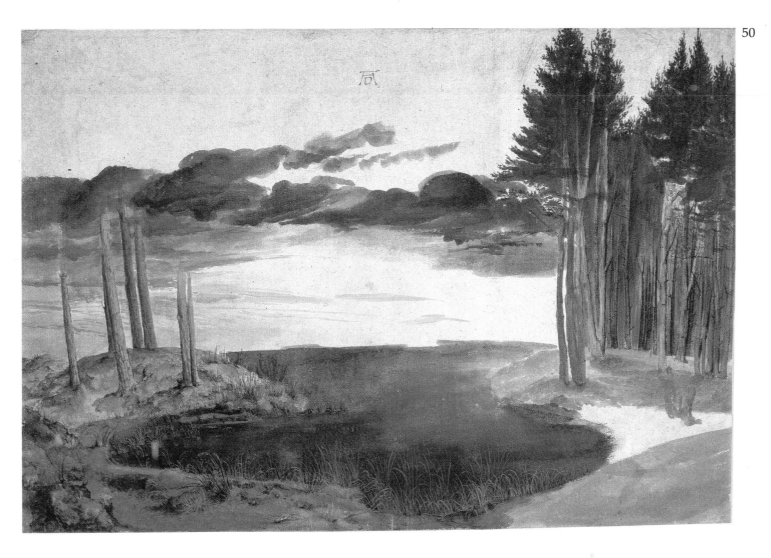

ALBRECHT DÜRER
1471-1528

50 *Study of Water, Sky and Pine Trees*

Watercolour and bodycolour; 26.2×36.5 cm
5218-167 Sloane Bequest, 1753

One of the finest of Dürer's watercolour landscapes, which
hold a position of unique prominence in the history of West
European art. It is generally considered that this belongs to a
group of landscapes of the countryside near Nuremberg,
done in 1496 or 1497 soon after Dürer's return from his first
visit to Italy.

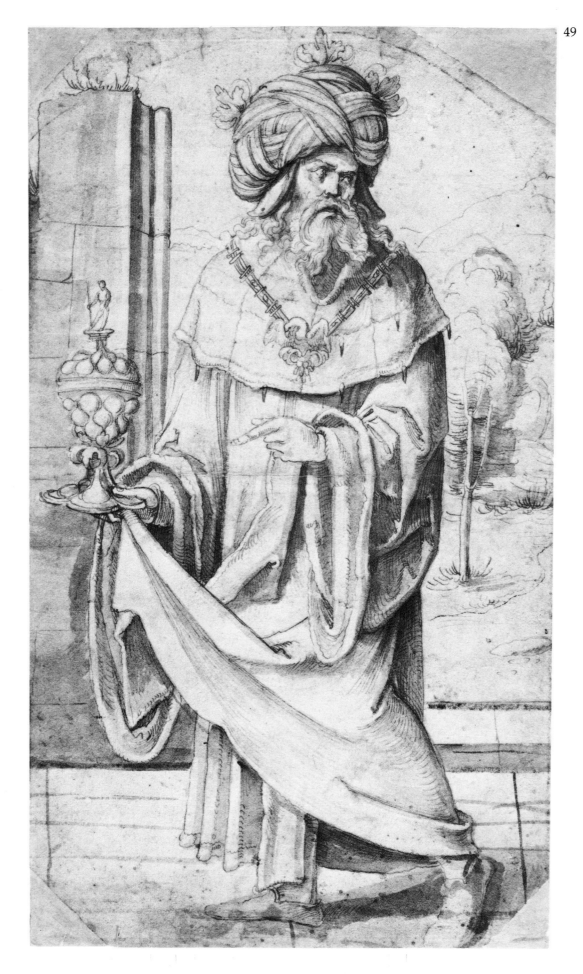

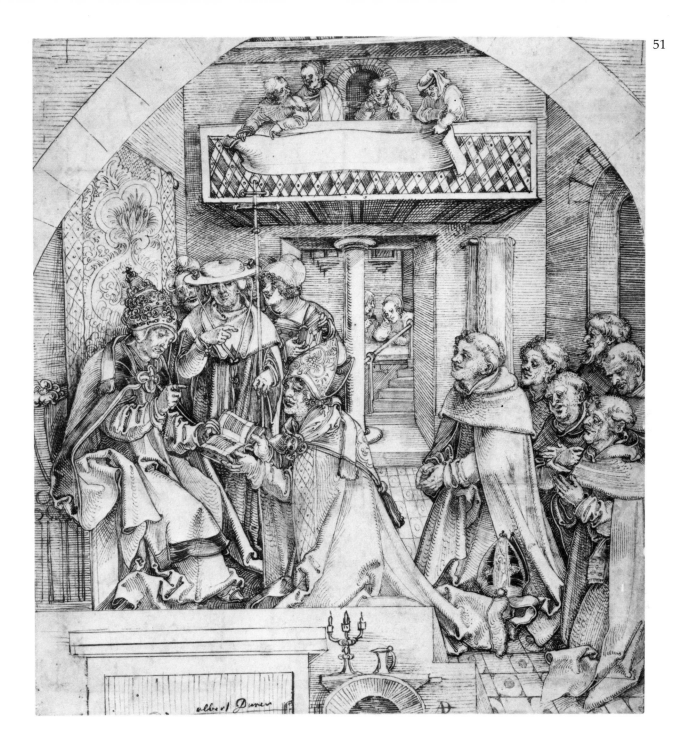

HANS SCHAUFELEIN
*c.*1480/85-.1538/40

51 *Pope Honorius II confirming the Rule of the Premonstratensian Order*

Pen and black and brown ink; 28.7×25.9 cm
1909-1-9-17

This is one of the finest drawings by this follower of Dürer, most probably executed during his stay in Augsburg, 1510-15, before he finally settled in Nördlingen for the rest of his career.

HANS BALDUNG GRIEN
1484/5-1545

52 *Virgin and Child seated on a Bank with attendant Putti and the Holy Dove*

Pen and black ink, heightened with white bodycolour on dark brown prepared paper; 27.9×19.5 cm
5218-179 Sloane Bequest, 1753

A superbly preserved example of Baldung's mature draughtsmanship probably done during the period *c.*1512-17, when the artist was working at Freiburg-im-Breisgau.

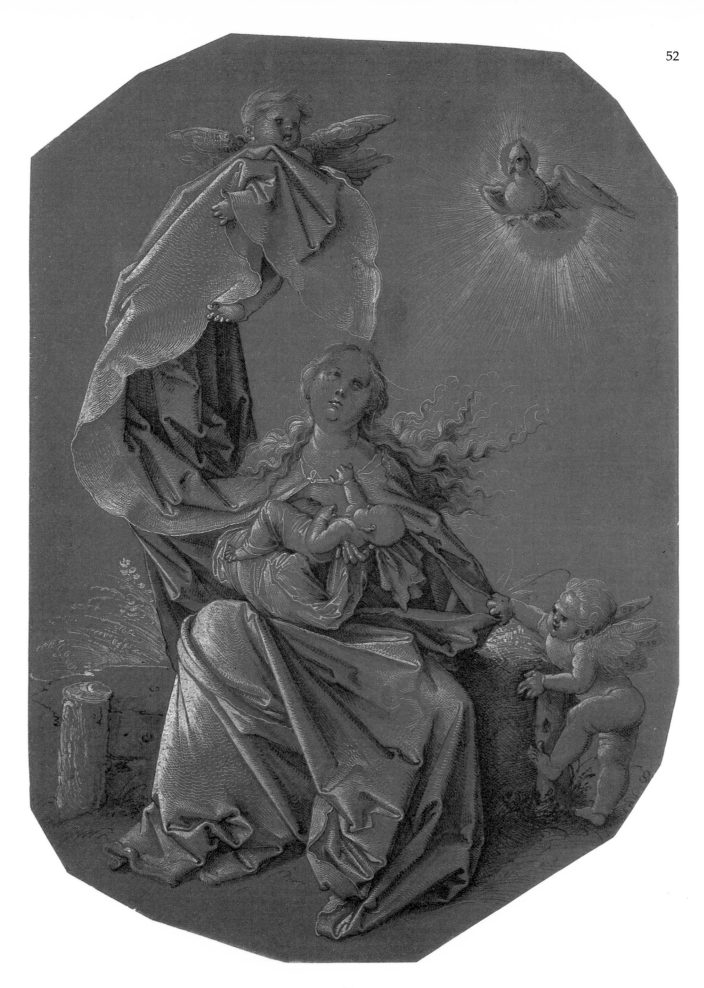

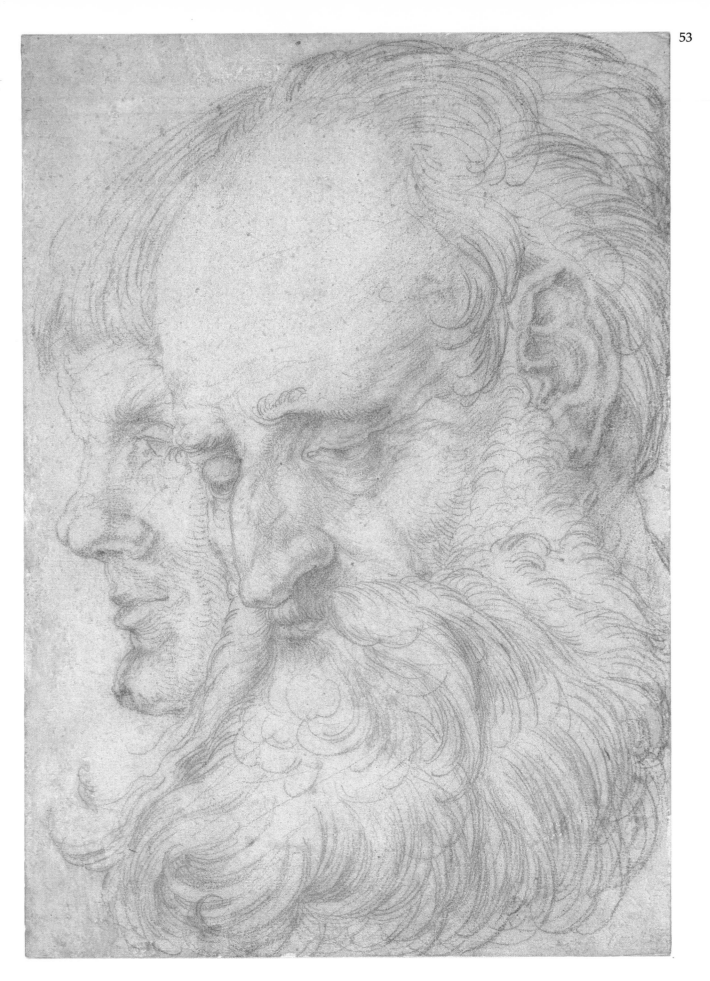

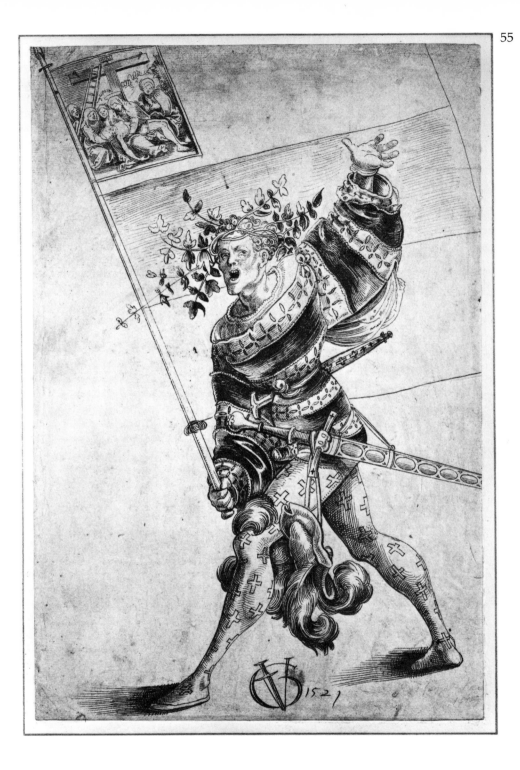

HANS BALDUNG GRIEN
1484/5-1545

53 *Study of the Heads of two Men*

Red chalk with touches of black chalk; 28.8×20.1 cm
1949-4-11-106 Campbell Dodgson Bequest

Like no. 52, this also very probably belongs to his years at
Freiburg-im-Breisgau. The contrasting on the same sheet of
different types of men and women at various ages is a theme
that Baldung shared with Dürer, although the latter's interest
was more theoretical.

HANS HOLBEIN THE ELDER
c.1465-1524

54 *St Margaret and St Dorothy*

Pen and black ink, heightened with white bodycolour, on
light brown prepared paper; 21×15.3 cm
1926-7-13-8

This characteristic early drawing can be dated before or in
1496 as it was used as a model by one of the artist's followers,
Gumpolt Giltlinger (active c.1481-1522) for an altarpiece for
the Abbot's Chapel in the Abbey of Sts Ulrich and Afra,
Augsburg, executed in 1496.

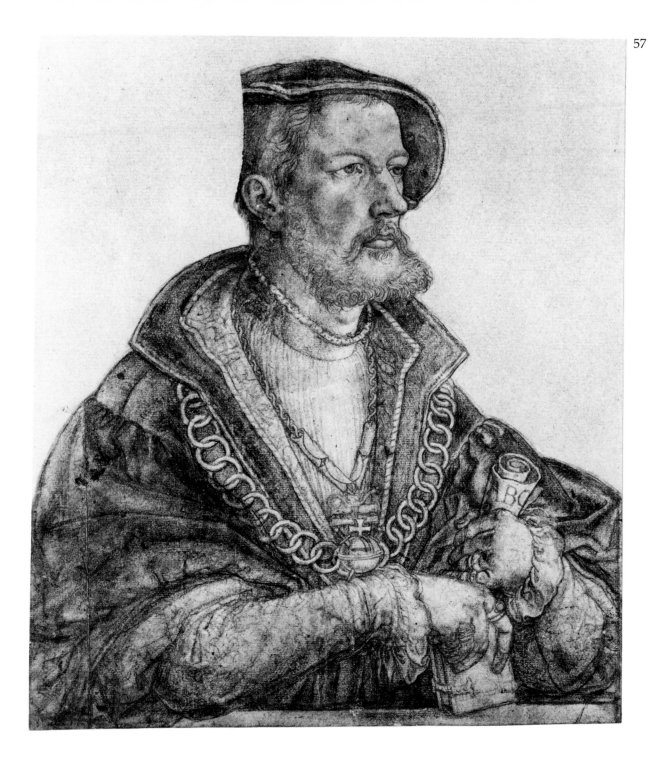

URS GRAF
c.1485–*c*.1527

55 *The Standard-Bearer of the Canton of Zug, 1521*

Pen and black ink; 27×18 cm
1912-7-9-1

Graf, who trained as a goldsmith, served as a mercenary
soldier, and in many of his drawings we are presented with a
highly satirical, often bitter, view of the world. As well as
producing a number of other drawings of standard-bearers,
in 1521 Graf also designed a series of white-line woodcuts of
the Standard-Bearers of the Swiss Confederacy.

LUCAS CRANACH THE ELDER
1472-1553

56 *Head of a Man wearing a Hat*

Brush drawing with brown, grey, black and red washes,
heightened with creamy-white bodycolour on rough light
brown paper; 26.8×18.7 cm
1896-5-11-1

This finely preserved portrait study can be linked in style
with paintings of the period 1510-15. The particular colours
used and the brush work are typical of Cranach.

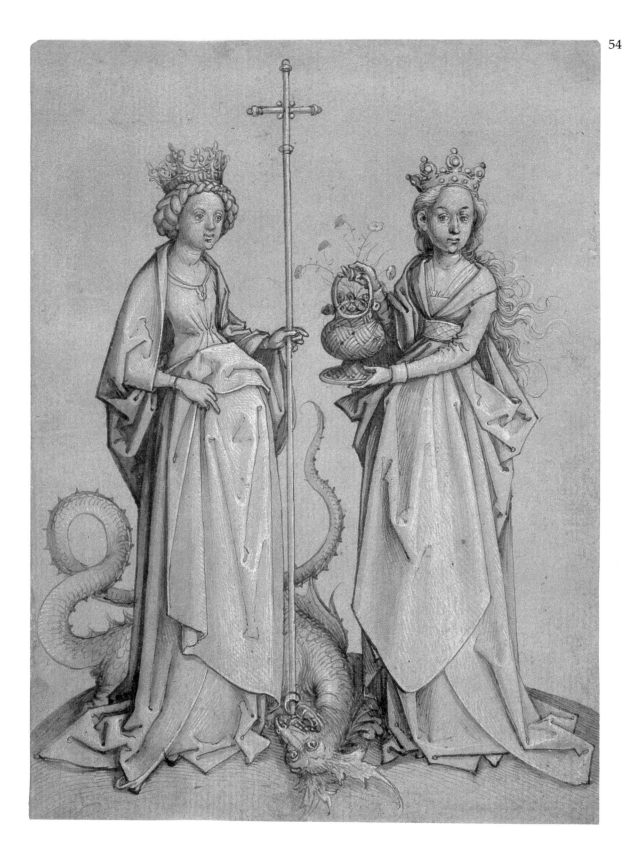

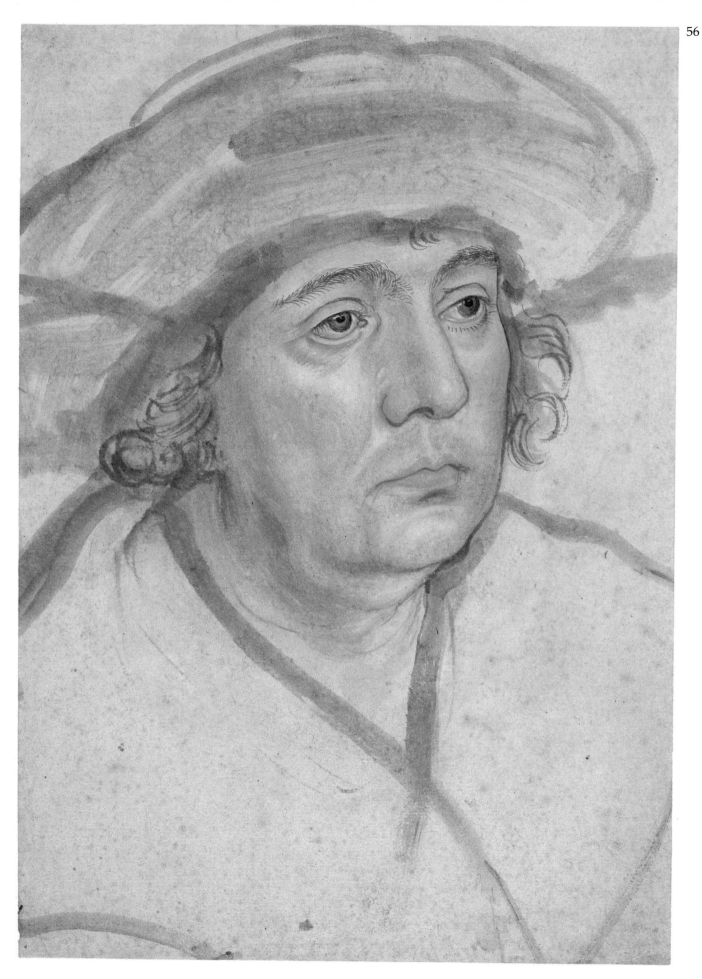

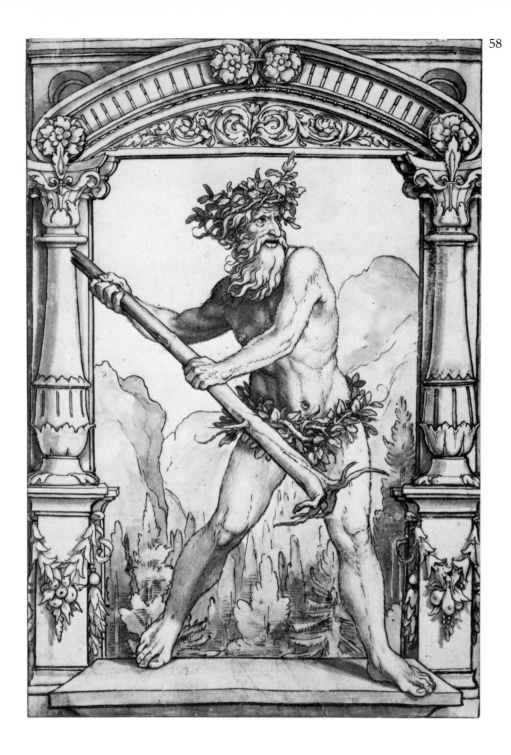

HEINRICH ALDEGREVER
1502-1555

57 *Portrait of Jan van Leyden*

Black chalk with red chalk on part of the face (cut out around
the outline of the sitter); 26.6×23.3 cm
1886-6-9-38

Perhaps the most important drawing surviving by this
Northern German master, it was done as a preparatory
sketch for his engraving of the notorious leader of the
Anabaptists, most probably soon after the sitter had been
captured following the fall of Münster in July 1535.

HANS HOLBEIN THE YOUNGER
1497/8-1543

58 *A Wildman brandishing an uprooted Tree Trunk*

Pen and black ink with black, brown and green washes;
32.1×21.5 cm
1895-9-15-992

This design was for a glass-painting almost certainly for a
window in the house of the Basel guild *Zur Hären*, who had
the figure of a Wildman as their badge.

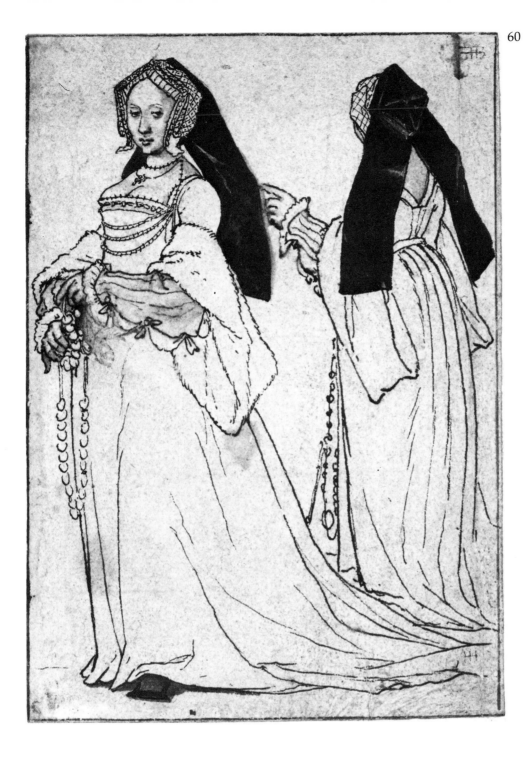

AMBROSIUS HOLBEIN
*c.*1494-1519/20

59 *Portrait of a young Man*

Brush drawing with black wash, with the features finished with pen and brown ink, and the background in red body-colour; 14.8×12.2 cm

1926-4-10-1 Presented by the National Art-Collections Fund, with the aid of contributions from Sir Otto Beit, and C.S. Gulbenkian

Opinion has been divided as to whether this portrait is by Hans Holbein the Younger or his elder brother Ambrosius, a shadowy figure who died young. Even so there are grounds for considering that it was probably done by Ambrosius shortly before his death.

HANS HOLBEIN THE YOUNGER
1497/8-1543

60 *Two Views of the same Lady wearing an English Hood*

Brush drawing with black ink, tinted with pink and grey washes; 15.9×11 cm

1895-9-15-991

These costume studies show a lady wearing a type of head-dress which was in fashion in England from the late 1520s for about a decade. Like a similar study of an English woman in the Ashmolean Museum, Oxford, this most probably belongs to the first years of Holbein's second stay in England, 1532-43.

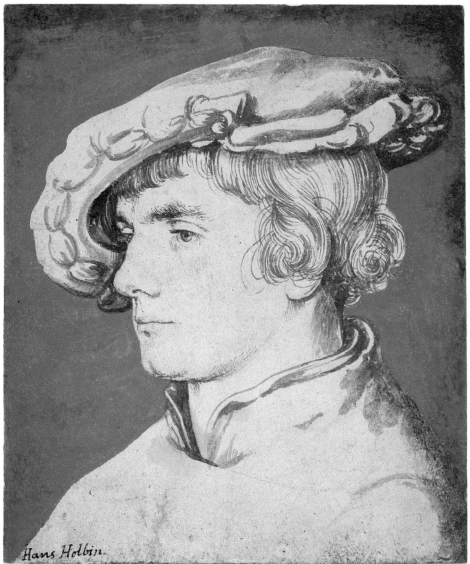

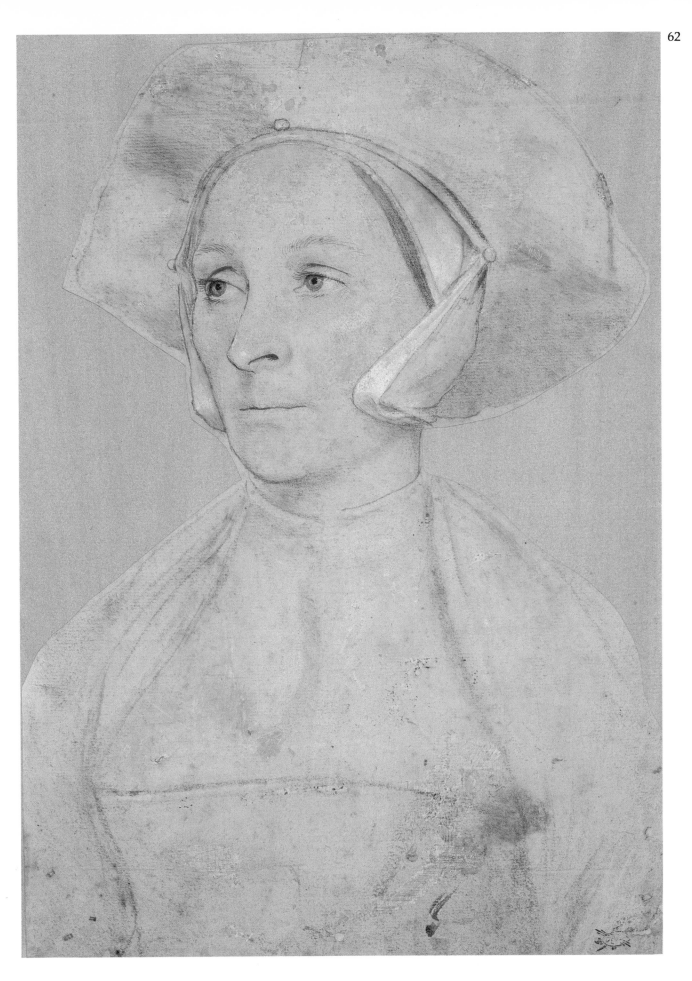

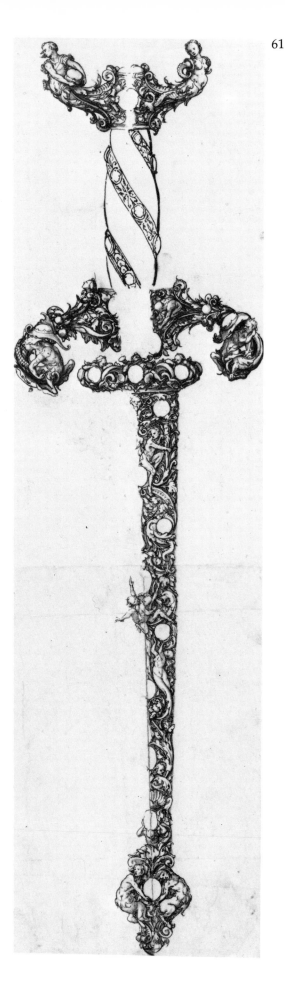

61

HANS HOLBEIN THE YOUNGER
1497/8-1543

61 *Design for a Dagger*

Brush drawing in black ink; 45.5 × 12.6 cm
1874-8-8-33

This richly ornamented and bejewelled weapon would obviously have been for ceremonial use only, and was almost certainly intended for King Henry VIII.

HANS HOLBEIN THE YOUNGER
1497/8-1543

62 *Portrait of an English Woman*

Black and red chalk, heightened with white bodycolour, on pink tinted prepared paper; the outlines of facial features are drawn in black ink with the point of the brush. The outline of the sitter has been silhouetted; 27.6 × 19.1 cm
1910-2-12-105 George Salting Bequest

Executed during the artist's second stay in England, most probably in the mid-1530s. It was formerly suggested that the sitter was Margaret Roper, Sir Thomas More's favourite daughter, but the features, although similar, are not close enough to those in Holbein's miniature of her, executed in 1536, for this identification to be proven.

HANS HOLBEIN THE YOUNGER
1497/8-1543

63 *Design for a Chimney Piece*

Pen and black ink with grey, blue, and red washes;
53.9×42.7 cm
1854-7-8-1

The use of the royal arms in the design indicates that it was
intended for one of the many royal buildings under con-
struction during Holbein's second stay in England, most
probably towards the end of his career.

ALBRECHT ALTDORFER
c.1479-1538

64 *A Wildman carrying an uprooted Tree,* 1508

Pen and black ink, heightened with white bodycolour on
reddish brown tinted paper; 21.4×14.6 cm
1910-6-11-1

The rough wooded terrain of the Upper Danube Valley in-
spired Altdorfer's landscape drawings. This early drawing
represents his draughtsmanship at its most spontaneous and
individual.

LUDWIG REFINGER
active c.1528-1548/9

65 *The Jews passing through the midst of the Red Sea*

Pen and brown ink and watercolour washes; 23.4×66.4 cm
5218-205 Sloane Bequest, 1753

Refinger was a Bavarian artist who specialised in producing
history-paintings on the grand scale. This sketch would have
been executed in preparation for one of these.

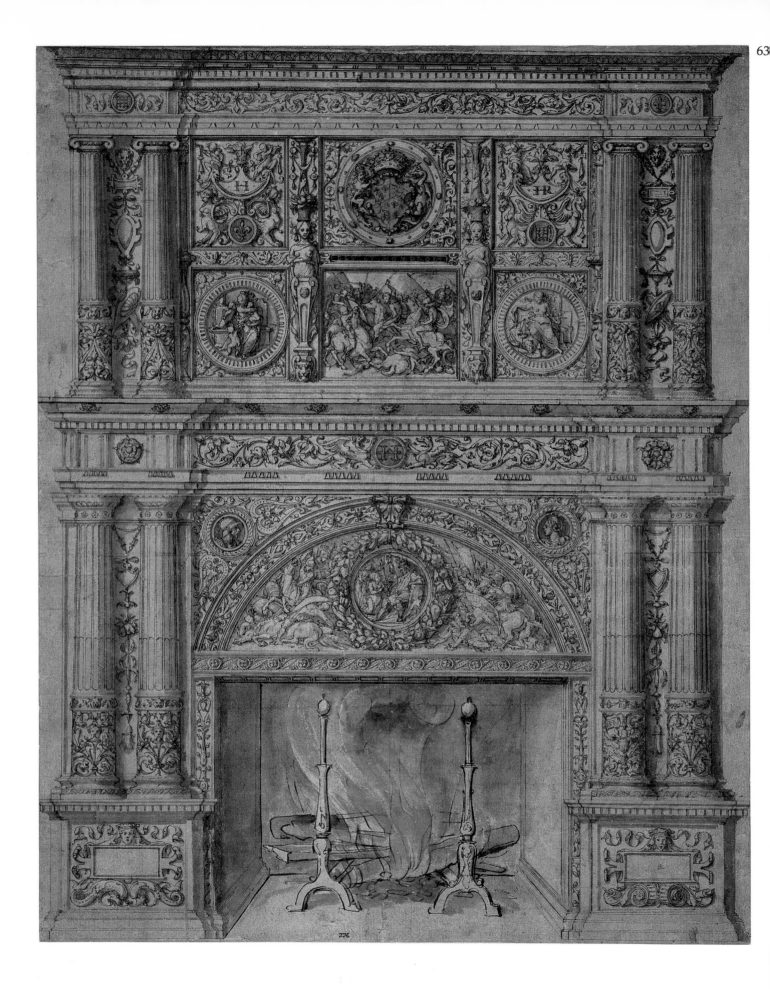

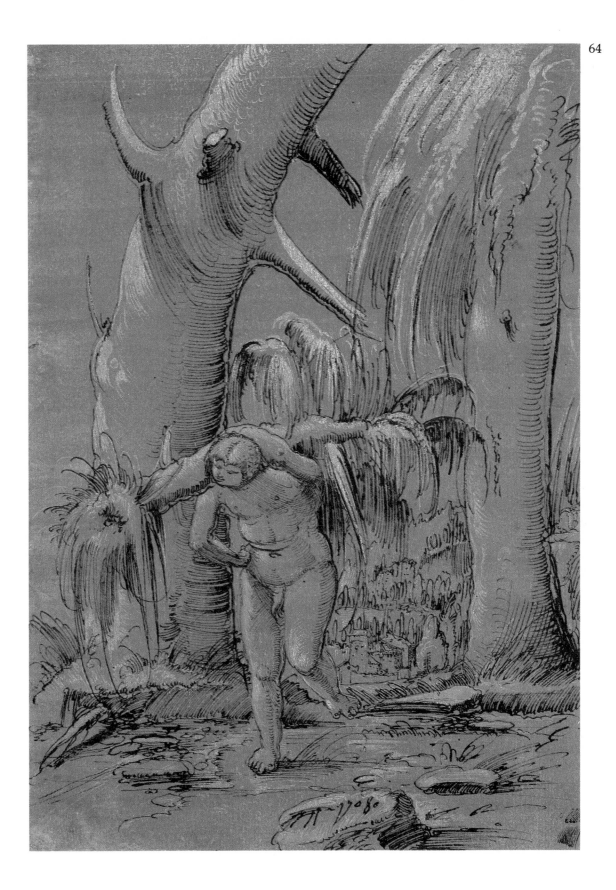

WOLF HUBER
*c.*1480/90-1553

66 *A View of a River Valley with a distant Mountain
Range,* 1523

Pen and brown ink; 31.3×21.3 cm
1883-7-14-101

This view has been identified as of Feldkirch in the Voral-
berg, where Huber had been working on the painted parts of
the St Anne altarpiece completed in 1521. Huber continued
to produce landscape drawings throughout his career, in
which the element of fantasy always played a large rôle.

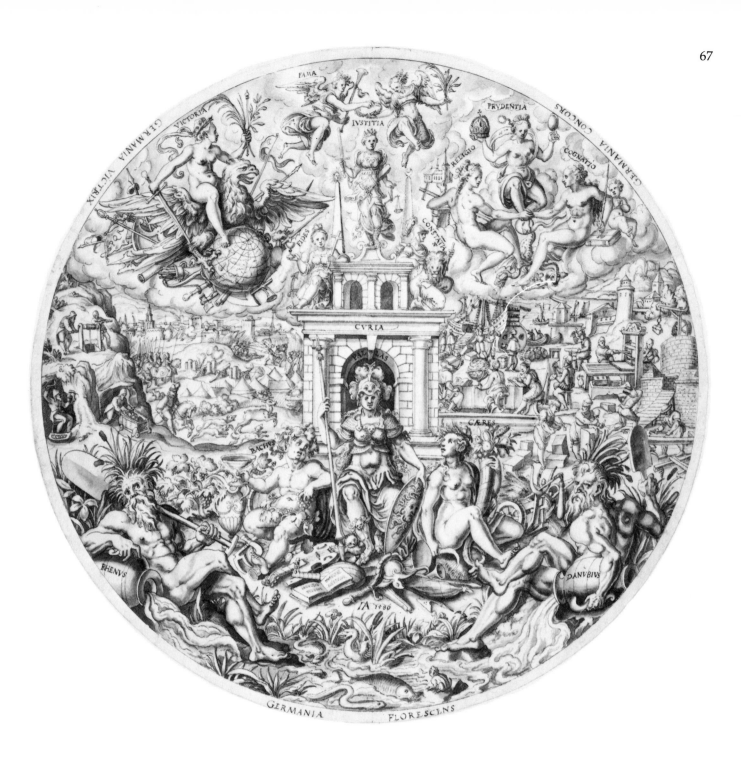

JOST AMMAN
1539-1591

67 *Germania Florescens: an Allegory of a prosperous Germany*, 1586

Pen and black ink with grey wash; 36.3 cm diameter
1949-4-11-105 Campbell Dodgson Bequest

Trained as a glasspainter, Amman produced many designs for such work. This accomplished decorative work, whose purpose is uncertain, was most probably executed at Nuremberg where he worked chiefly for book publishers and goldsmiths, and the patrician families of the city.

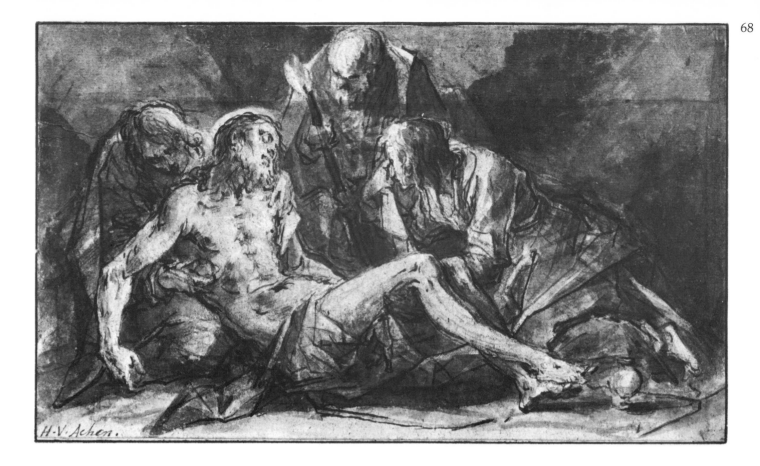

HANS VON AACHEN
1552-1615

68 *The Entombment of Christ*

Pen and black ink with grey wash, heightened with white
bodycolour, with black chalk on grey paper; 15×24.5 cm
1895-9-15-1026

Hans von Aachen was a leading exponent of the late Man-
nerist allegorical type of genre painting prized at the court of
the Emperor Rudolf II in Prague. Here the artist has pro-
duced through the tension of his line and the dramatic light-
ing a remarkably intense rendering of the subject.

HANS ROTTENHAMMER
1564-1625

69 *The Assumption of the Virgin*, 1612

Pen and black and brown ink with watercolour washes and
traces of squaring in black chalk, heightened with white
bodycolour on buff-tinted paper; 29.2×21.1 cm
1861-8-10-13

This is one of the finest of Rottenhammer's late drawings,
executed in Augsburg following the artist's return from
Venice, where he had fallen particularly under the influence
of Veronese and Tintoretto.

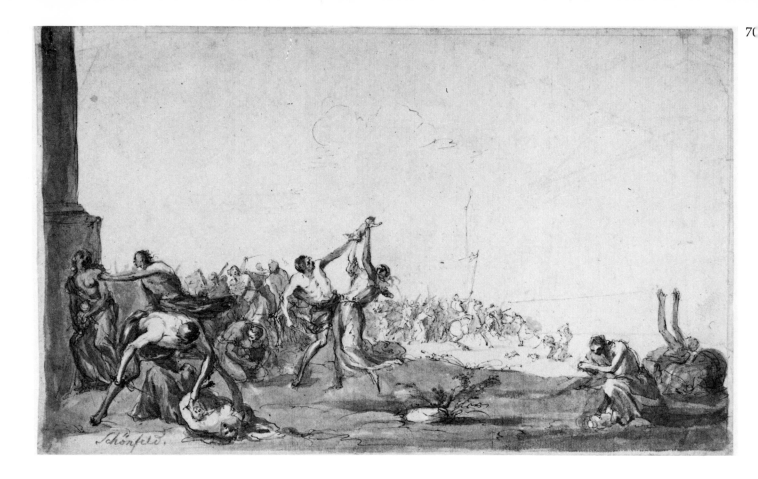

JOHANN HEINRICH SCHÖNFELD
1609-1684

70 *The Slaughter of the Innocents*

Pen and black ink with grey wash and traces of an under-
drawing in black chalk; 20.7×33.4 cm
1928-10-16-9

Both this drawing and the painting in Biberach connected
with it are likely to be from Schönfeld's lengthy stay in
Naples, so strongly do they reflect the influence of contem-
porary Neapolitan art.

ADAM ELSHEIMER, attributed to
1578-1610

71 *Landscape with wooded Hills beside a River at
Sunset*

Brush drawing in black and white bodycolour with touches
of light violet-rose on brown prepared paper; 18.3×25.8 cm
1895-9-15-1032

One of the finest of the 'Elsheimer' gouache landscapes
whose attribution to this leading German artist, chiefly
active in Italy, is now questioned. Some of these have been
reattributed to a Dutch artist, Gerrit van Battem (c.1636-84),
whose other drawings lack the evocative spirit of the best of
these landscapes.

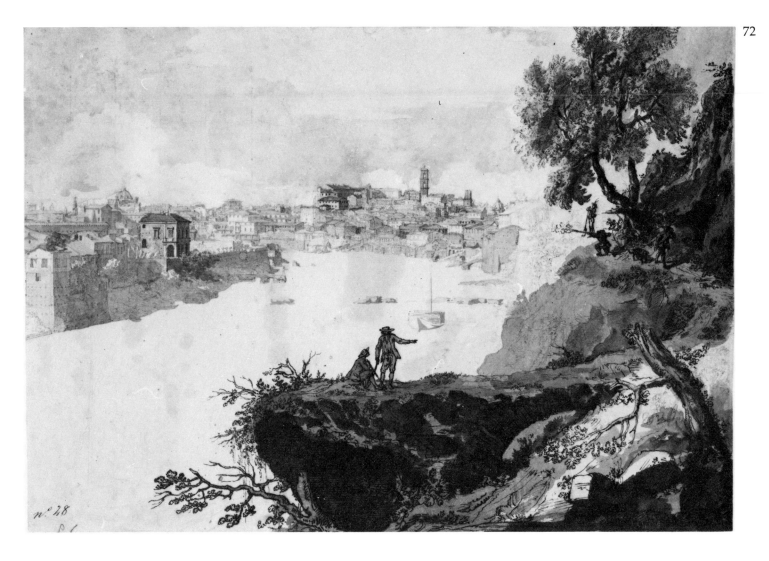

CARL HACKERT
1740-1796

72 *View of the Tiber*

Pen and brown ink and pencil, and watercolour;
31.5×42.3 cm
1946-7-13-1161 Presented anonymously (Phillipps-Fenwick Collection)

Carl was the younger brother of the more famous Jacob Philip Hackert, through whom he gained work and encouragement when he joined him in Rome in 1772. This unfinished sketch of Carl's, although akin to his brother's drawings in style and colouring, is far more freely executed.

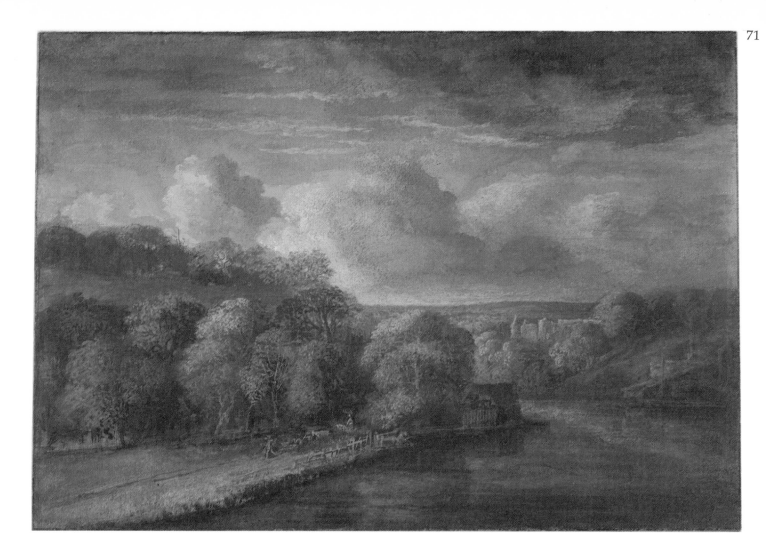

GEORG DIONYSIUS EHRET
1708-1770

73 *Longleaf Pine* (*Pinus palustris*, Miller, *P. australis*, Michaux)

Bodycolour on vellum; 53.7×36.8 cm
1974-6-15-28 Presented by Dame Joan Evans

Trained as a gardener, Ehret was the first botanical draughts-man to record accurately the 'character' of plants in accordance with the new Linnaean system of classification. This drawing of an 'exotic', a combination of scientific observation and artistic skill, is typical of the work highly prized by his rich English patrons.

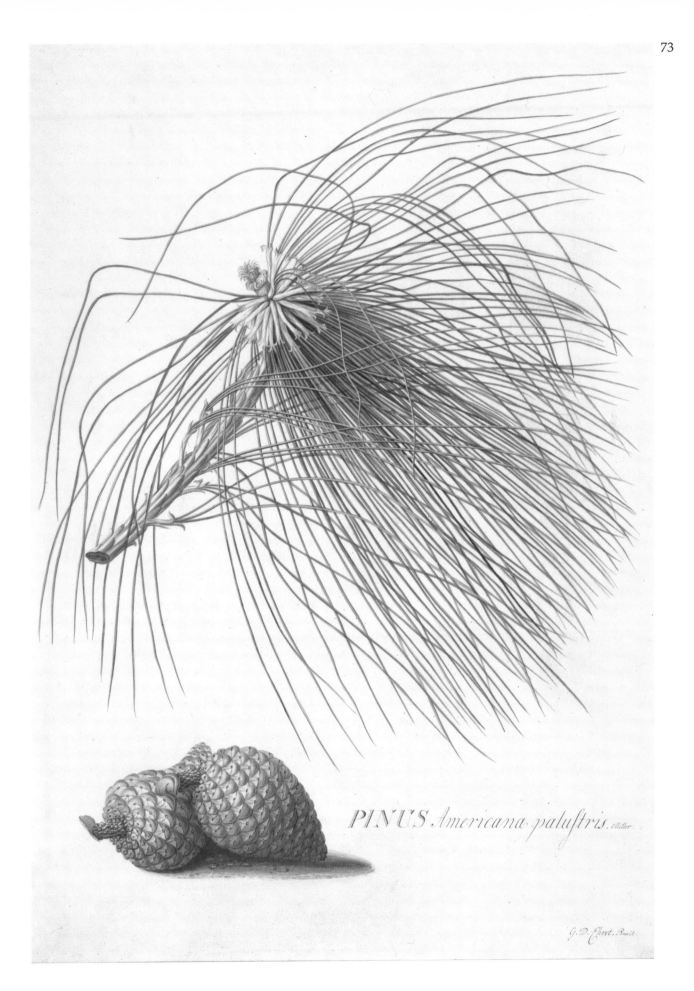

PINUS *Americana paluftris.* ehitter

G. D. Ehret. Pinxit

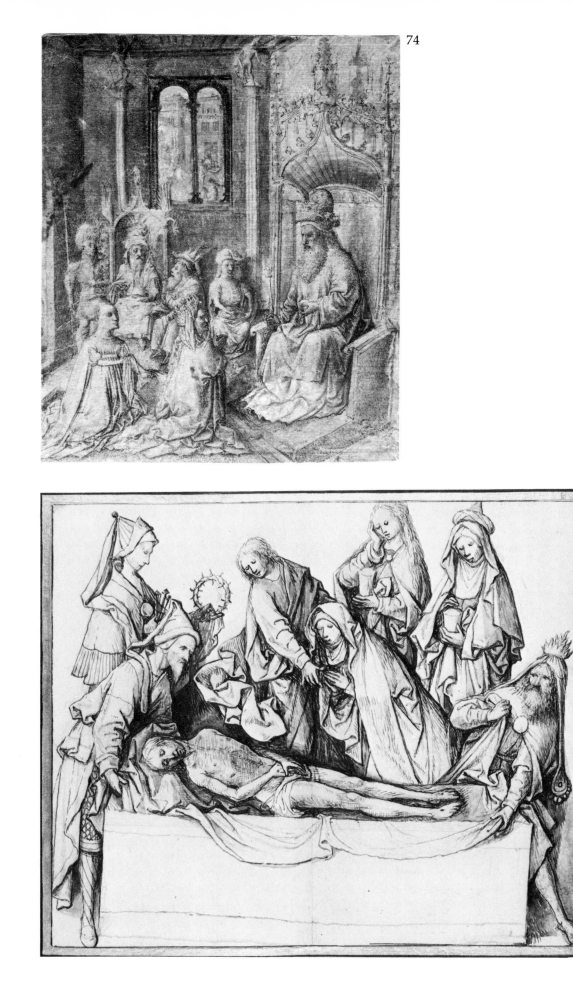

74

75

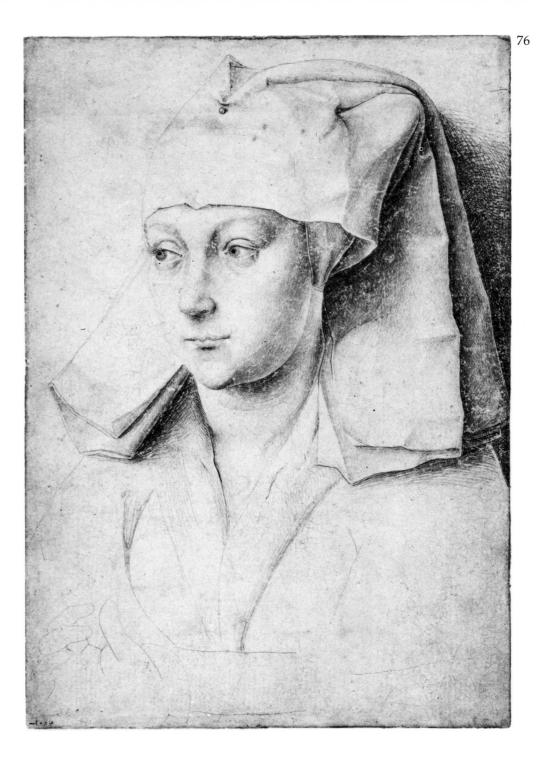

BURGUNDIAN SCHOOL
*c.*1430

74 *Esther and Ahasuerus*

Pen and black ink with grey and brown wash, heightened with white bodycolour, on pink prepared paper;
14.9×12.5 cm
1978-6-24-30

The composition is similar to that of a miniature of 1436 painted for René d'Anjou. A good early copy of this drawing, showing it before it was trimmed on the left, is in Brunswick.

HIERONYMUS BOSCH
*c.*1450-1516

75 *The Entombment*

Brush drawing in grey over traces of an underdrawing in black chalk; 25.3×30.4 cm
1952-4-5-9 Presented by the National Art-Collections Fund

The drawing was first discovered and identified as by Bosch in 1952. Its high quality of brush work and unusual iconography seem characteristic, and no convincing alternative attribution has been suggested.

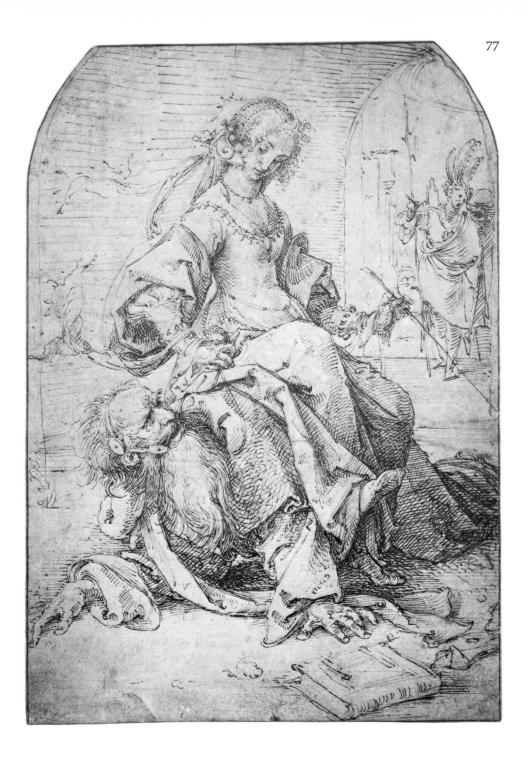

ROGER VAN DER WEYDEN
1397/1400-1464

76 *Portrait of a young Woman*

Silverpoint on prepared cream paper; 16.6×11.6 cm
1874-8-8-2266

One of very few drawings attributable on grounds of quality
to Roger himself rather than to his school. It is not related to
any known painting or commission.

JAN DE BEER
c.1475-before 1536

77 *Aristotle and Phyllis*

Pen and brown ink; 27.4×19.2 cm (top corners rounded)
1929-4-16-1

Jan de Beer was a Mannerist painter working in Antwerp
around 1520. The subject is an allegory of the influence of
women over men: Phyllis, concubine of Alexander, humili-
ates Aristotle by wooing him and then forcing him to allow
her to ride on his back.

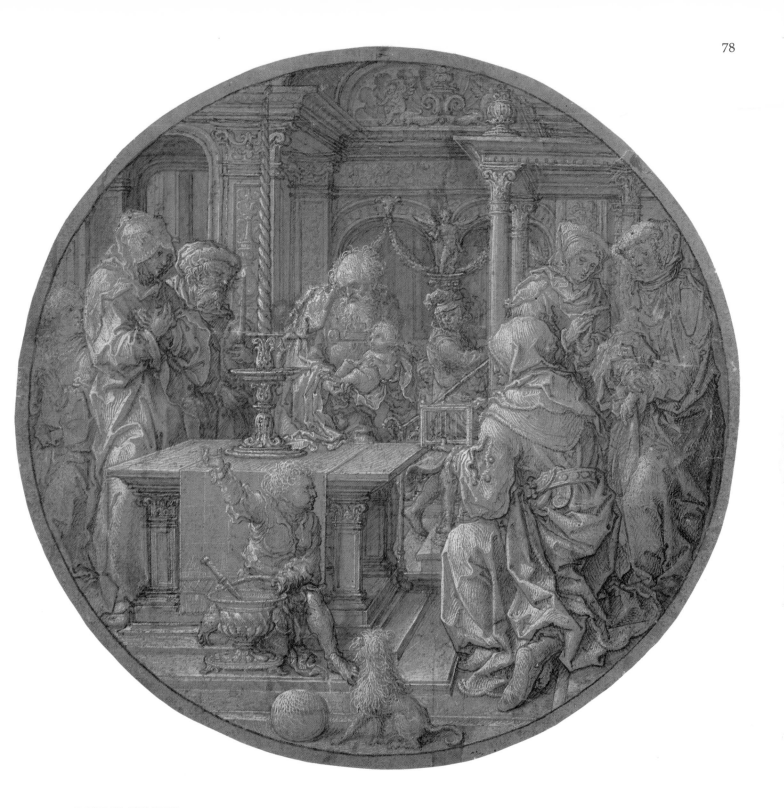

DIERICK VELLERT
*c.*1485-after 1544

78 *The Presentation in the Temple*

Brush drawing in brown and white over black chalk, on grey
prepared paper; 23.7 cm diameter
1952-1-21-85 Purchased (Vallentin Fund) with the aid of a
grant from the National Art-Collections Fund

A design for stained glass. Another drawing for the same
composition is in the Museum. Vellert achieved consider-
able renown as a glass painter in Antwerp, where he was
principally active.

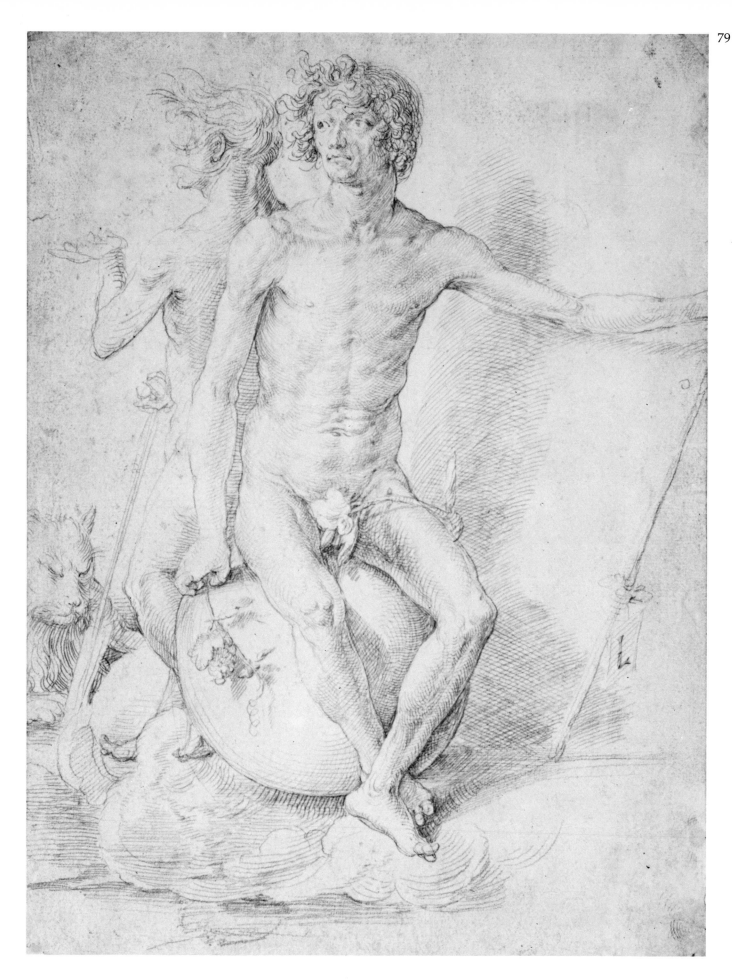

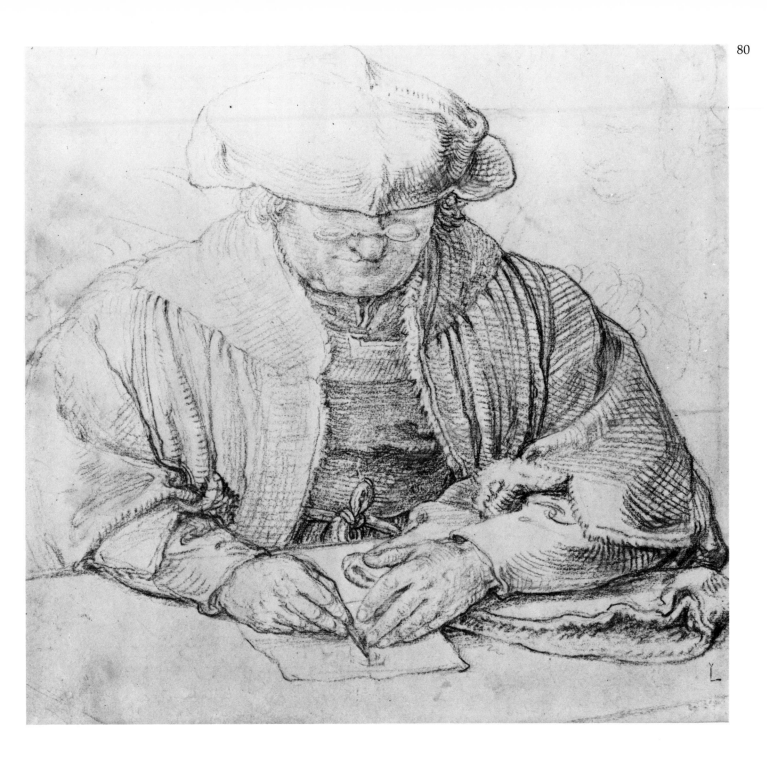

LUCAS VAN LEYDEN
?1494-1533

79 *Allegorical Figures seated on a Globe*

Silverpoint on prepared cream paper;
27.6×20.3 cm
1892-8-4-9

Probably drawn *c.*1520. The allegory has not been explained.

LUCAS VAN LEYDEN
?1494-1533

80 *An old Man drawing*

Black chalk; 27.2×27.2 cm
1892-8-4-16

Generally dated *c.*1512 on stylistic grounds although it could
be somewhat later. The sitter has not been identified.

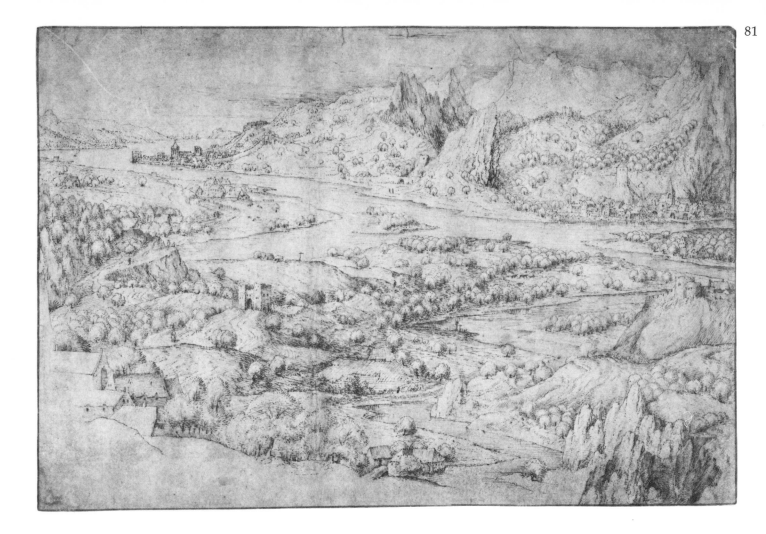

PIETER BRUEGEL THE ELDER
*c.*1525-1569

81 *Alpine Landscape*

Pen and brown ink over black chalk; 24.5×35.2 cm
1963-10-12-1

Bruegel studied Alpine scenery during his journey to Italy,
undertaken between 1551 and 1554. The present sheet prob-
ably dates from slightly later, *c.*1555, and was made in prepa-
ration for a print entitled *Solicitudo Rustica*, published by
Hieronymus Cock.

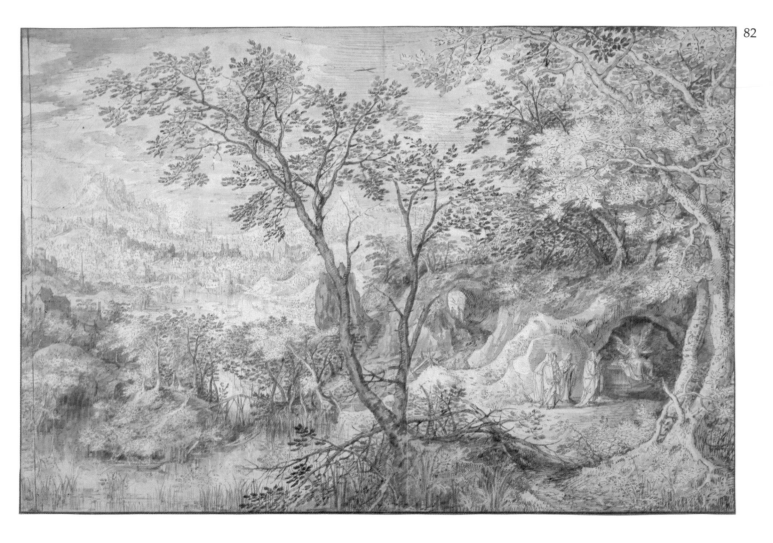

DAVID VINCKBOONS
1578-*c*.1632

82 *Landscape with the three Maries at the Sepulchre*

Pen and brown ink with brown, grey and blue washes;
32.8×48 cm
1946-7-13-135 Presented anonymously (Phillipps-Fenwick
Collection)

Vinckboons was of Flemish origin but moved to Amsterdam
with his family in 1586. His interest in landscape and genre
subjects forms an important link between the art of Pieter
Bruegel the Elder and the naturalism of seventeenth-century
Dutch art.

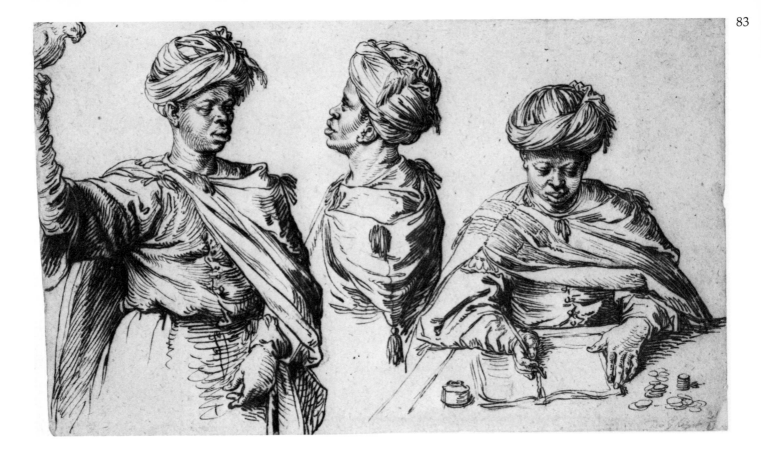

JACOB DE GHEYN THE YOUNGER
1565-1629

83 *Three Studies of a Negro*
Pen and brown ink on pale cream paper; 20.1×32 cm
1869-6-12-594
De Gheyn was the leading pupil of Hendrick Goltzius. He is best remembered for his drawings, many of which reveal his extensive knowledge of anatomy and his interest in botany.

ROELANDT SAVERY
1576-1639

84 *Alpine Landscape*
Black and red chalk; 40.3×39.7 cm
1946-7-13-1013 Presented anonymously (Phillipps-Fenwick Collection)
One of a group of large drawings of mountainous scenery by Savery. He is thought to have drawn them during a journey to the Tyrol in the years 1606-8, undertaken as a commission to record the landscape for Emperor Rudolf II.

HENDRICK GOLTZIUS
1558-1617

85 *Venus, Bacchus and Ceres ('Sine Cerere et Baccho friget Venus'),* 1593
Pen and brown ink on vellum; 63.1×49.5 cm
1861-6-8-174
This celebrated drawing, mentioned in the *Schilderboek* by van Mander published in 1604, is a *tour-de-force* of disciplined technique, imitating the effect of an engraving. Through his engravings and drawings, Goltzius, a Haarlem artist, helped to establish a truly international style in Holland for the first time.

SIR PETER PAUL RUBENS
1577-1640

86 *Study for a crucified Man*
Black chalk, heightened with white chalk, touched with brown wash; 52.8×37 cm
Oo. 9-26 Richard Payne Knight Bequest, 1824
This particularly fine figure study is datable *c*.1614-15 on grounds of style. It cannot, however, be connected with any surviving painting.

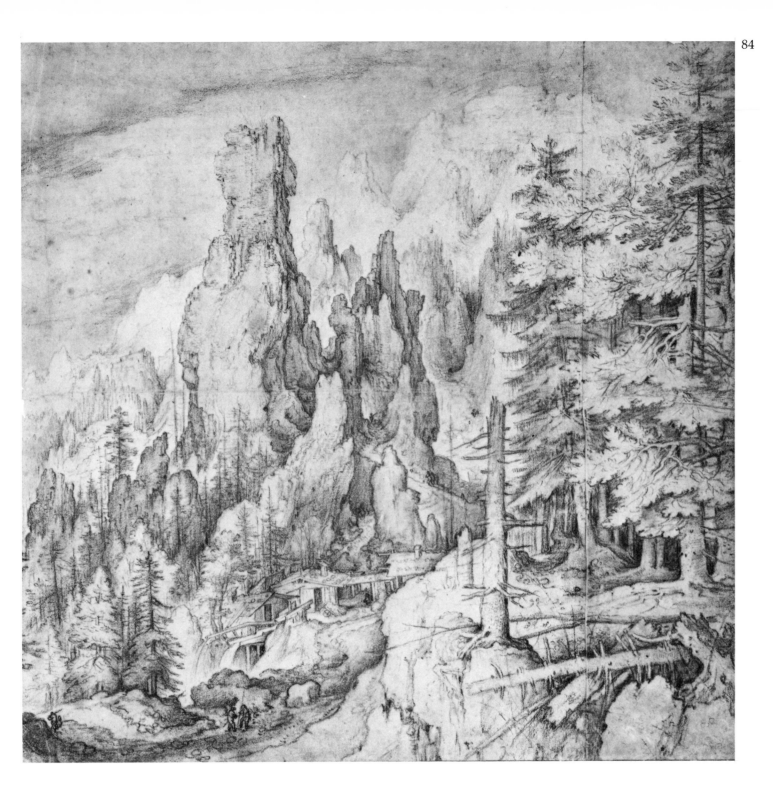

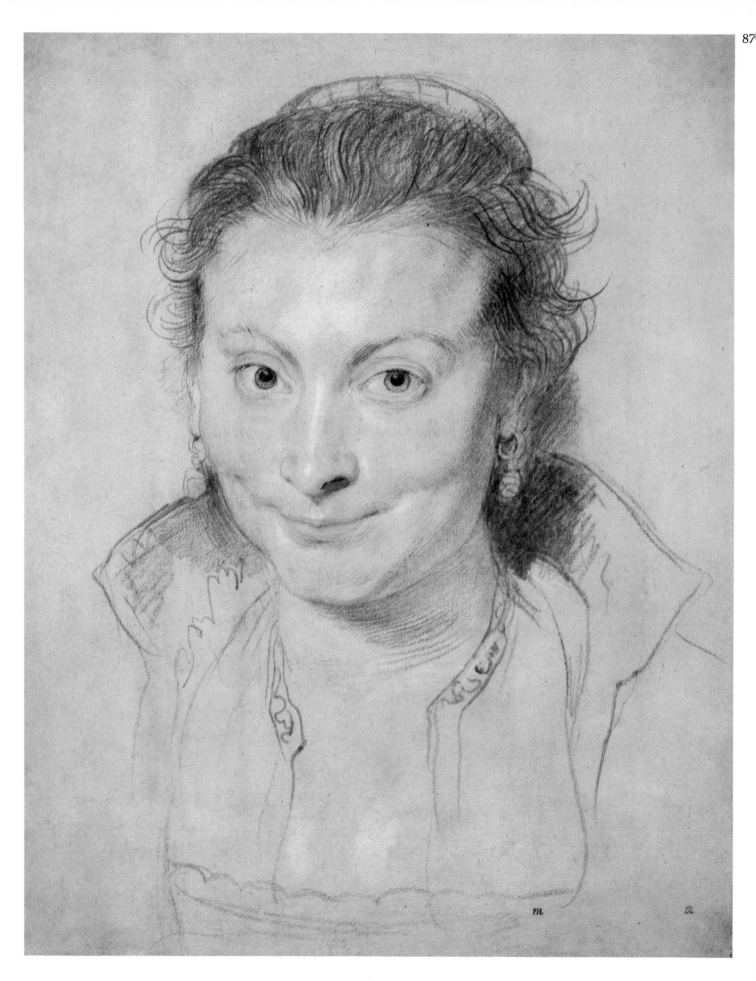

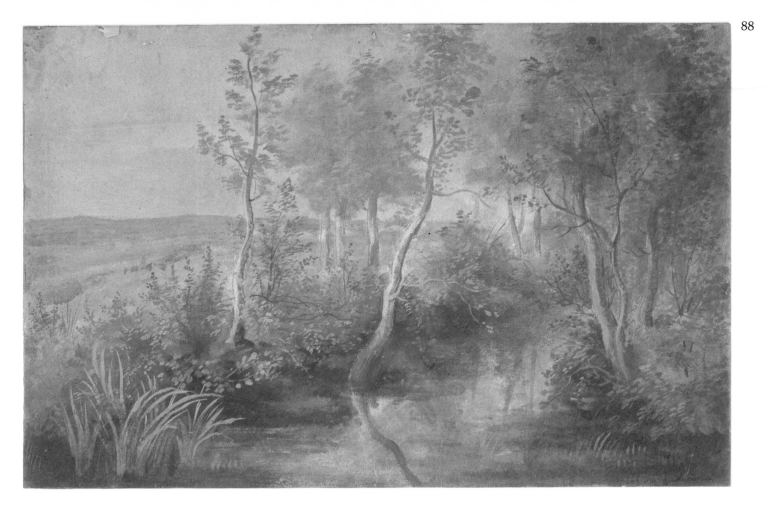

SIR PETER PAUL RUBENS
1577-1640

87 *Portrait of Isabella Brant*

Black, red and white chalk with pale brownish wash,
touched with pen and black ink on pale brown paper;
38.1×29.5 cm
1893-7-31-21

Drawn c.1622. Isabella Brant (d.1626) was Rubens' first wife.
On the *verso* is a lightly sketched self-portrait of the artist
with his second wife, Helena Fourment.

PETER PAUL RUBENS
1577-1640

88 *Landscape with a Stream overhung with Trees*

Watercolours and bodycolour. 20.4×30.8 cm
1859-8-6-60

Landscape became a major part of Rubens' output only in his
last years (c.1637-40), when the present study was probably
made. The medium is unusual for a landscape sketch by the
master, but the attribution is supported by its stylistic
proximity to his informal studies of nature both in oils and
chalk.

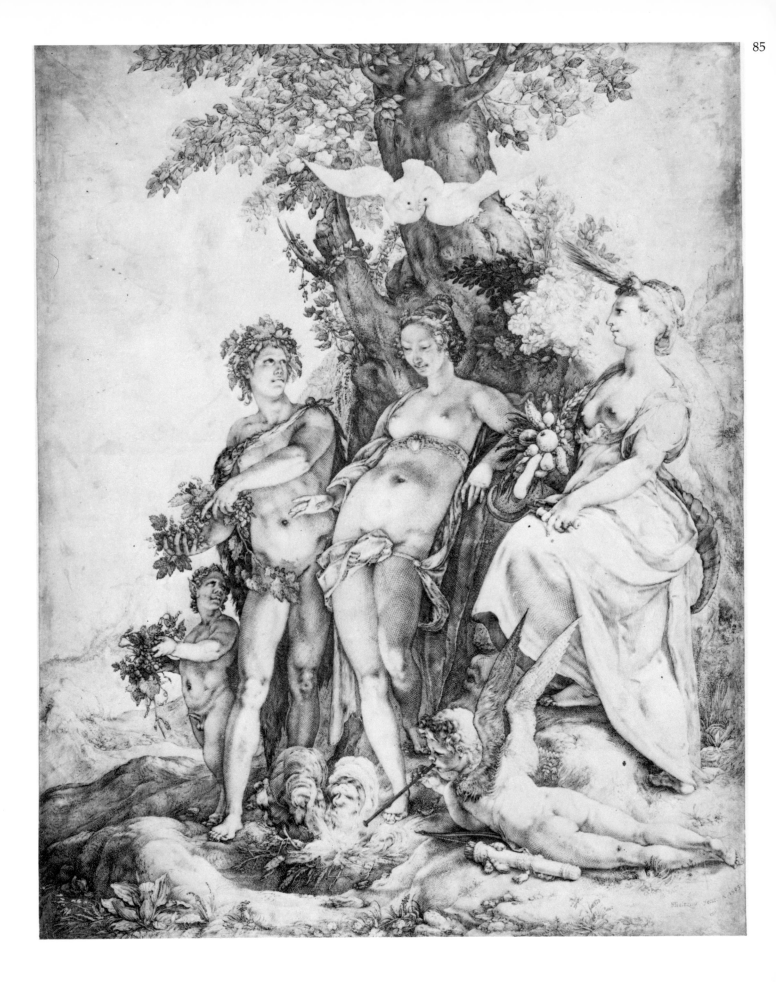

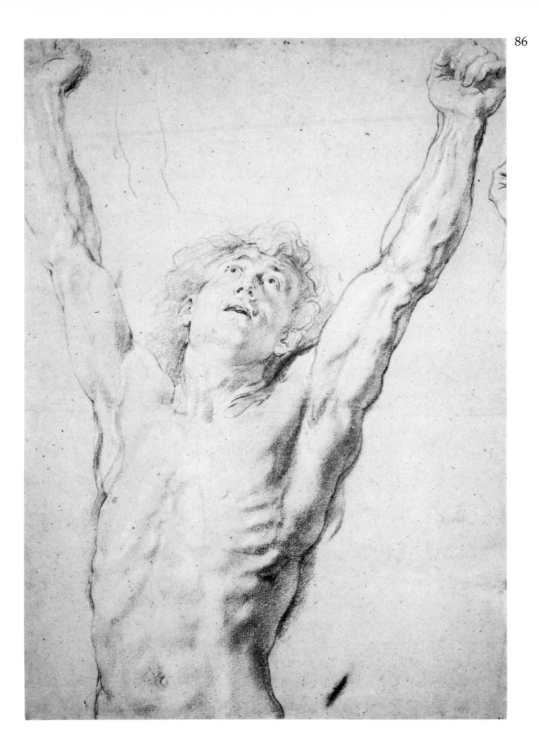

LUCAS VAN UDEN
1595-1672

89 *Landscape with a gabled House and Turret in the Foreground*

Pen and brown ink and watercolour with bodycolour; 21.7×35 cm
1836-8-11-527

A characteristic work by van Uden, a follower of Rubens who specialized in landscape.

SIR ANTHONY VAN DYCK
1599-1641

90 *Study of Trees*

Pen and brown ink and watercolour; 19.5×23.6 cm
Oo. 9-50 Richard Payne Knight Bequest, 1824

This study was used by van Dyck for the landscape background of the *Equestrian Portrait of Charles I* in the National Gallery, painted in the late 1630s.

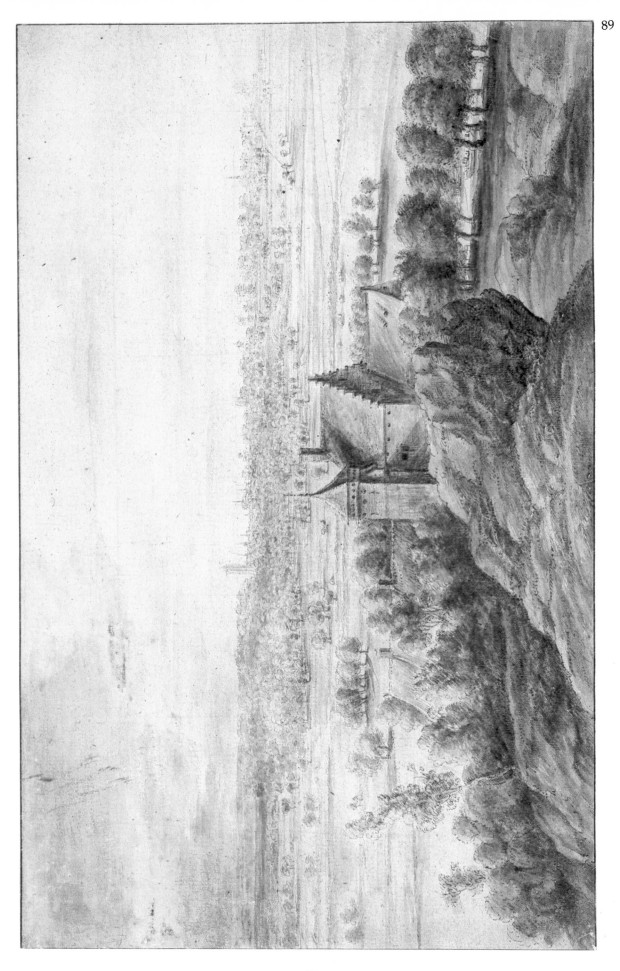

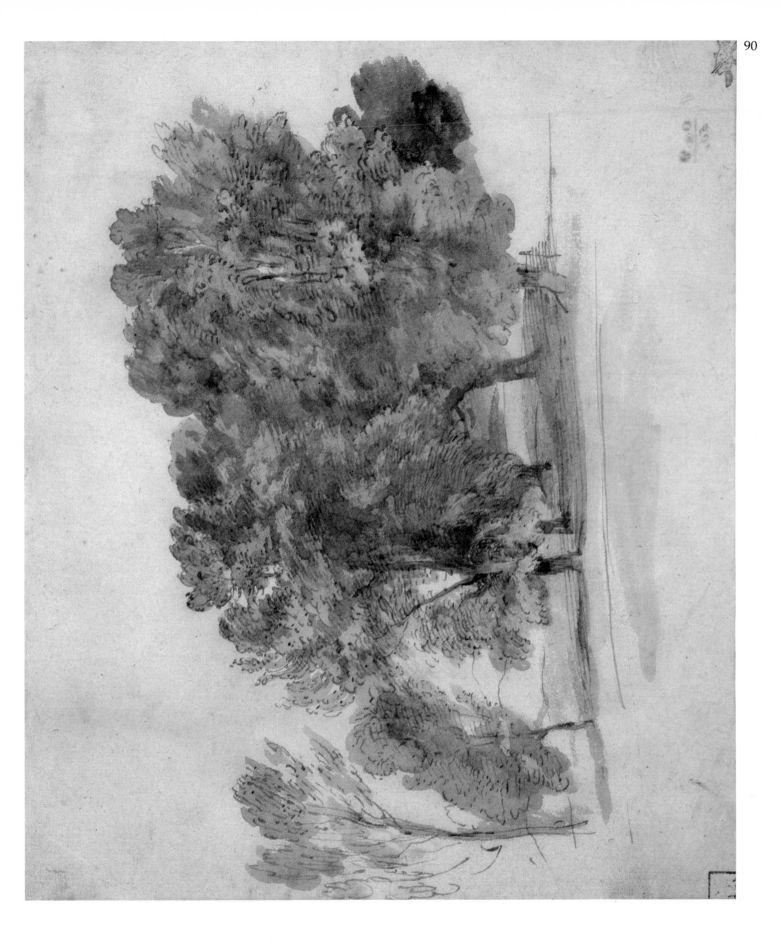

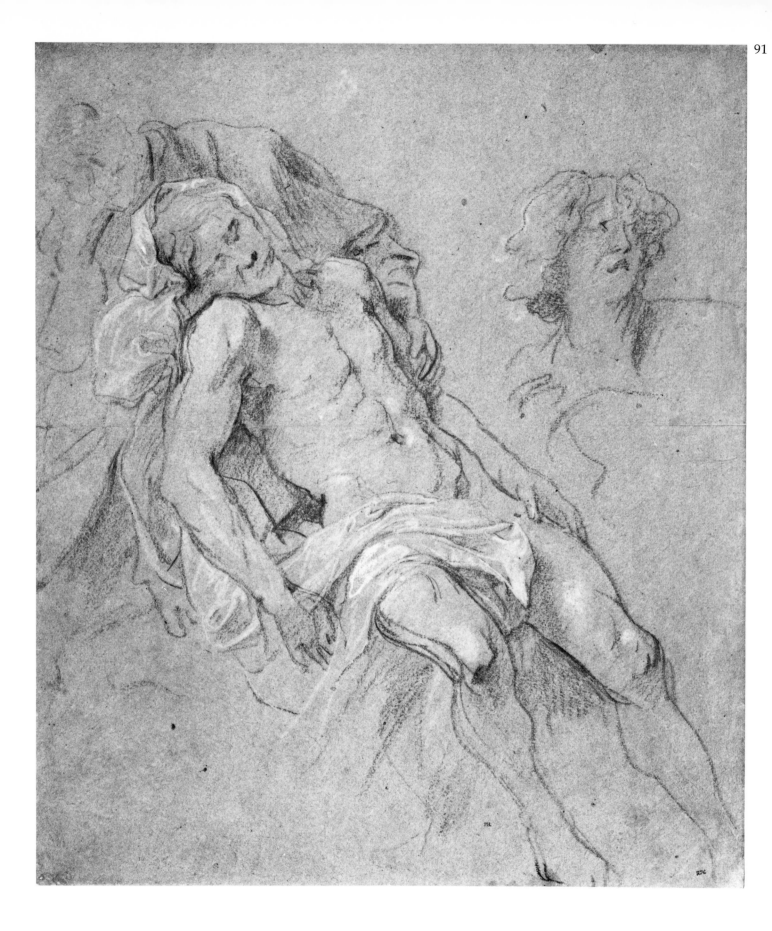

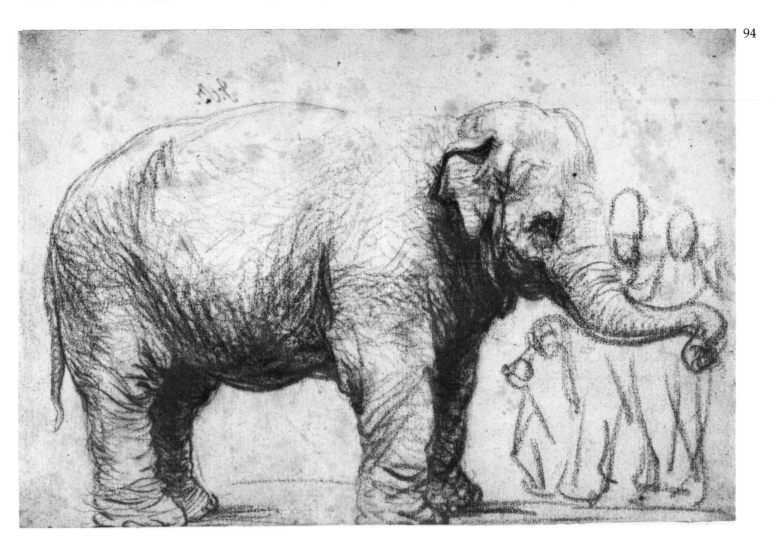

SIR ANTHONY VAN DYCK
1599-1641

91 *Study for the Lamentation*

Black chalk, heightened with white chalk, on greenish grey
paper; 53.3×45.1 cm
1875-3-13-45

A study for the painting of *c.*1630 formerly in Berlin. In the
picture St John was seen looking up, following the correction
on the right of this sheet.

JACOB JORDAENS
1593-1678

92 *The Boating Party*

Bodycolour; 28×38.1 cm
1885-7-11-268

Probably a design for tapestry. The style suggests a date in
the mid-1630s. After Rubens and van Dyck, Jordaens is
generally considered to be the leading Flemish painter of the
seventeenth century.

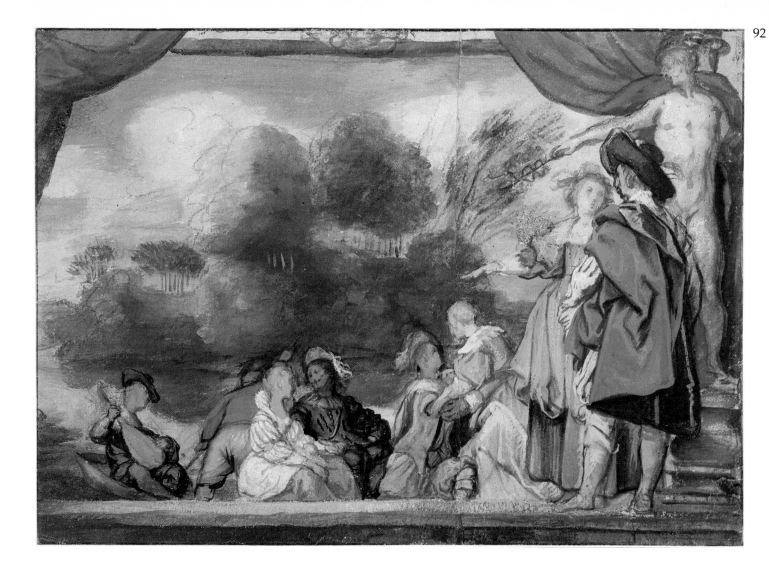

LEONARD BRAMER
1596-1674

93 *A Concert of Angels*

Brush in grey, yellow, green and pinkish wash over traces of black chalk; 53.1×40.6 cm
1966-7-23-2

On the other side of the sheet is a further ceiling design, *The Four Latin Fathers of the Church and numerous Saints*. Bramer, a Delft artist who spent many years in Rome, is one of the few seventeenth-century Dutch painters known to have painted frescoes in the Netherlands, none of which survive. The present drawing is presumably a design for such a scheme.

REMBRANDT HARMENSZ. VAN RIJN
1606-1669

94 *An Elephant*

Black chalk; 17.7×25.5 cm
Gg.2-259 The Rev. C.M. Cracherode Bequest, 1799

One of four drawings of elephants probably all made in 1637, the date inscribed on a similar study in the Albertina, Vienna.

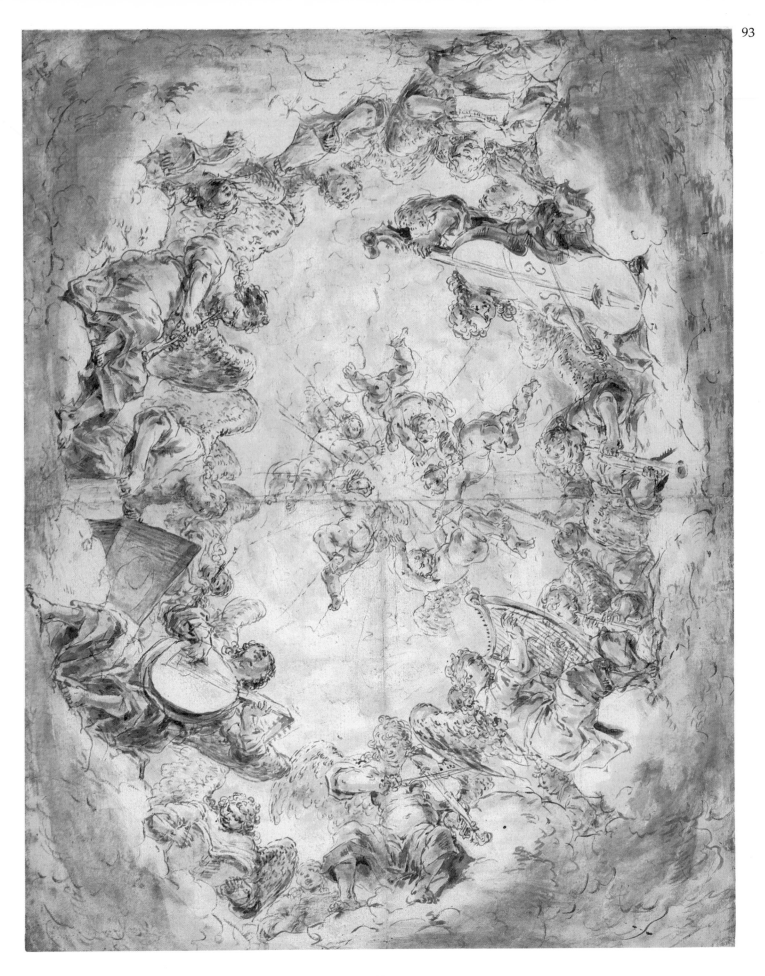

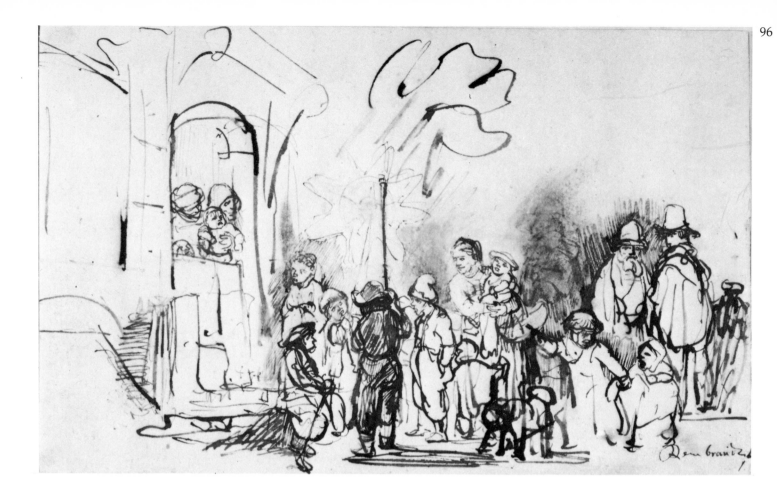

REMBRANDT HARMENSZ. VAN RIJN
1606-1669

95 *A Girl Sleeping*

Brush drawing in brown wash; 24.5×20.3 cm
1895-9-15-1279

Executed *c.*1655-6. The model was probably Hendrickje
Stoffels, who entered Rembrandt's house as a servant *c.*1645.

REMBRANDT HARMENSZ. VAN RIJN
1606-1669

96 *The Star of the Kings*

Pen and brown ink and brown wash: 20.4×32.3 cm
1910-2-12-189 George Salting Bequest

The Star of the Kings was carried by children as part of
Epiphany celebrations. The drawing was executed *c.*1641-2.

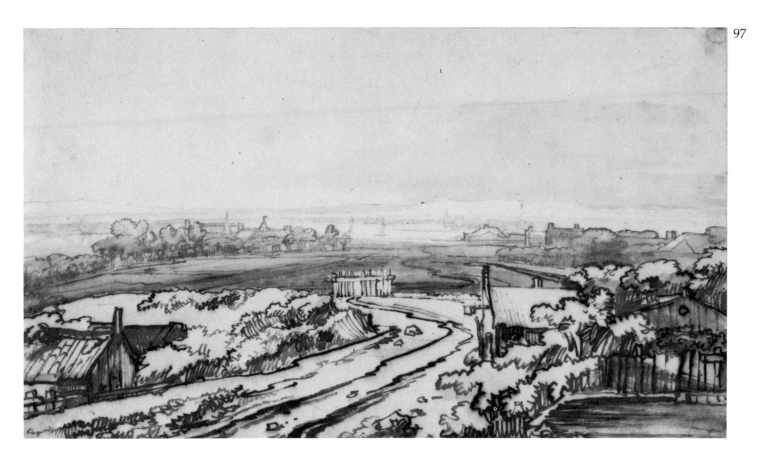

PHILIPS KONINCK
1619-1688

97 *Open Landscape with a Road and River*

Pen and brown ink and brown wash, lightly washed with
white bodycolour; 18.8×31.7 cm
Oo. 10-172 Richard Payne Knight Bequest, 1824

The drawing is very much in the style of Rembrandt, with
whom Koninck may have studied in the later 1630s.

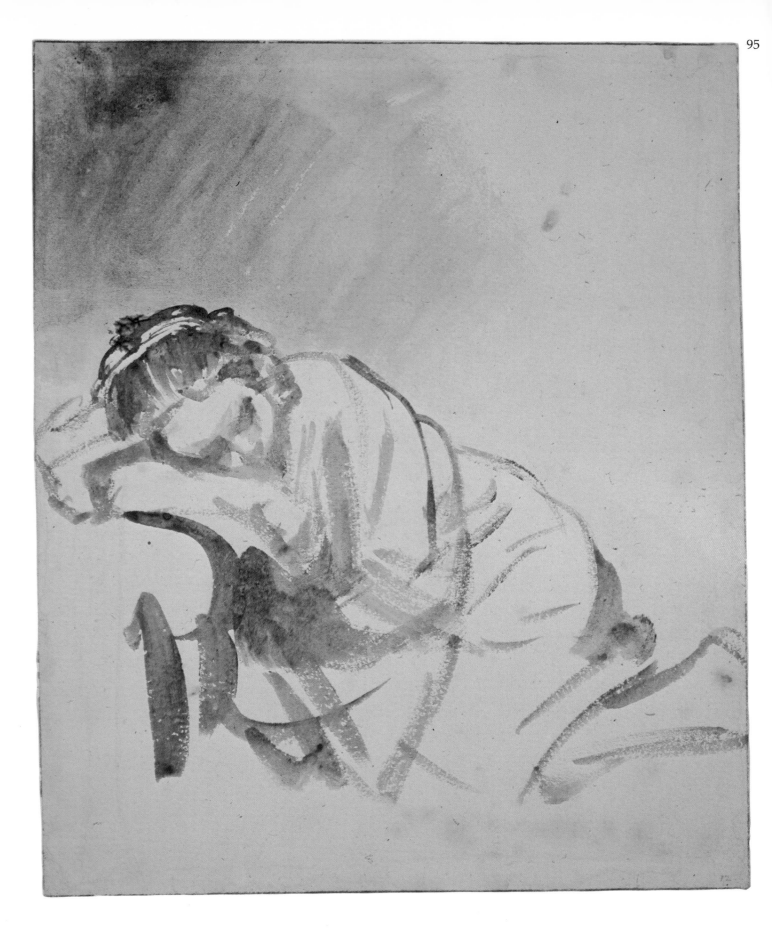

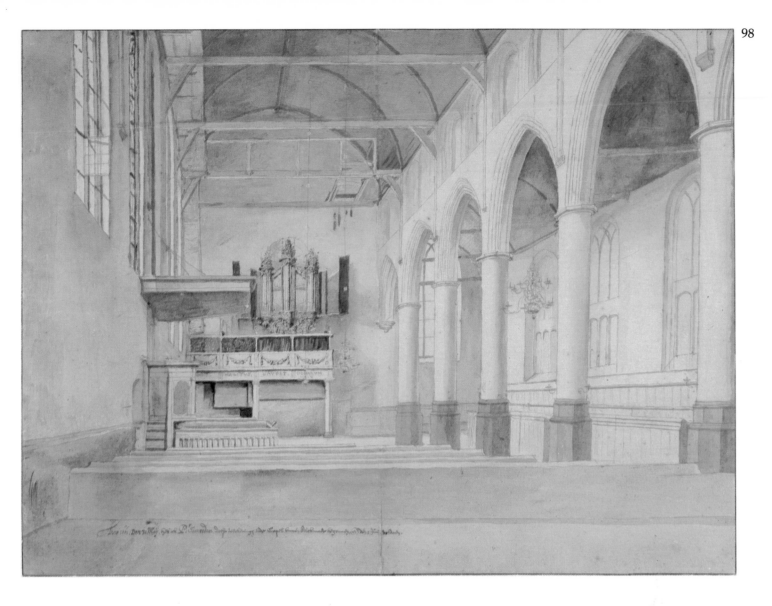

PIETER JANSZ. SAENREDAM
1597-1665

98 *Interior of the so-called Chapel Church at Alkmaar*

Pen and brown ink and watercolour; 38.3×49.6 cm
1854-6-28-84

Inscribed by the artist: *Anno 1661 den 31 Maij, heb ich Pr:
Saenredam deese teekeninge in de Capel binnen Alckmaer
begonnen, en 1 Junij voldaen* (on 31 May 1661, I, P. Saenredam,
began this drawing in the Chapel in Alkmaar and completed
it on 1 June). Saenredam, who was active mostly in his native
town, Haarlem, is best remembered for his views of church
interiors.

JAN LIEVENS
1607-1674

99 *Portrait of a Man, half-length*

Black chalk; 30×23.5 cm
1861-8-10-17

Although inscribed below, *Jacob Matham Plaatsnyder*, the
drawing is not in fact a portrait of the engraver Jacob
Matham; however, the true identity of the sitter has not been
established.

Lievens was a close associate of Rembrandt during his
Leiden period, *c.*1625-31. The present drawing is later, after
Lievens came under the influence of van Dyck in Antwerp,
where he resided from *c.*1634-43.

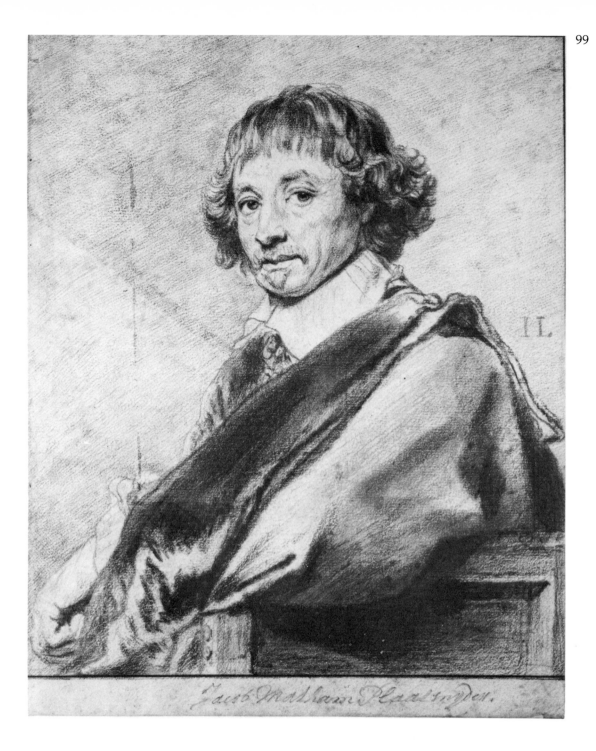

CAREL DUJARDIN
1622-1678

100 *Self-Portrait, 1658*

Red chalk; 30.5×23 cm
1836-8-11-325

Dujardin was primarily a painter of Italianate landscapes,
influenced by Nicholaes Berchem, whose pupil he may have
been.

JACOB VAN RUISDAEL
1628/29-1682

101 *Two Barges on a Canal*

Black chalk and grey wash; 21×26 cm
1876-12-9-631

Ruisdael, one of the most celebrated landscape painters of
his time, worked in his native Haarlem and in Amsterdam.
The present sheet probably dates from the late 1640s.

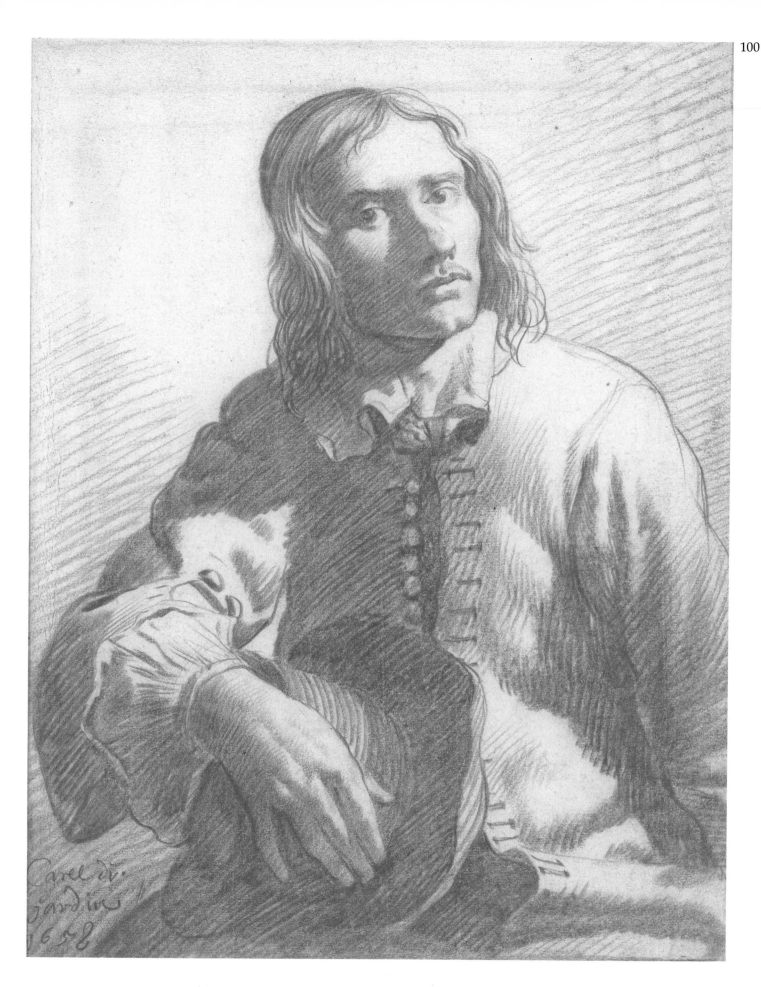

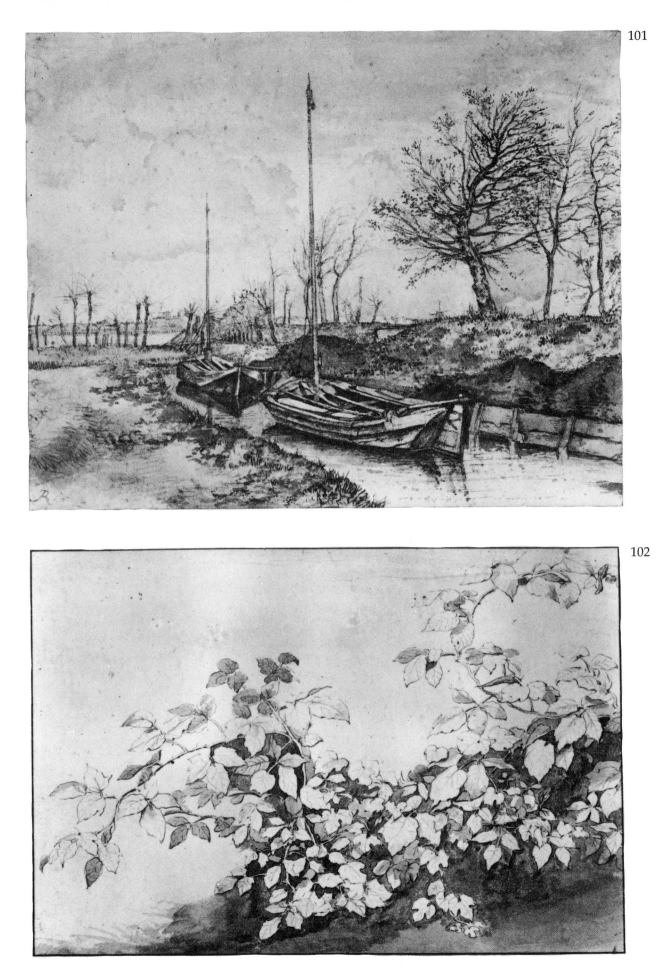

101

102

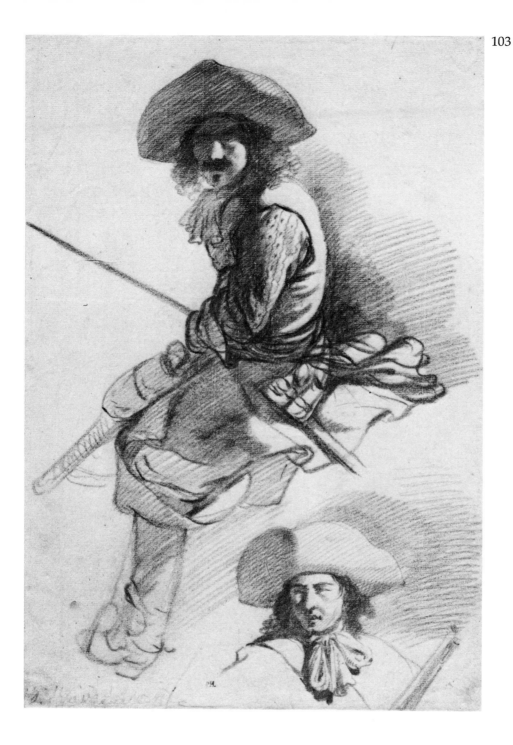

JAN WYNANTS
c.1620-1684

102 *A Study of Branches and Leaves*

Black chalk and grey wash; 19.7×28.5 cm
Oo. 9-63 Richard Payne Knight Bequest, 1824

Wynants was almost exclusively a landscape painter, work-ing firstly at Haarlem and after *c*.1660 in Amsterdam.

ADRIAEN VAN DE VELDE
1636-1672

103 *Study of a Cavalier on Horseback*

Red chalk; 29×19.5 cm
1895-9-15-1330

Adriaen van de Velde, the brother of the marine artist Willem van de Velde the Younger, was one of the most gifted figure draughtsmen of the 17th century in Holland, although as a painter he specialized in landscape. He worked for most of his life in Amsterdam.

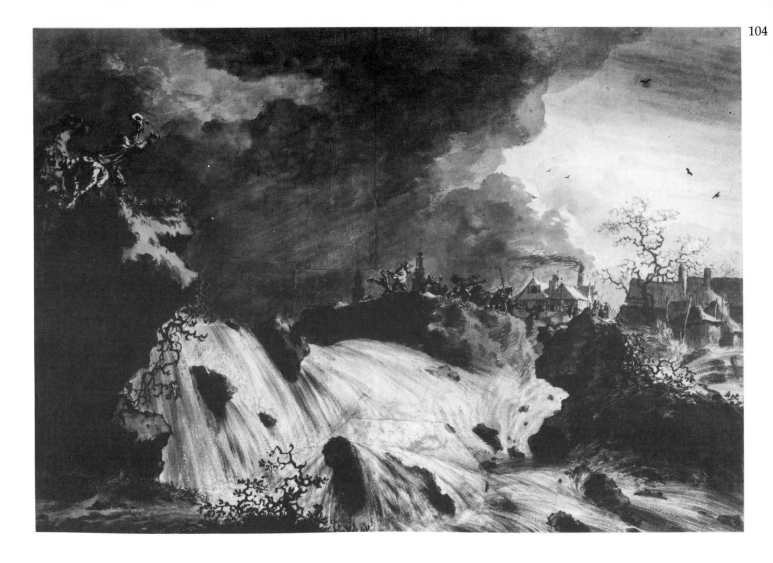

WILLEM SCHELLINKS
1627-1678

104 *The Bursting of the Dyke at Houtewael, near
Amsterdam, 1651*
Pen and brown wash over black chalk. Three pieces of paper
inserted for corrections. The outlines indented for transfer;
37.1×51.7 cm
Oo. 10-202 Richard Payne Knight Bequest, 1824
Schellinks was from Amsterdam, but travelled widely in
Europe in the 1640s and 1660s. The present drawing is the
design for a print executed by Pieter Nolpe.

AELBERT CUYP
1620-1691

105 *The Mariakerk, Utrecht*
Black chalk with grey, brownish-yellow and red wash;
22×31 cm
1836-8-11-95
Cuyp was from Dordrecht, but his landscapes show that he
travelled widely in the Netherlands. The church is seen from
the north east, showing the north transept and the east end.

CORNELIS VISSCHER
1629-1658

106 *A Boy with Cap and Mask (Folly)*
Black chalk on vellum; 24.2×29.2 cm
1910-2-12-203 George Salting Bequest

In his short career Visscher, who worked in Haarlem and
Amsterdam, produced numerous engravings and drawings,
mostly portraits and genre scenes. The present sheet was
engraved in reverse by Pierre Aveline (1710-60) with the title
La Folie.

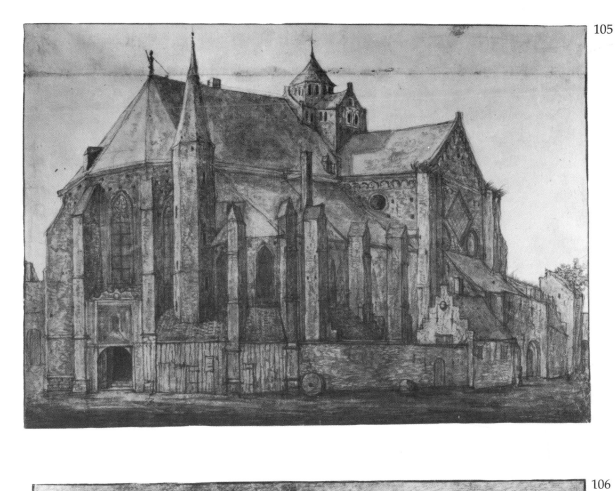

105

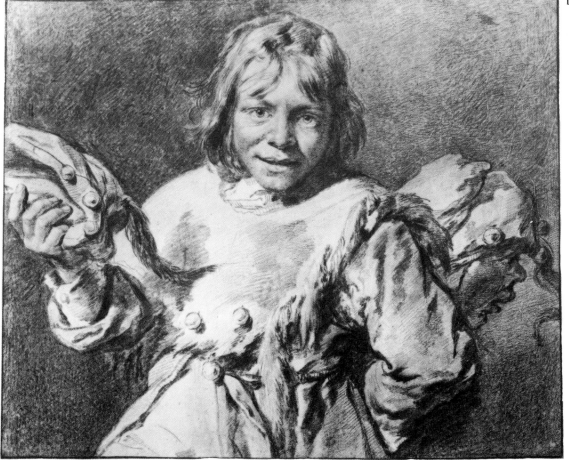

106

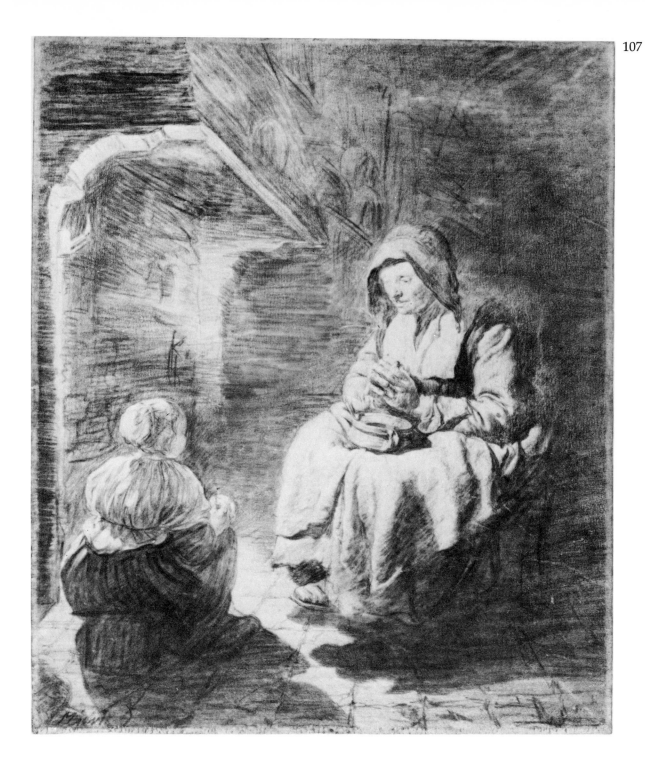

FRANS VAN MIERIS THE ELDER
1635-1681

107 *An old Woman and a Child by a Fire*

Black chalk on vellum; 25×21 cm
1854-6-28-3

Van Mieris and his master Gerrit Dou were the chief exponents of domestic genre in Leiden in the seventeenth century. A highly-finished drawing on vellum such as this was probably an independent work of art rather than a preparatory study for a painting.

HERMAN SAFTLEVEN
c.1609-1685

108 *Part of the Castle of Wittenhorst*

Black chalk with brown wash; 40.8×37.1 cm
1836-8-11-501

Saftleven was probably a pupil of his brother Cornelis. He worked mainly in Utrecht as a painter and etcher of landscapes. The Wittenhorst family had an important house near Utrecht which is probably the one represented in this drawing.

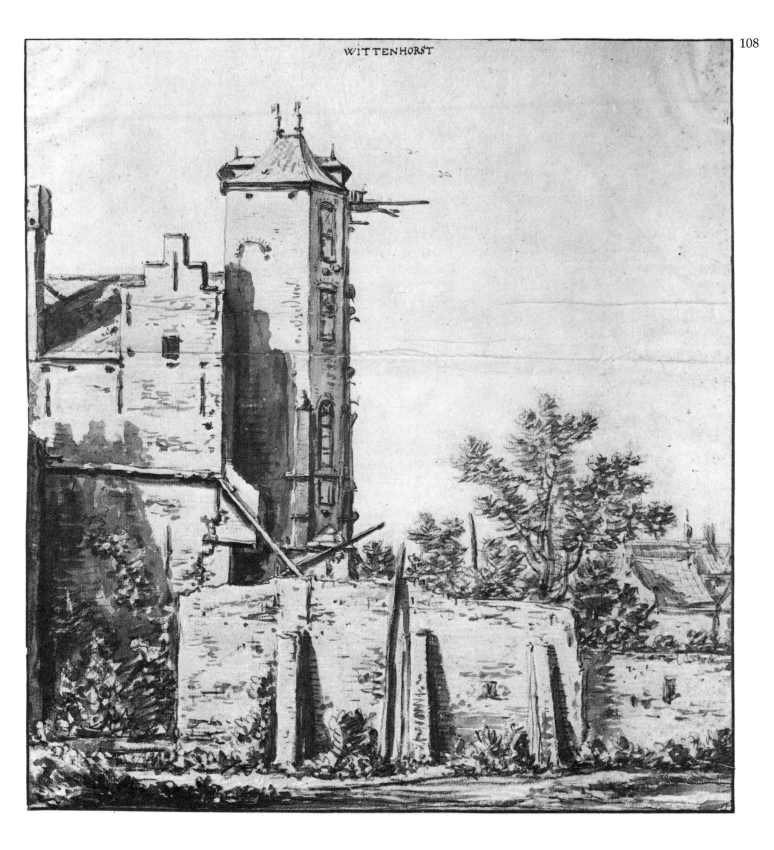

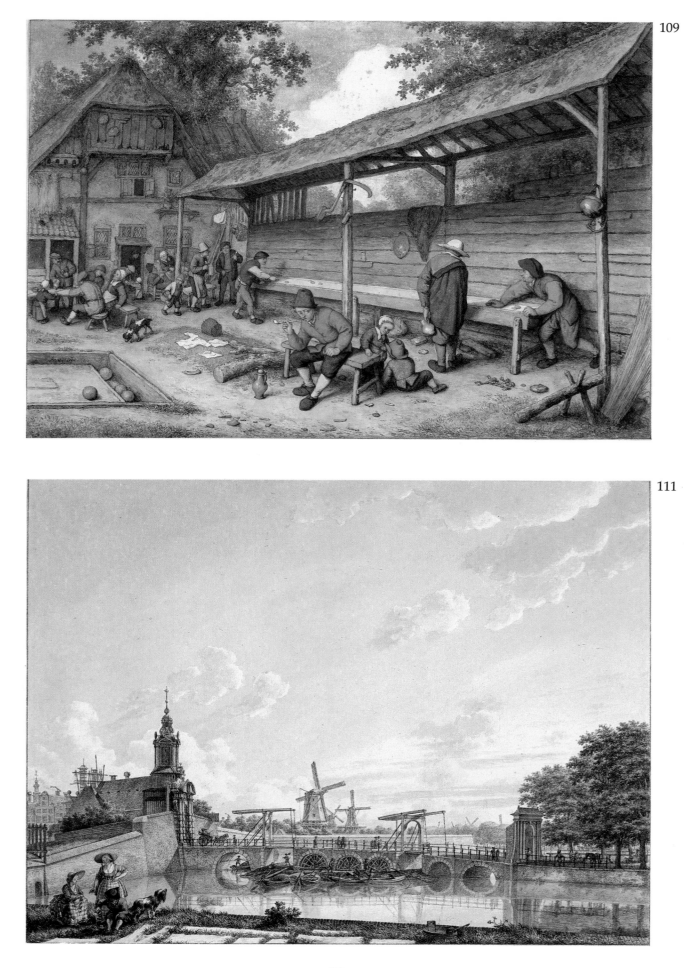

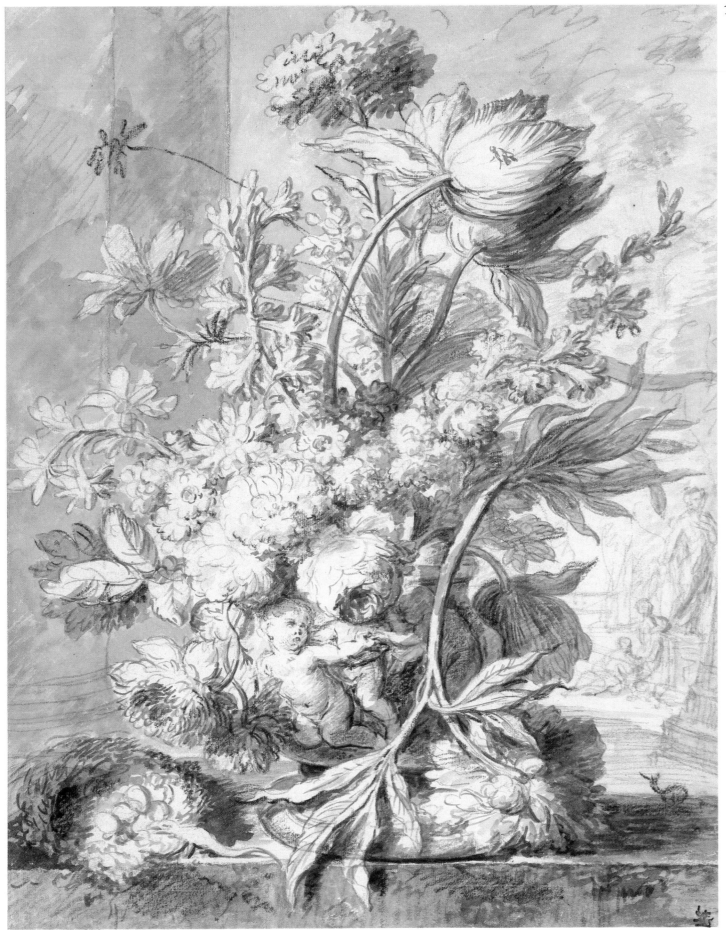

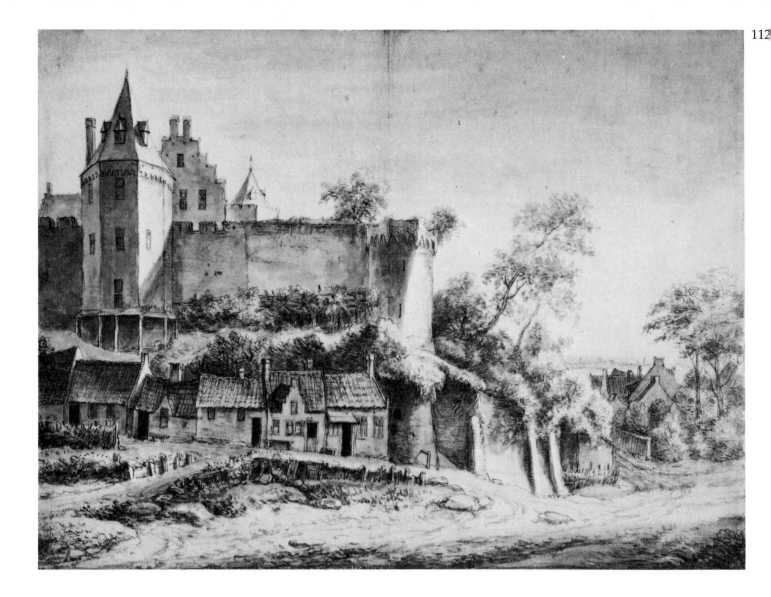

ADRIAEN VAN OSTADE
1610-1685

109 *Peasants playing Gallet outside an Inn, 1677*

Pen and brown ink and watercolour; 25.8×38.2 cm
1847-3-26-6

Ostade was an influential Haarlem painter and etcher of genre subjects. He was a pupil of Frans Hals and greatly influenced by Adriaen Brouwer. An oil painting of this subject by van Ostade, also dated 1677, is at Apsley House. A preparatory drawing is at Amsterdam.

JAN VAN HUYSUM
1682-1749

110 *Study of Flowers in a Vase*

Black and red chalk with grey wash; 40.1×30.6 cm
1876-12-9-627

A characteristic study by van Huysum, one of the most celebrated Dutch flower-painters. He spent his entire career in Amsterdam and although he had no pupils he influenced several generations of still-life artists.

JACOB CATS
1741-1799

111 *View near the Haarlem Gate, Amsterdam*

Watercolour; 27.2×35.9 cm
1886-11-22-6

Cats spent most of his life in Amsterdam. He was one of the few eighteenth-century Dutch artists who produced work of a consistently high quality, comparable to that of the masters of the century before.

ANTHONIE WATERLOO
c.1610-1690

112 *View of a Castle with Cottages below*

Black chalk and grey wash; 39.6×51.5 cm
1836-8-11-807

Waterloo was born in Lille but spent his career in various parts of Holland, including Amsterdam and Utrecht. Few of his paintings survive, and he is best known for his drawings and etchings of the Dutch landscape.

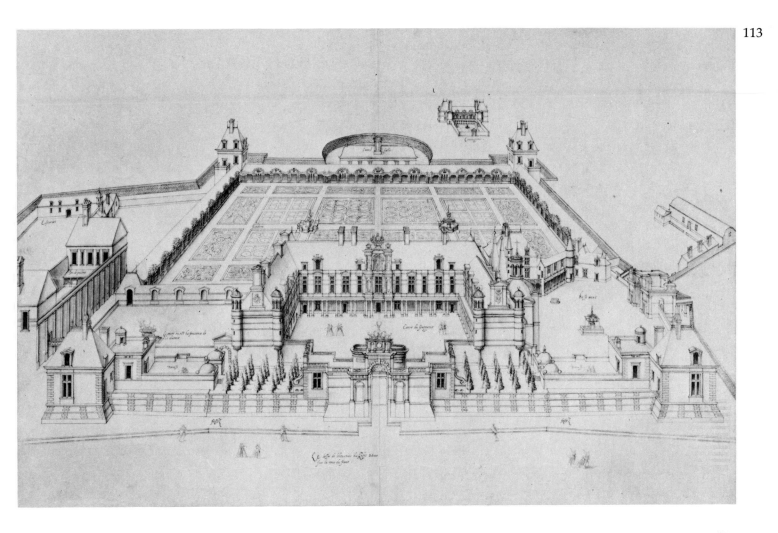

JACQUES ANDROUET DUCERCEAU
1510/12-after 1584

113 *A Plan of the Château d'Anet*

Pen and black ink with grey and yellow wash on vellum;
51.4×75.2 cm
1972.U.887

A drawing made in connection with Ducerceau's two
volume publication, *Les Plus Excellents Bastiments de France*
of 1576 and 1579. The Château d'Anet was commissioned by
Henri II for his mistress Diane de Poitiers, to the designs of
Philibert de l'Orme, and was completed between 1548 and
1553.

JEAN CLOUET
1485/90-1541

114 *Portrait of an Unknown Lady*

Black and red chalk; 29.1×19.6 cm
1908-7-14-46

The drawing has been dated *c.*1520/25. Clouet's portrait
drawings are always distinguished by a delicate rendering of
the sitter's features. The use of red and black chalk appears to
be a French invention, made more famous by Hans Holbein
the Younger who evidently started using the technique after
his visit to France in 1524.

JACQUES BELLANGE
c.1575-1616

115 *Standing figure of a young Woman wearing a
Bonnet*

Pen and brown ink with blue wash; 40.2×24.9 cm
1870-5-14-1207

Bellange was court painter to the Duke of Lorraine in Nancy.
He is best known from his drawings and etchings which
display remarkable extremes of Mannerist convolution. This
drawing is similar in treatment to the elaborately dressed
female figures in the artist's series of etchings, *Hortulana*.

JACQUES CALLOT
1592-1635

116 *A Horse turned to the left with various Figure
Studies*

Pen and brown ink and brown wash with touches of red
chalk; 24×34.9 cm
5213 Vol. 4 No. 38 William Fawkener Bequest, 1769

The main figure of the horse is one of a number of sketches
which Callot made after prints of horses by Antonio
Tempesta (1555-1630). During his career as a printmaker
Callot appears to have used such studies as points of refer-
ence when he made etchings of cavalry subjects.

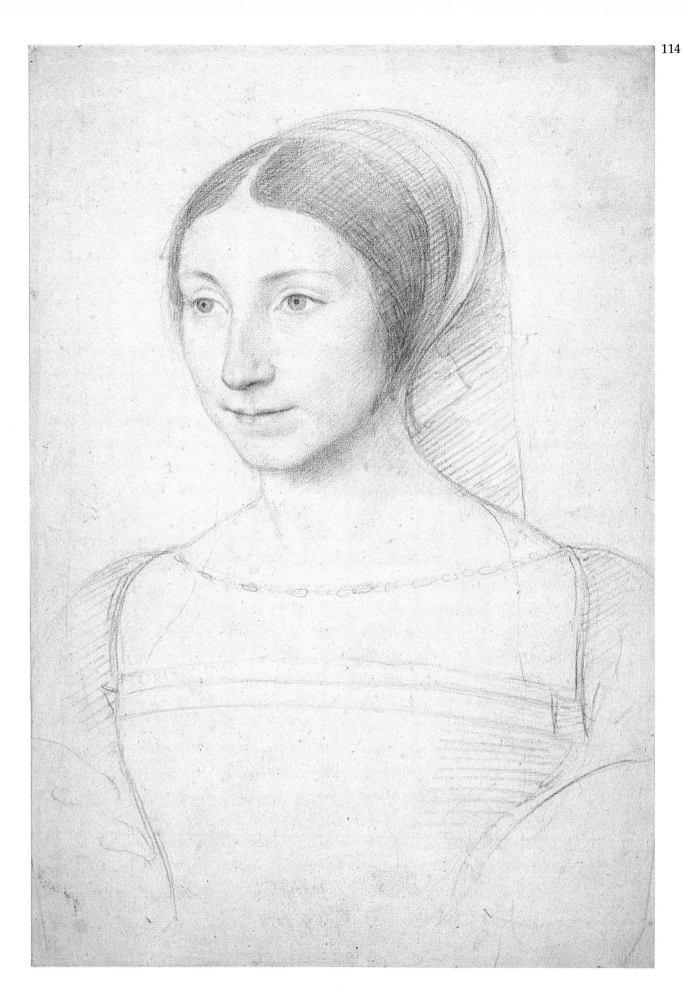

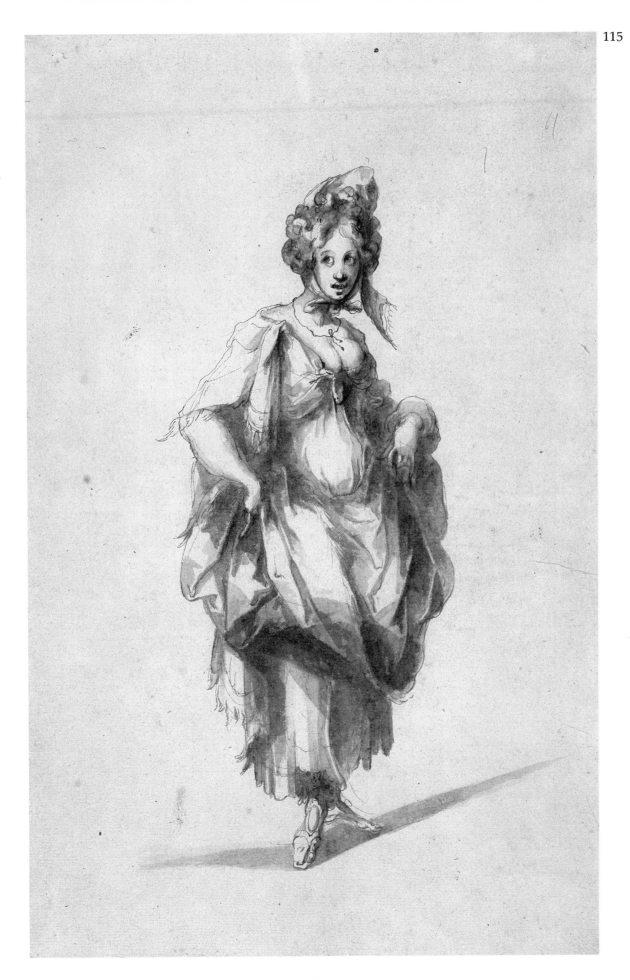

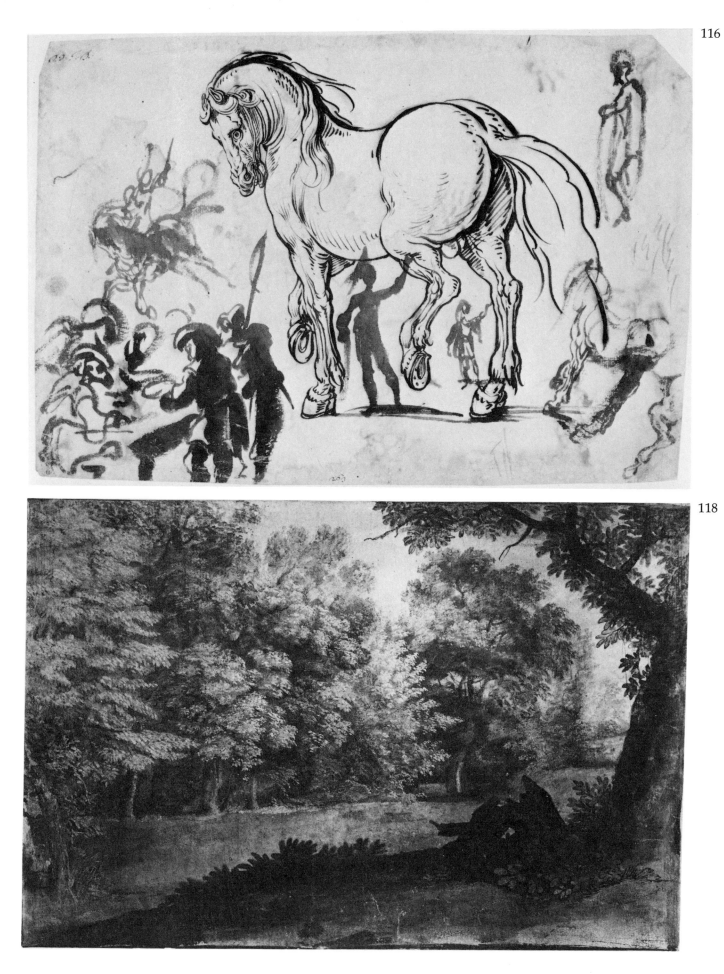

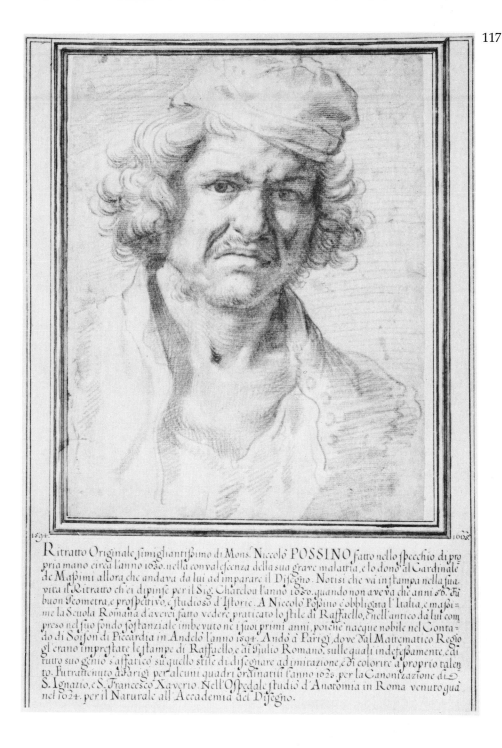

NICOLAS POUSSIN
1594-1665

117 *Self-Portrait*

Red chalk; 25.9×19.3 cm
1901-4-17-21

The inscription in Italian below the drawing states that it
was made *c.*1630 when Poussin was recovering from a
serious illness and that it was given to Cardinal Massini, one
of his best patrons. Although no other studies of heads by
the artist survive the identification may be confirmed by
comparison with portraits in other mediums.

CLAUDE GELLÉE, called CLAUDE LORRAIN
1600-1682

118 *Trees in a sunlit woodland Glade*

Pen and brown ink, and brown and red wash, heightened
with white bodycolour, over black chalk and black lead, on
blue paper; 22.3×32.7 cm
Oo. 7-190 Richard Payne Knight Bequest, 1824

A highly-finished, pictorial drawing which is similar in
technique to other studies made by Claude *c.*1645.

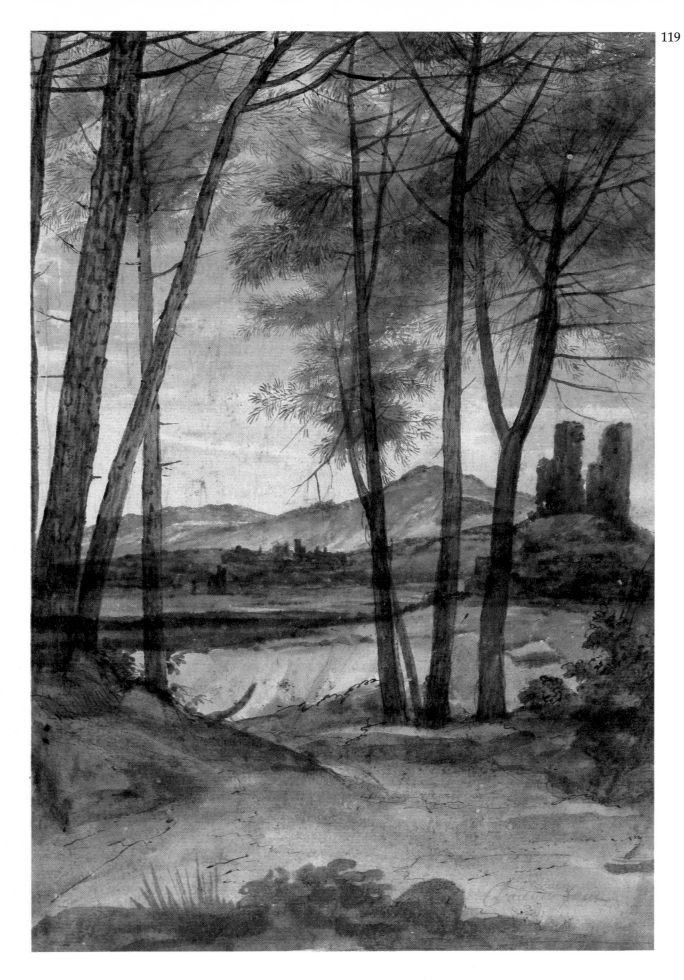

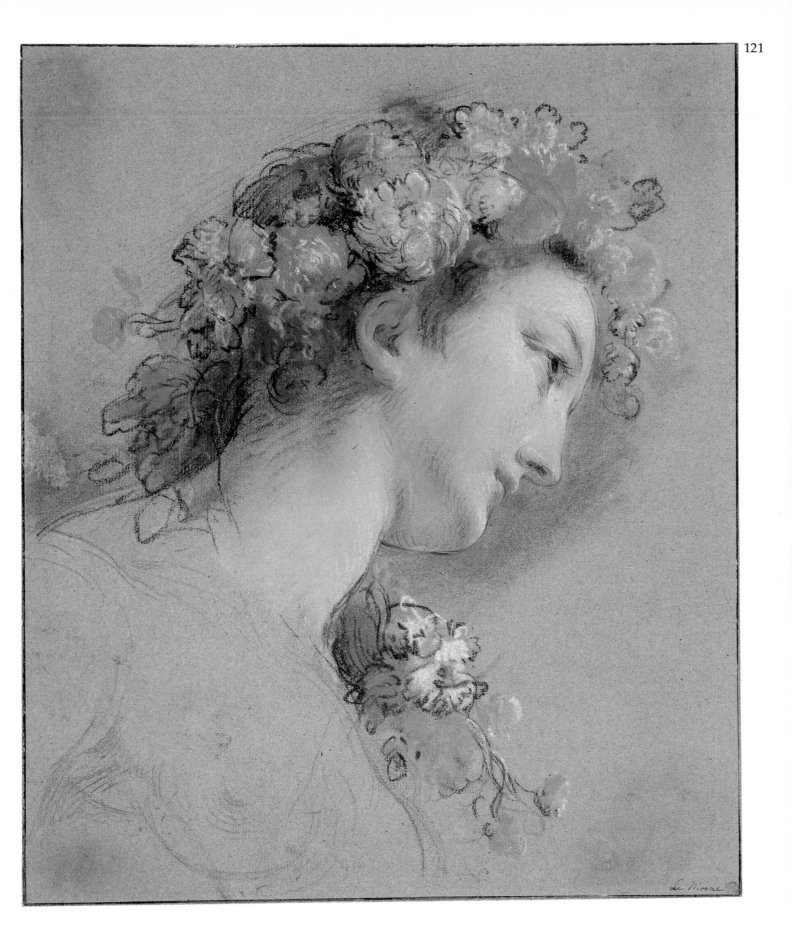

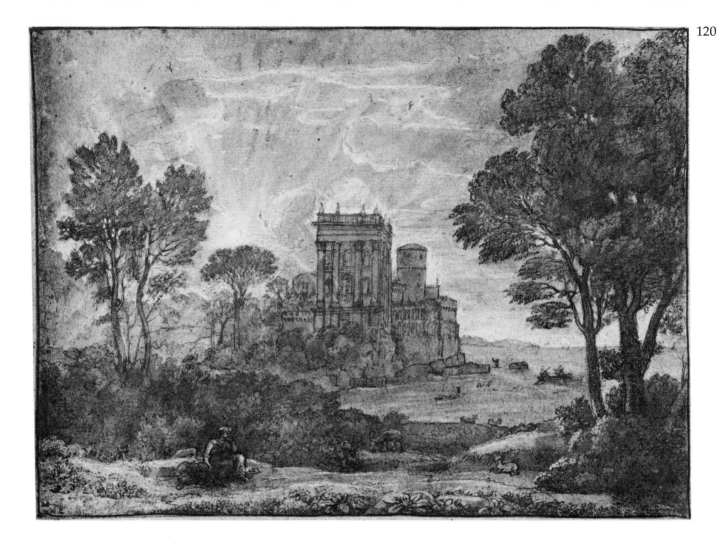

CLAUDE GELLÉE, called CLAUDE LORRAIN
1600-1682

119 *Landscape with Ruins*

Pen and brown ink with pink, grey and brown wash over
traces of black lead; 31.9×21.7 cm
Oo. 7-230 Richard Payne Knight Bequest, 1824

An impressive example of Claude's studies made directly
from nature which has been dated *c.*1638-9. It was probably
made in the region of Civitavecchia, near Rome, for the *verso*
contains several studies of the fortifications of this port.

CLAUDE GELLÉE, called CLAUDE LORRAIN
1600-1682

120 *Landscape with the abandoned Psyche at the
Palace of Cupid (Apuleius, The Golden Ass)*

Pen and brown ink and brown wash, heightened with white
bodycolour, over black chalk, on blue paper; 19.6×26.3 cm
1957-12-14-168 Accepted in lieu of Estate duty and allocated
to the Museum

From the celebrated *Liber Veritatis*, a book in which Claude
kept a record of his paintings. The drawing corresponds to
the painting, now in the National Gallery, which was com-
missioned by Lorenzo Onofrio Colonna (1637-89), the
artist's most important patron, in 1664. The painting is
popularly called *The Enchanted Castle* and inspired memor-
able lines by John Keats (1795-1821) in his *Ode to a
Nightingale* and elsewhere.

FRANÇOIS LEMOINE
1688-1737

121 *Head of the goddess Hebe*

Pastels on blue paper; 31.1×25.8 cm
1850-3-9-1

A study for part of the figure representing Hebe, the hand-
maiden of the gods, in the ceiling decoration, *The Apotheosis
of Hercules* at Versailles, which Lemoine completed in 1736.
The drawing has maintained much of its original freshness,
and is an excellent example of the pictorial type of study
popular in eighteenth-century France.

JEAN-ANTOINE WATTEAU
1684-1721

122 *Landscape with Cottages and Figures*

Red chalk; 16.7×23.9 cm
1846-5-9-155

This study from nature was probably made at Porcherons,
the estate of Watteau's wealthy patron, Crozat. The artist
appears to have been offered accommodation there as early
as 1712 and this drawing would date from about that time.

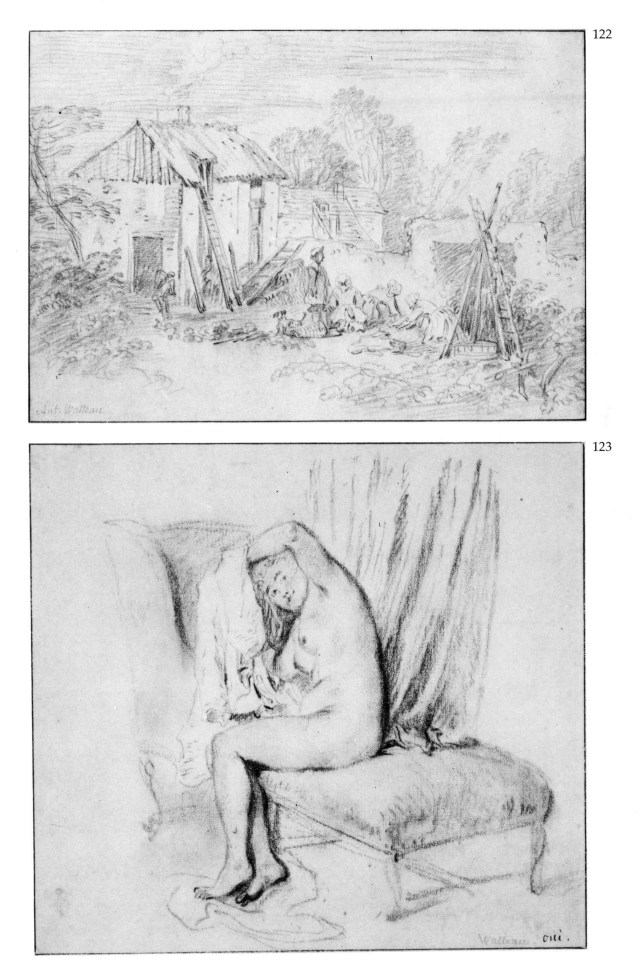

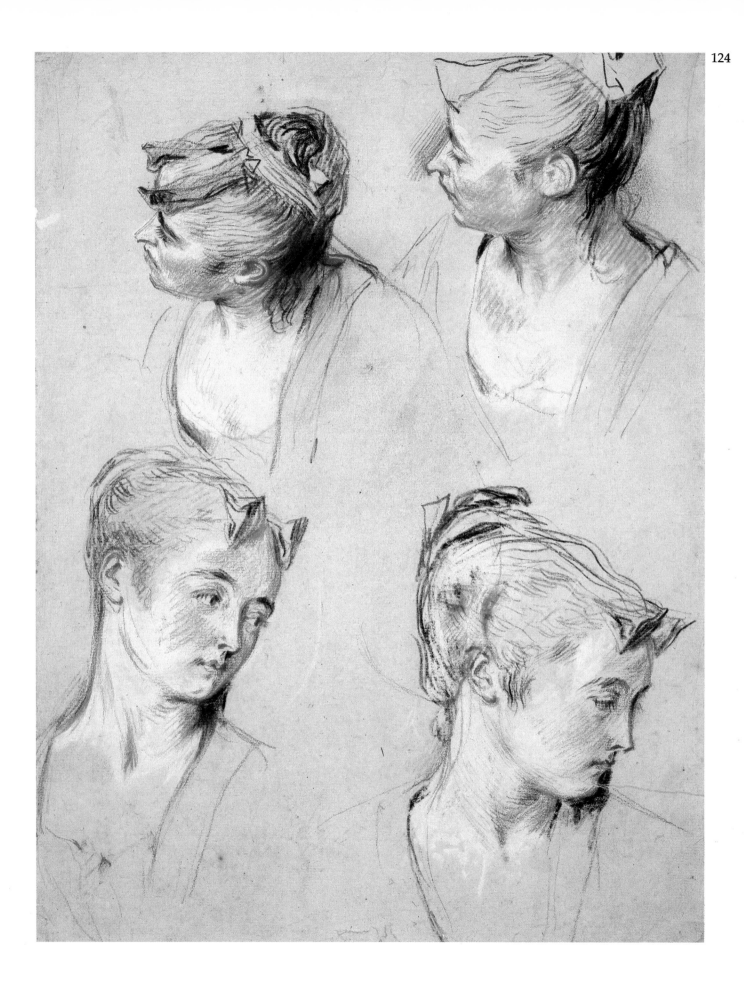

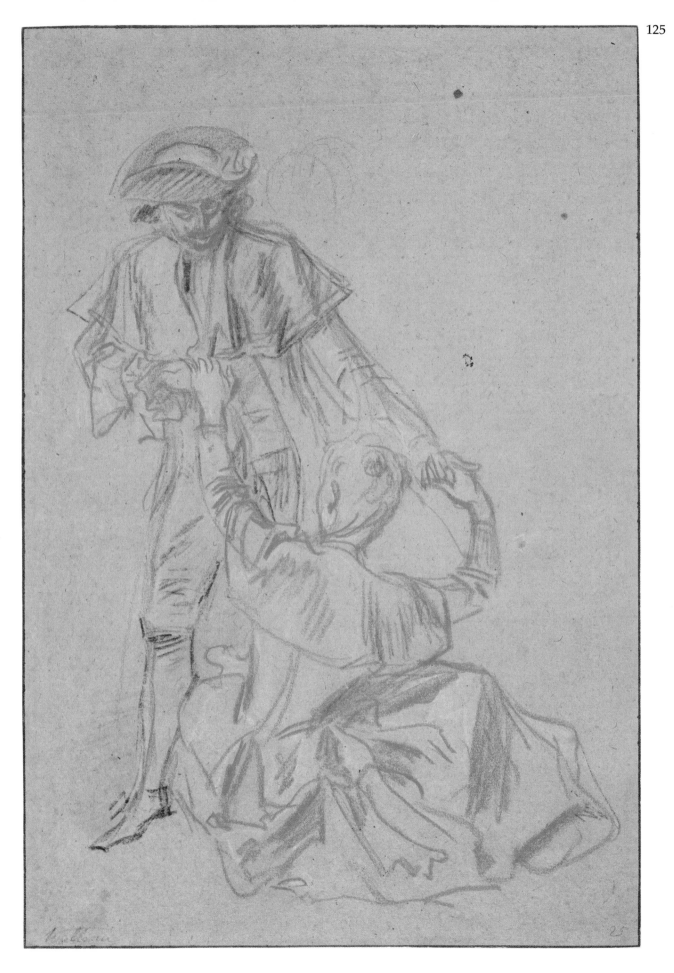

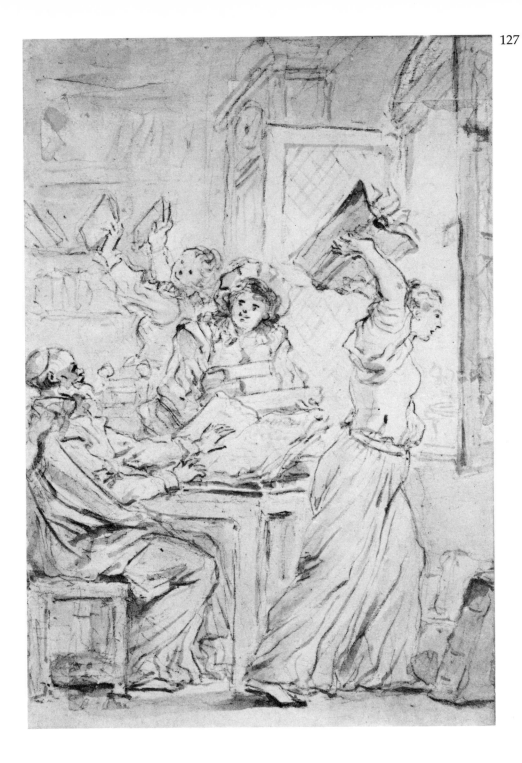

JEAN-ANTOINE WATTEAU
1684-1721

123 *A nude Woman seated on a Chaise-longue*

Red and black chalk; 22.5×25.4 cm
1910-2-12-99 George Salting Bequest

Watteau did not apparently make academic figure studies
but he can be seen, particularly in his drawings of male
nudes, to have had an understanding of anatomy. In this
drawing, however, he is more concerned to show the texture
and suppleness of the flesh. It is one of a group in which the
same model is posed on a chaise-longue and was used for the
painting *La Toilette* in the Wallace Collection.

JEAN-ANTOINE WATTEAU
1684-1721

124 *Four Studies of the Head of a young Woman*

Two shades of red chalk, and black and white chalk;
33.1×23.8 cm
1895-9-15-941

Although Watteau made few formal portraits there are a
number of highly expressive and convincing drawings of
heads of friends. In this particularly fine example he has
characteristically combined different coloured chalks (*aux
trois crayons*) with the background colour of the paper to
throw the heads into relief.

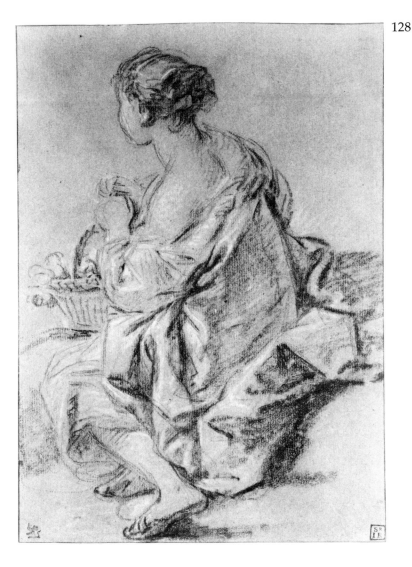

JEAN-ANTOINE WATTEAU
1684-1721

125 *Study for two of the principal Figures in
L'Embarquement pour Cythère*, **before** 1717

Red, black and white chalk on light brown paper;
33.6×22.6 cm
1910-2-12-98 George Salting Bequest

One of numerous studies for Watteau's painting of 1717 in
the Louvre, the couple appearing to the right of centre in the
finished work. The composition appears in the frontispiece
to the second volume of Boucher's etchings after Watteau,
Figures de différents Caractères.

NICOLAS LANCRET
1690-1745

126 *A Tree*

Red chalk; 34.9×25.3 cm
1901-4-17-6

Lancret was the most gifted follower of Watteau, the inventor
of the *fête galante* and the Rococo style in France. Both artists
produced few drawings of landscape despite its prominence
in their paintings.

JEAN-HONORÉ FRAGONARD
1732-1806

127 *A Scene from 'Don Quixote'*

Black chalk and brown wash on light brown paper;
41.6×28.2 cm
1908-4-14-1

Fragonard, one of the most spirited French draughtsmen of
the eighteenth century, produced twenty-nine drawings
illustrating Cervantes' *Don Quixote*. They are datable
stylistically to *c.*1769, but their purpose is not known. The
present sheet illustrates the episode when the priest orders
the destruction of Don Quixote's books on chivalry.

FRANÇOIS BOUCHER
1703-1770

128 *A seated Woman with a Basket*

Black and white chalk on blue paper; 30.9×21.8 cm
1868-6-12-1868 Presented by John Edward Taylor

The pose of the woman resembles that of a figure in
Boucher's painting of the *Rape of Europa* in the Louvre, and
in a tapestry, *Le Marchand d'Oeufs*, in the Metropolitan
Museum, New York. The drawing probably dates from the
mid-1760s.

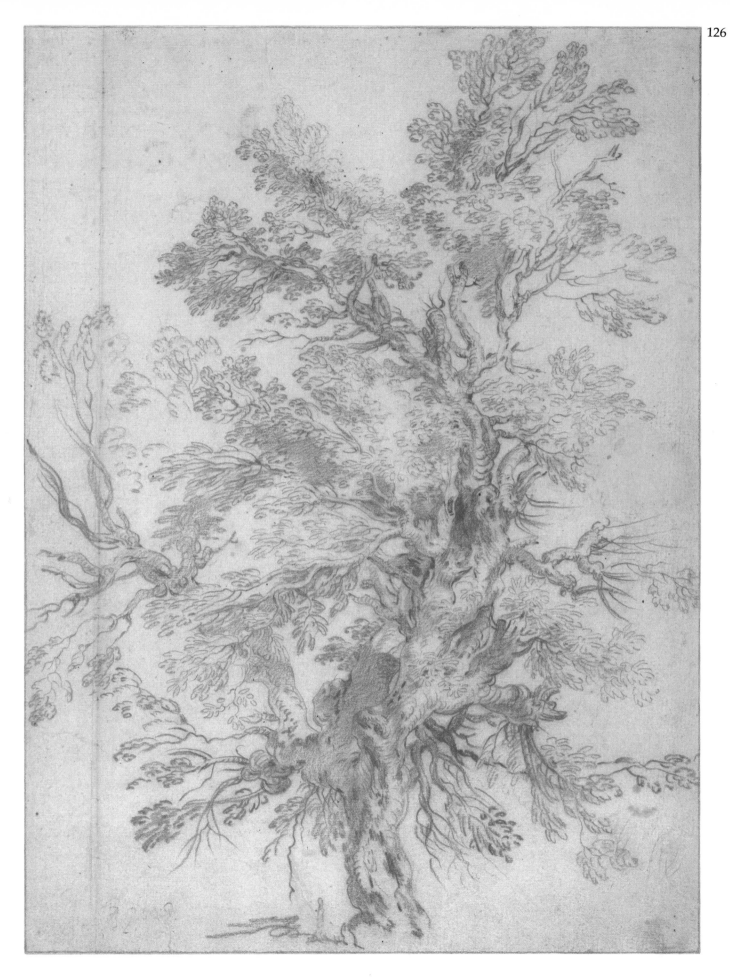

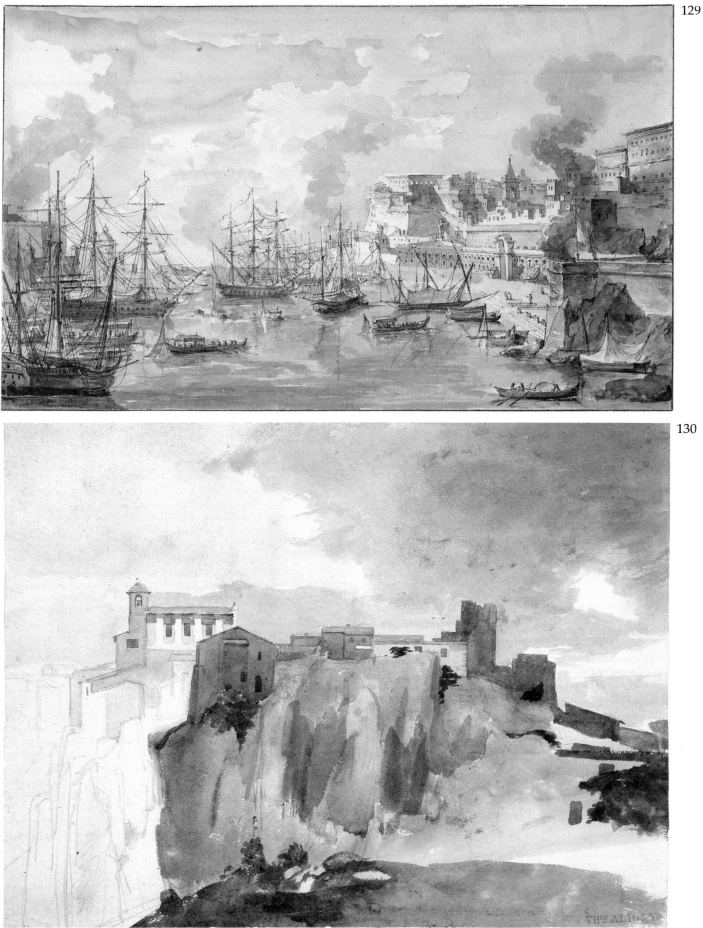

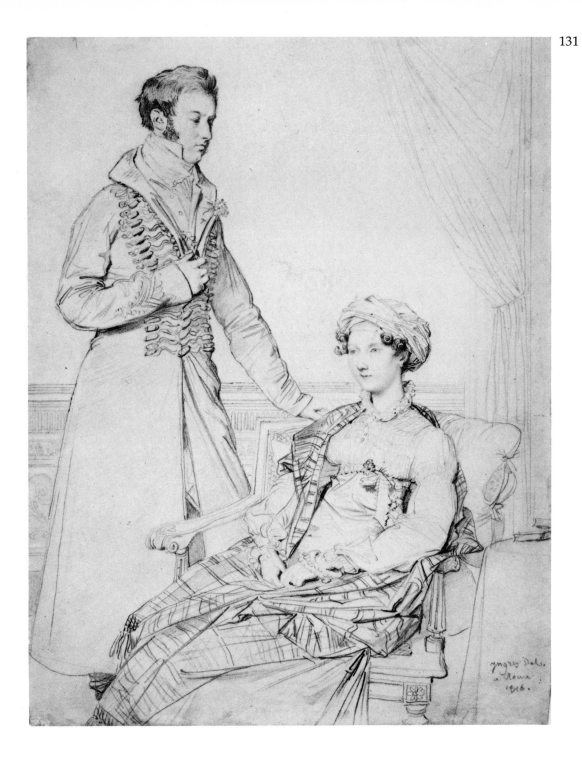

LOUIS-JEAN DESPREZ
1743-1804

129 *View of the Harbour at Valetta, Malta*

Pen and brown ink with watercolour; 20.8×34.3 cm
1946-7-13-119 Presented by the National Art-Collections
Fund (Phillipps-Fenwick Collection)

An etching was made of the drawing for publication in the
Abbé de St Non's *Voyage Pittoresque du Royaume de Naples*,
vol. IV, of 1786.

THÉODORE CARUELLE D'ALIGNY
1789-1871

130 *View of Castel Sant'Elia*

Watercolour over pencil; 24.7×32.3 cm
1977-7-16-1

Aligny was a painter and etcher of historical landscapes and
a recorder of classical antiquities. He spent his early years as
an artist in Rome.

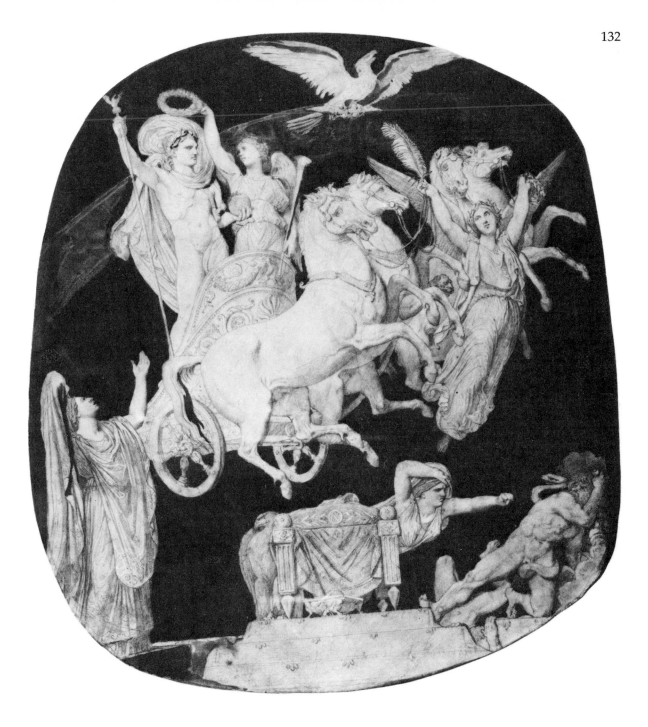

JEAN-AUGUSTE-DOMINIQUE INGRES
1780-1867

131 *Sir John Hay (1788-1838) and his sister, Mary, later Mrs George Forbes (1790-1877), 1816*

Pencil; 29.1×22 cm
1938-8-17-1 Presented by the National Art-Collections Fund

A fine example of the elaborate finished portrait drawings for which Ingres became famous during his stay in Rome from 1806-24. The arrangement of the figures would appear to be more appropriate to an engaged couple than to a brother and sister and in fact the original commission was for a portrait of Mary Hay and her fiancé. Hay was substituted when Forbes was obliged to leave Rome unexpectedly but the artist disdained to alter his composition.

JEAN-AUGUSTE-DOMINIQUE INGRES
1780-1867

132 *The Apotheosis of Napoleon: a design for a Cameo,* 1859

Pencil with dark brown wash; 42.8×38 cm
1949-2-12-6

In 1859 Napoleon III commissioned a cameo from Adolphe David which was to be a pendant to the largest surviving antique cameo, the *Grand Camée de la Chapelle Royale* (in the Bibliothèque Nationale). The design, the shape of which is exactly that of the *Grand Camée*, was based by Ingres on his ceiling in the Hôtel de Ville painted five years earlier. In the event David could find no suitable stone and used only the principal group of figures.

The date *1821* inscribed on the drawing refers to the year of Napoleon's death.

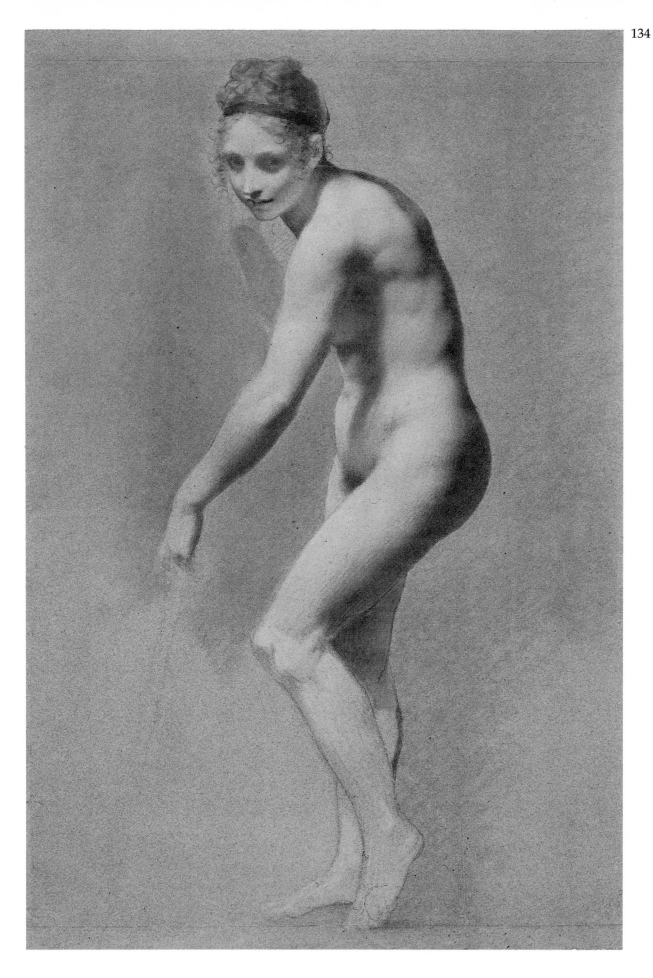

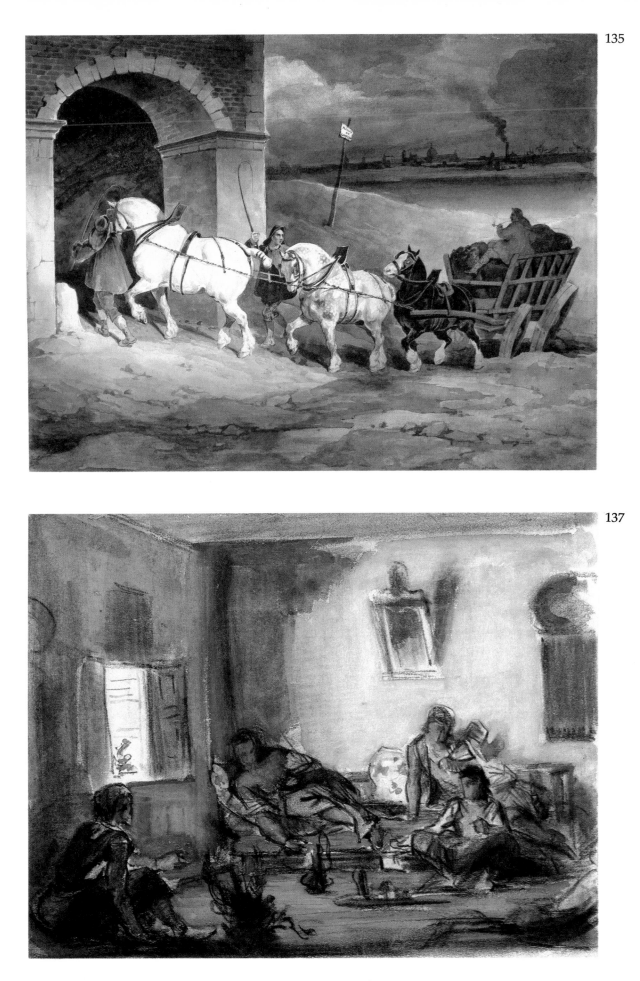

135

137

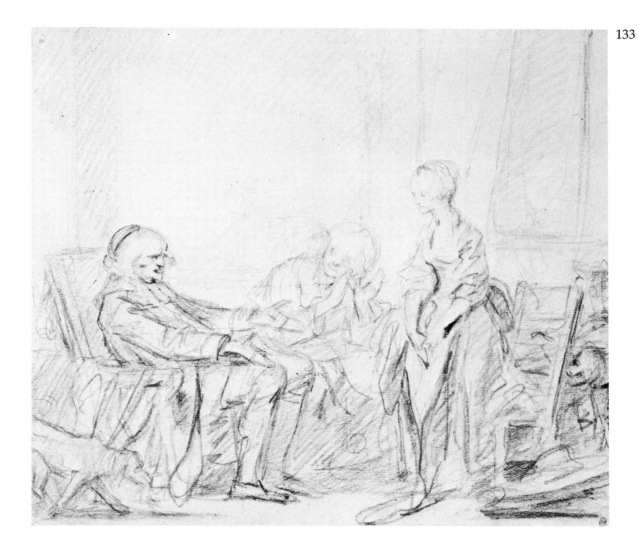

JEAN-BAPTISTE GREUZE
1725-1805

133 *La Veuve et son Curé*

Black chalk with touches of red and white chalk;
30.2×34.9 cm
1860-4-14-2

A study for the painting *La Veuve et son Curé* which was
made in 1786 and is now in the Hermitage, Leningrad. The
figures in the drawing correspond in general with the three
main figures of curate, widow and daughter in the painting.
The moralising, sentimental overtones of Greuze's work
brought him much success early in his career, although his
art went out of fashion after the beginning of the French
Revolution.

PIERRE PAUL PRUD'HON
1758-1823

134 *Standing female Nude*

Black and white chalk on blue paper; 62.5×41.5 cm
1968-2-10-18 César Mange de Hauke Bequest

A highly-finished study from the nude in the academic tradi-
tion, this drawing may be connected with Prud'hon's
designs for the monumental decorations in honour of the
marriage of Napoleon and Marie-Louise in 1810. The pose is
close to that of a personification of Navigation, one of ten
figures surmounting a colonnade erected in the Place de
l'Hôtel de Ville in Paris.

JEAN-LOUIS-ANDRÉ-THÉODORE GÉRICAULT
1791-1824

135 *The Coal Waggon*

Watercolour over black chalk; 21.7×27.8 cm
1968-2-10-28 César Mange de Hauke Bequest

During Géricault's stay in England from 1820 to 1821, he
made a number of works on the theme of coal-carting. The
landscape background of London in this drawing is hardly to
be taken as strictly topographical.

CAMILLE-JEAN-BAPTISTE COROT
1796-1875

136 *A Seated Woman*

Pencil; 28.1×23 cm
1935-6-8-2 Presented by the National Art-Collections Fund

This drawing, probably of a chambermaid, has been dated
c.1845-50 on stylistic grounds, and is an outstanding
example of Corot's portraiture.

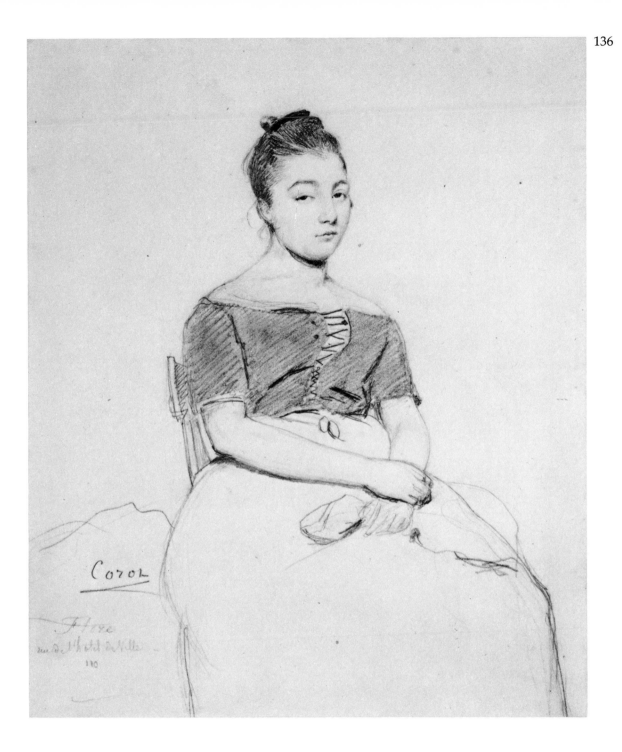

EUGÈNE DELACROIX
1798-1863

137 *An Algerian Interior*

Watercolour and bodycolour with black chalk; 22.4×28.5 cm
1898-5-20-23

A preliminary sketch for Delacroix's famous painting en-
titled *Les Femmes d'Alger*, exhibited at the Salon of 1834 and
now in the Louvre. This and other studies for the picture
were probably made in Algeria in July 1832.

GUSTAVE COURBET
1819-1877

138 *Self-Portrait, 1852*

Charcoal; 46.9×45 cm
1925-7-11-1 Presented by the National Art-Collections Fund,
Samuel Courtauld, and other subscribers

Courbet's predilection for self-portraiture was quickly
seized upon by contemporary caricaturists. The British
Museum's drawing has been used as the basis for dating a
painting in the Ny Carlsberg Glyptothek in Copenhagen.

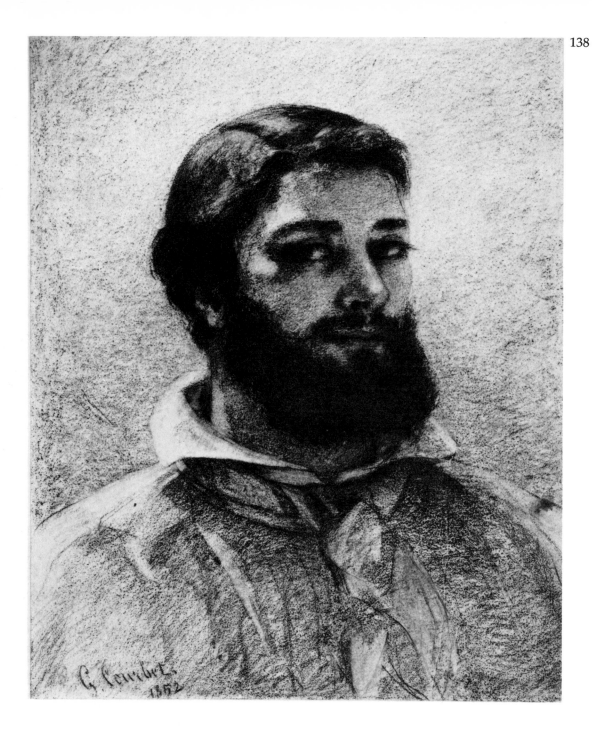

CHARLES-FRANÇOIS DAUBIGNY
1817-1878

139 *The Victoria Embankment under construction, 1866*
Black chalk; 32.3×48.9 cm
1908-6-16-47

In 1865 the exhibition of Daubigny's *Lever de Lune* at the Royal Academy led to an invitation to London from a group of artists headed by Lord Leighton. A number of drawings, oil sketches and finished paintings of the Thames were made during a stay of several months. This drawing, dated July 1866, shows the construction of the Embankment (1862-70) at a point close to Charing Cross Station, with Waterloo Bridge in the background.

JEAN-FRANÇOIS MILLET
1814-1875

140 *A Shepherd showing Travellers on their Way*
Charcoal; 22.4×28.9 cm
1931-7-21-1 Bequeathed by H. Velten

One of four studies for a highly finished drawing of 1857 now in the Corcoran Gallery of Art, Washington. Millet may have ben inspired by earlier compositions of *Christ on the Road to Emmaus* and more immediately by Courbet's *Le Rencontre* of 1855 in the Musée Fabre, Montpellier.

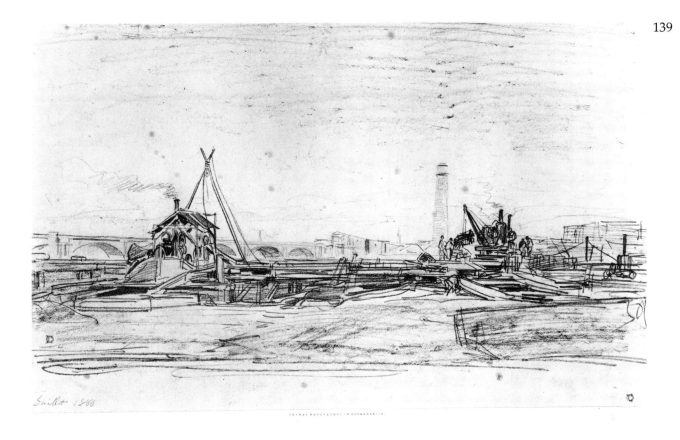

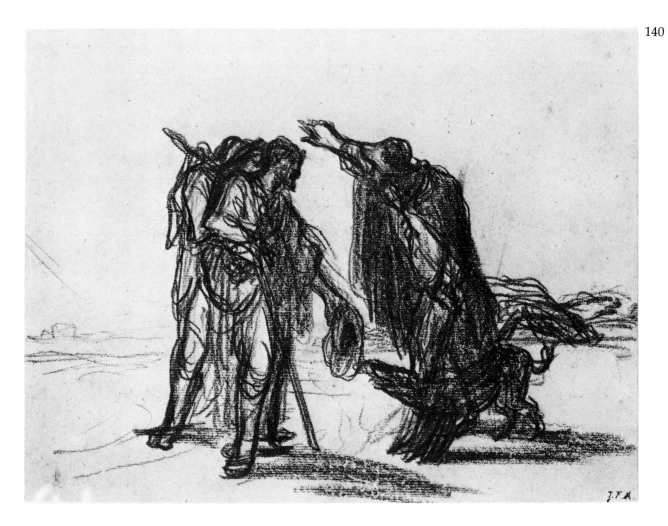

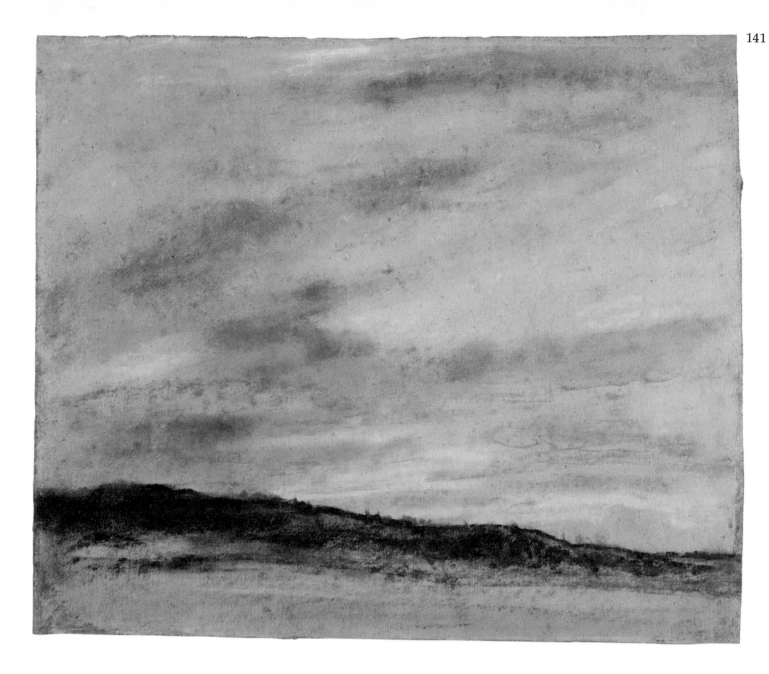

EUGÈNE DELACROIX
1798-1863

141 *Landscape at Sunset*

Pastel and watercolour on blue-grey paper; 23.3×26.8 cm
1975-3-1-34 (formerly T.G. 3302)

This study relates to a small group of atmospheric pastel
studies of landscapes at sunset made by Delacroix in 1849.

CAMILLE PISSARRO
1830-1903

142 *Study of a young Peasant Woman, seen from
behind,* 1881

Charcoal heightened with blue and white chalks on blue
paper; 44.8×32 cm
1920-7-12-3

Pisarro made extensive use of preparatory drawings; this
study provides an example of the artist working from a posed
model.

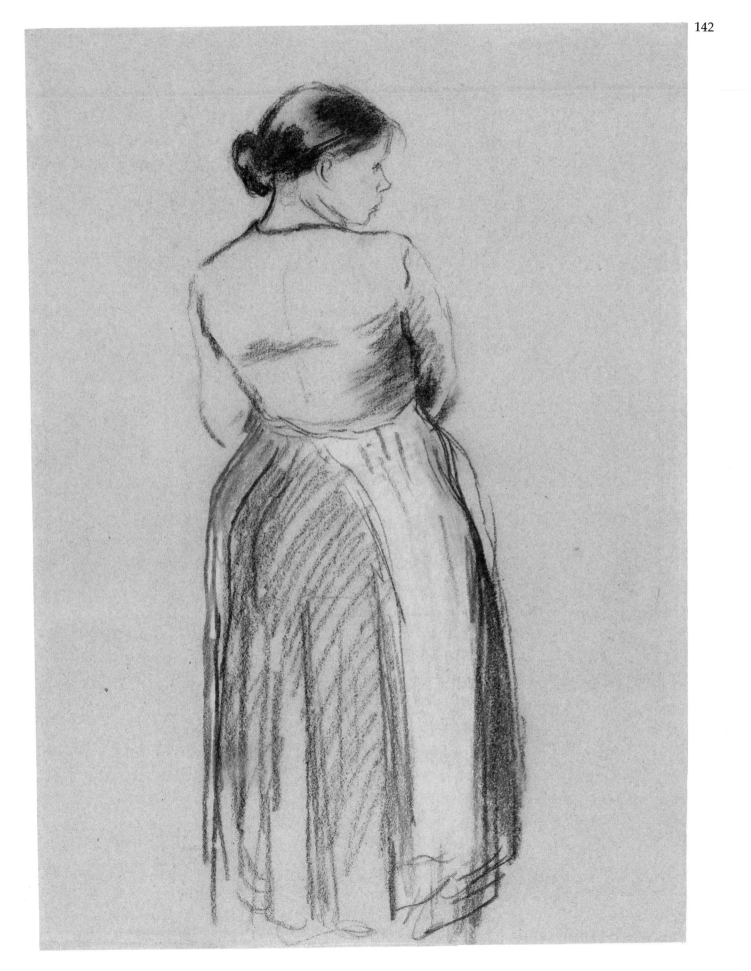

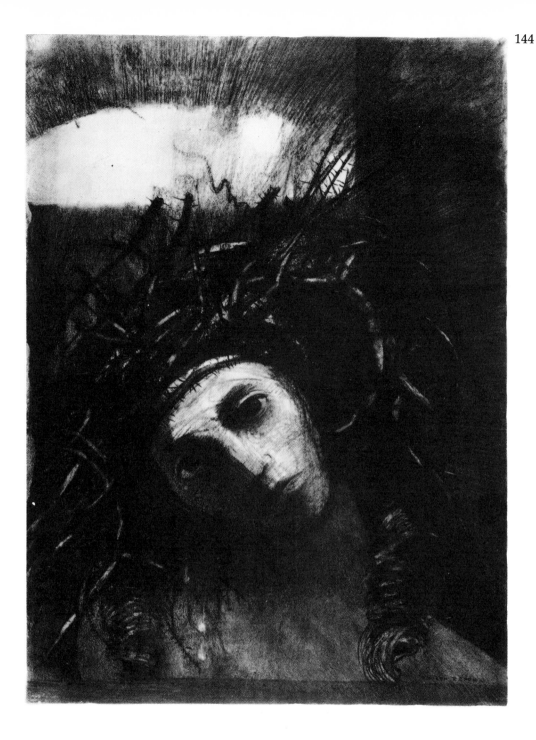

EDGAR DEGAS
1834-1917

143 *Woman with Field Glasses, c.1865*

Oil paint thinned with turpentine on pink paper;
28×22.4 cm
1968-2-10-26 César Mange de Hauke Bequest

Three full-length oil studies and two further drawings are recorded of this figure, which originally appeared beside the artist's brother, Achille, in the painting *Aux Courses* of 1868 (Private Collection, U.S.A.). The woman was subsequently painted out from the composition, which remained in Degas's studio until his death.

ODILON REDON
1840-1916

144 *Christ as the Man of Sorrows*

Charcoal; 53.2×37.9 cm
1921-4-11-1

Redon began his series of powerful black charcoal drawings, known as *fusains* in the 1870s, after his return from the Franco-Prussian war. He rapidly grasped the expressive potential of lithography after being introduced to this medium in 1879 by Fantin-Latour, as a means of reproducing his drawings. Christ as the Man of Sorrows was the subject of one of Redon's lithographs published in 1887, to which this work bears a close resemblance.

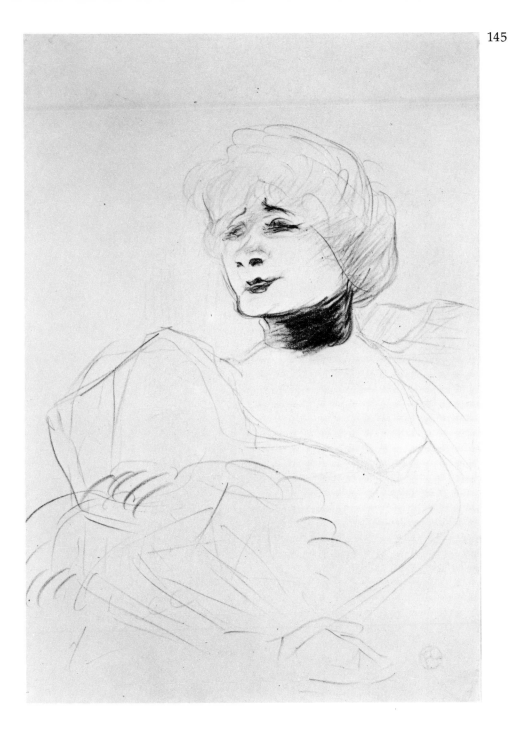

HENRI DE TOULOUSE-LAUTREC
1864-1901

145 *Portrait of Marcelle Lender*

Pencil and black chalk; 33×22.2 cm
1968-2-10-22 César Mange de Hauke Bequest

Marcelle Lender was one of Toulouse-Lautrec's favourite
subjects from among the cabaret and theatre performers of
Paris. The pose in this drawing is quite similar to the attitude
in which the artist depicted her in a lithograph of 1893, *Mlle
Lender et Baron.*

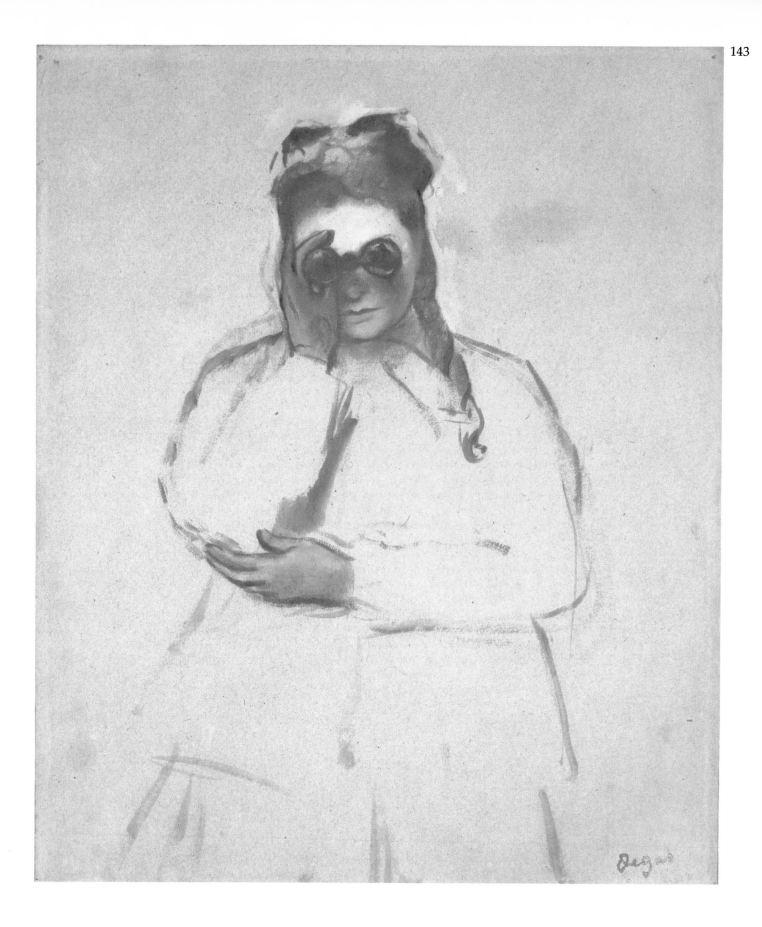

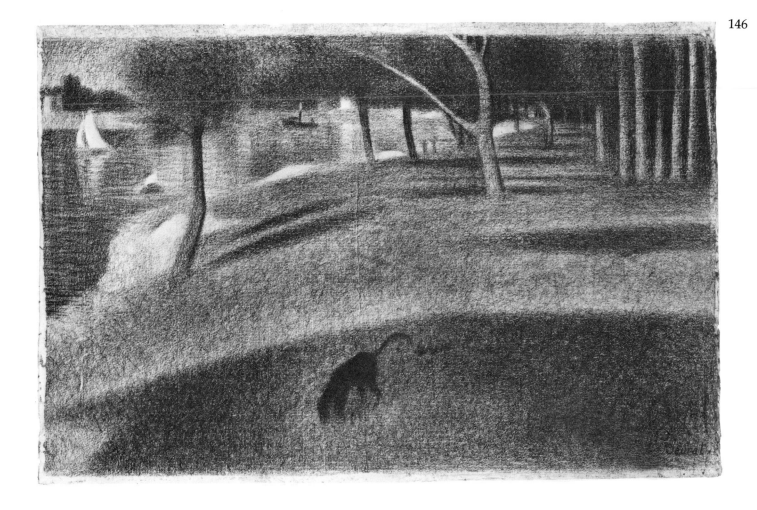

GEORGES SEURAT
1859-1891

146 *Landscape study for 'La Grande Jatte'*

Conté crayon; 42.2×62.8 cm
1968-2-10-17 Céssar Mange de Hauke Bequest

The preliminary studies for *A Sunday Afternoon on the island
of La Grande Jatte* (Chicago Art Institute) comprise about fifty
oil sketches and drawings in conté crayon which were
executed between 1884 and 1886, when the painting was
shown at the last Impressionist exhibition. A figure study for
the work came with the same Bequest.

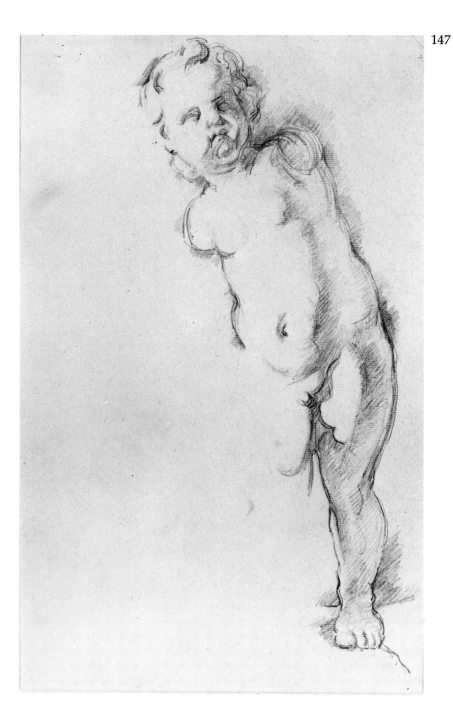

PAUL CÉZANNE
1839-1906

147 *Study from the Statuette of a Cupid, c.1890*

Black chalk; 50.5×32.5 cm

1935-4-13-2 Presented by the National Art-Collections Fund

Chappuis in his *catalogue raisonné* of Cézanne's drawings,
describes eleven studies after the plaster cast owned by the
artist, which is still to be seen in his studio in Aix-en-
Provence. The original sculpture was formerly attributed to
Puget (1620-94) but is now thought to have been the work of
Coustou (1658-1733).

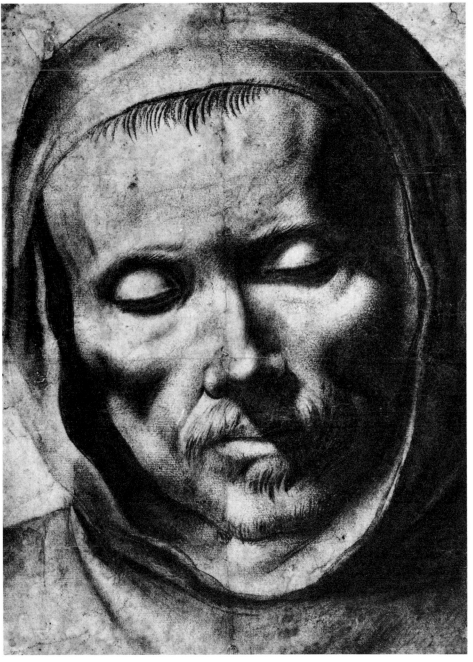

JOSÉ RIBERA
1590-1652

148 *St Albert tied to a Tree, 1626*

Red chalk; 23.2×16.9 cm
1850-7-13-4

The date *1626* inscribed by the artist on this drawing provides the key to the dating of a group of similarly highly finished red chalk drawings in which Ribera shows his mastery of the classical tradition of Renaissance and Baroque drawing. Bound men are frequently to be found in Ribera's work, martyrdom being a major Counter-Reformation theme. The identification of the subject as St Albert may be ascertained by the presence of his attribute, a cross.

FRANCISCO ZURBARÁN
1598-1664

149 *Head of a Monk with closed Eyes, 1629*

Black chalk and dark grey wash; 27.7×19.6 cm
1895-9-15-873

One of the few drawings generally accepted as attributable to Zurbarán. It may have been a preliminary study for his painting of *St Bonaventura on his Bier* of 1629, now in the Louvre.

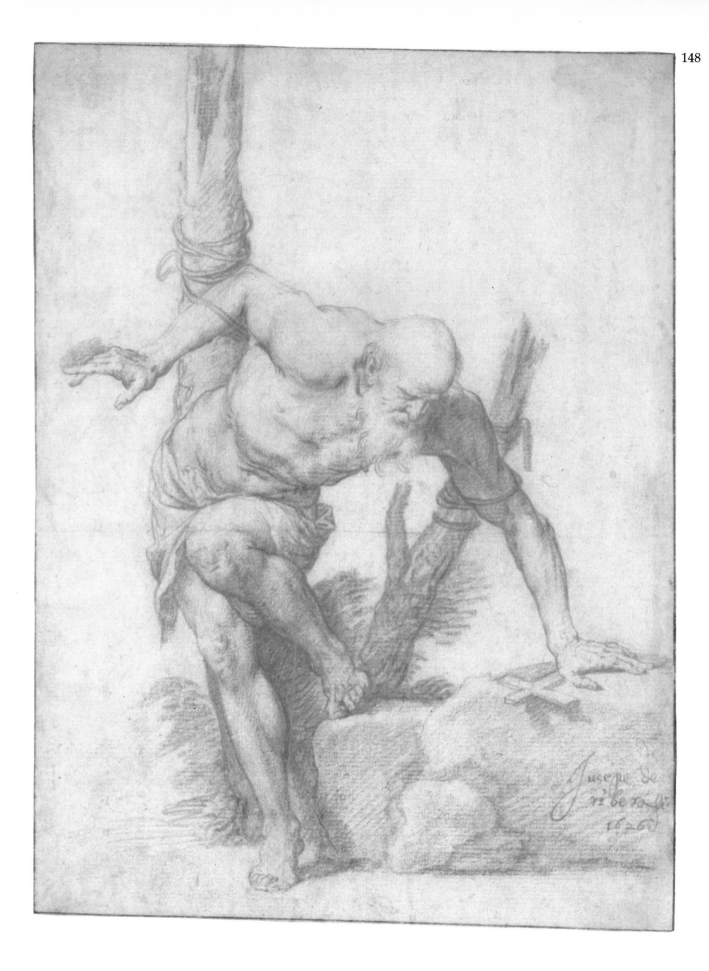

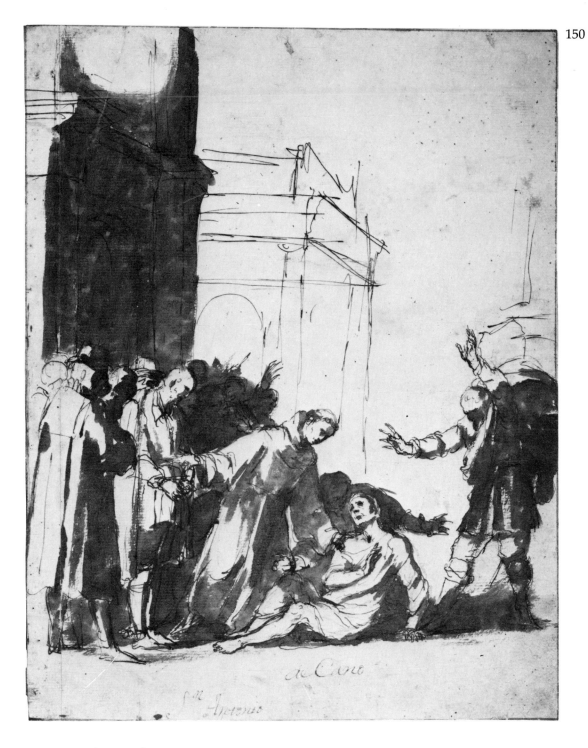

BARTOLOMÉ ESTEBÁN MURILLO
1617-1682

150 *The Miracle of St Antony of Padua and the irascible
Son*

Pen and brown ink with brown wash over traces of black
chalk; 34.6×26.5 cm
1920-11-16-20

On stylistic grounds this drawing may be dated in the mid-
1640s. It is probably a discarded idea for one of the scenes
from the lives of Franciscan saints painted in 1646 in a
cloister in the Convento de San Francisco in Seville. St
Antony is shown restoring the foot of a young man who had
mutilated himself as an act of contrition for having kicked his
mother.

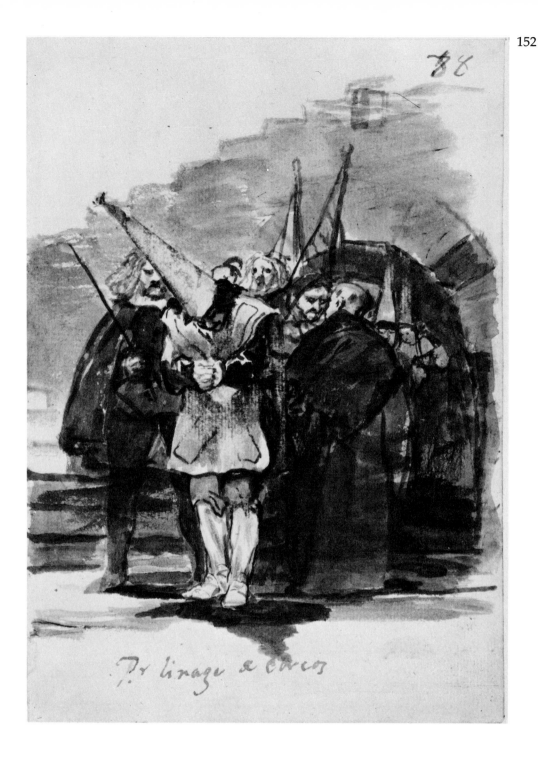

ANTONIO DE PEREDA Y SALGADO
1608/11-1678

151 *St Jerome*

Black and red chalk, and brown and grey wash, heightened
with white bodycolour; 25.3×21.5 cm
1895-9-15-883

This study may possibly be related to Pereda's painting of St
Jerome in the Prado which is dated 1634. One of the four
Latin Fathers of the Church, the saint is shown, typically, as
an old ascetic, semi-nude, at work on his translation of the
Vulgate.

FRANCISCO GOYA Y LUCIENTES
1746-1828

152 *Por linage de ebreos* (For being of Jewish
ancestry), *c.*1814-24

Brush and grey and brown wash; 20.3×14.2 cm
1862-7-12-187

One of a series of drawings made between *c.*1814 and 1823
during the period of repression under Ferdinand VII. The
subjects are victims of the Inquisition, as is shown by their
paper tunics and tall hats. Goya inscribed many of his draw-
ings with brief enigmatic titles.

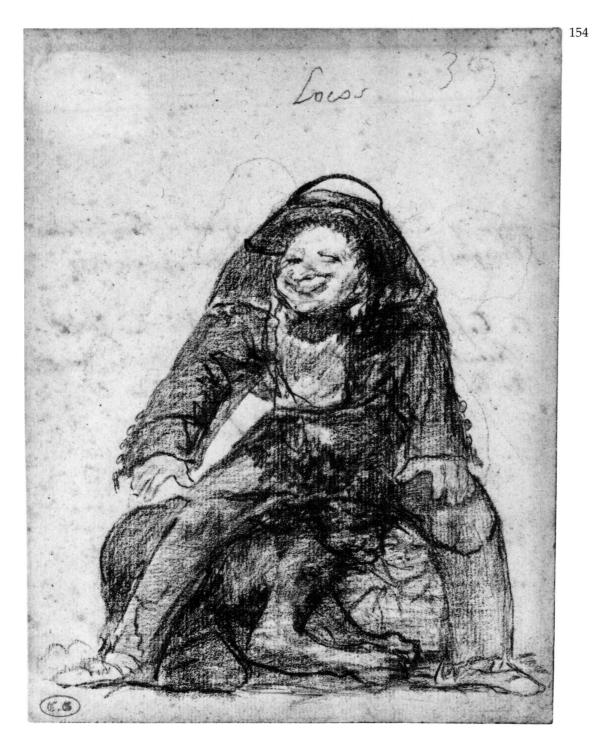

FRANCISCO GOYA Y LUCIENTES
1746-1828

153 *Arthur Wellesley, 1st Duke of Wellington (1769-1852), 1812*

Red chalk over pencil; 23.5×17.8 cm
1862-7-12-185

This study would have been made within days of Welling-ton's victory over the French at Salamanca on 23rd July 1812. It was used as the basis for Goya's portraits of the Duke in the National Gallery and at Apsley House. Traces of folds around the drawing indicate that it would have been transferred to a copper plate, the space below the design being left blank for an inscription. No impressions of the intended etching are known.

FRANCISCO GOYA Y LUCIENTES
1746-1828

154 *Locos* (Madmen), *c.*1824-8

Black chalk; 19.1×14.7 cm
1980-6-28-56

This drawing comes from an album dating from the last four years of Goya's life while he was living in Bordeaux. The subjects repeat his continual preoccupations, the present drawing being one of a group of thirteen showing different types of lunatic.

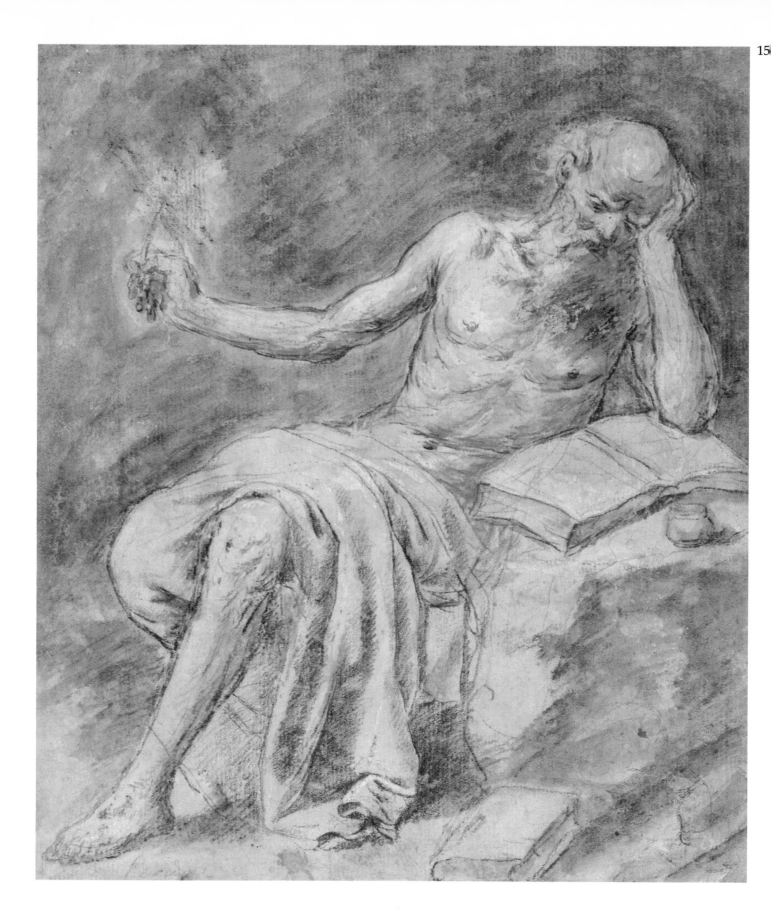

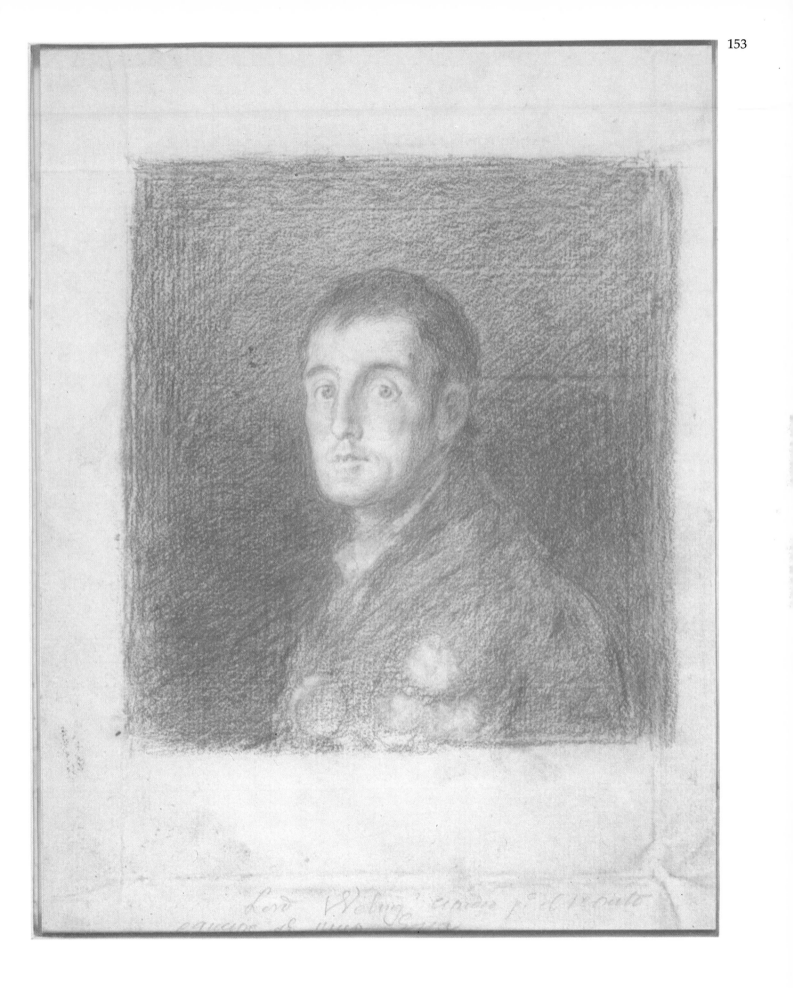

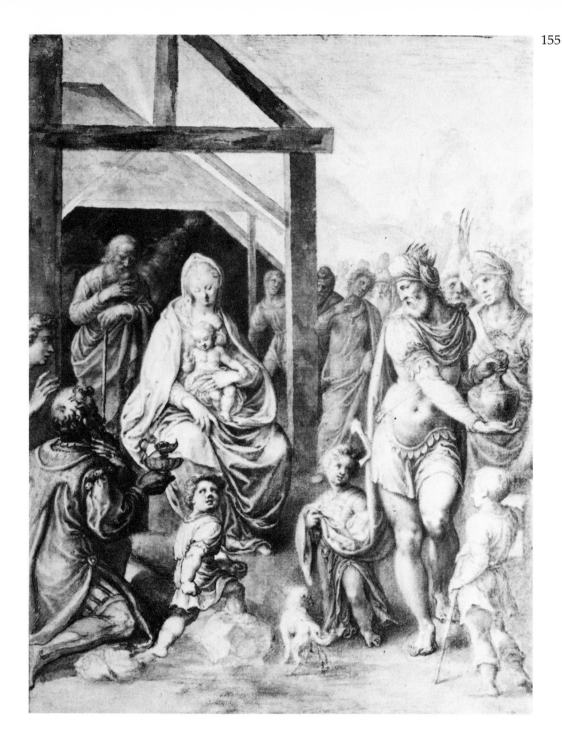

ISAAC OLIVER
*c.*1556?-1617

155 *The Adoration of the Magi*

Grey and purplish-brown wash, touched with pen and brown ink and heightened with white, over black lead and black chalk; 22.7×16.8 cm

1855-7-14-55

This highly-finished signed drawing was doubtless conceived as a work of art in its own right rather than as a preliminary study. The sinuous elongated figures reveal the influence of mannerist artists like Parmigianino and Spranger whose work Oliver would have seen during his travels on the Continent.

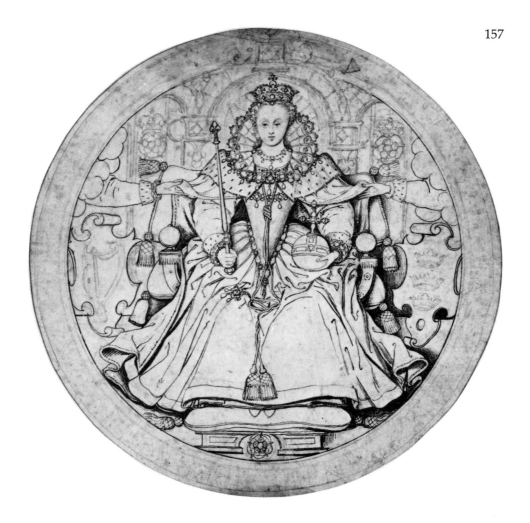

JACQUES LE MOYNE DE MORGUES
*c.*1533-1588

156 *Quince and Grey Dagger Moth Caterpillar, c.*1585

Watercolour and bodycolour; 21.6×13.9 cm
1962-7-14-1(38) Purchased with the aid of the Pilgrim Trust,
the Nuffield Foundation, the National Art-Collections Fund
and private gifts

From an album of fifty drawings by the artist which are
probably the finest botanical studies of the period. Their
high finish and meticulous technique would suggest that
they were intended for presentation to some discriminating
patron, perhaps Lady Mary Sidney to whom Le Moyne dedi-
cated, in 1586, a small volume of woodcuts, *La clef des champs.*
A number of the designs were taken from drawings in the
album although greatly simplified to serve as models for
embroidery and other decorative work.

NICHOLAS HILLIARD
1547-1619

157 *Queen Elizabeth I: Design for the Obverse of the
Great Seal of Ireland*

Pen and black ink, strengthened with wash, over black lead;
12.4 cm diameter
1912-7-17-1 Presented by Mrs Peter Gellatly

This design was not apparently carried out but it is identifi-
able by two essentially Irish emblems; the Harp and the
Three Crowns. There are a number of similarities with Eliza-
beth's second Great Seal of England designed by Hilliard in
1584, although the Queen appears considerably younger in
the present drawing.

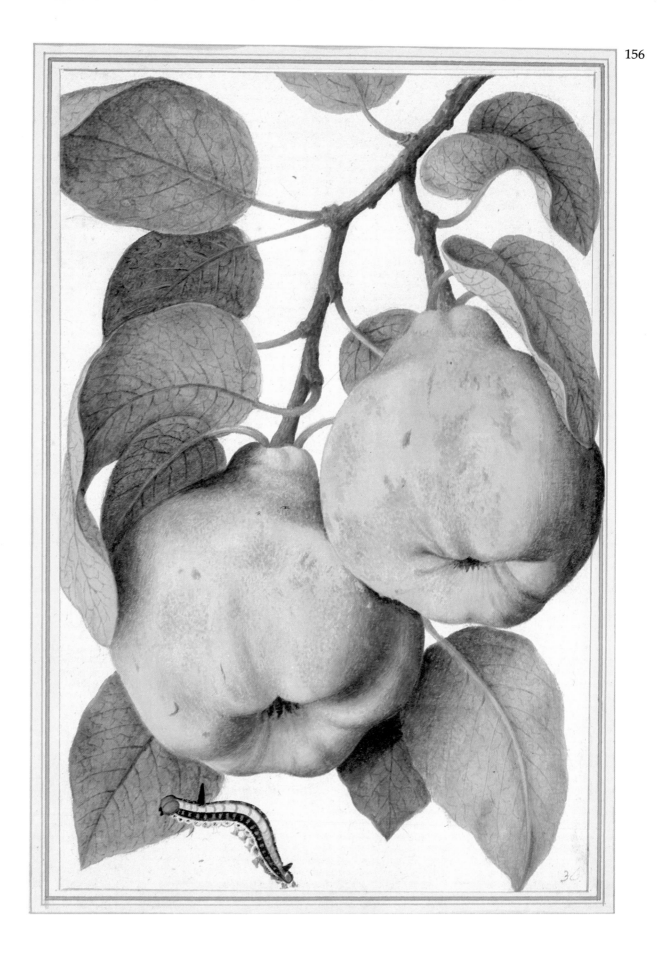

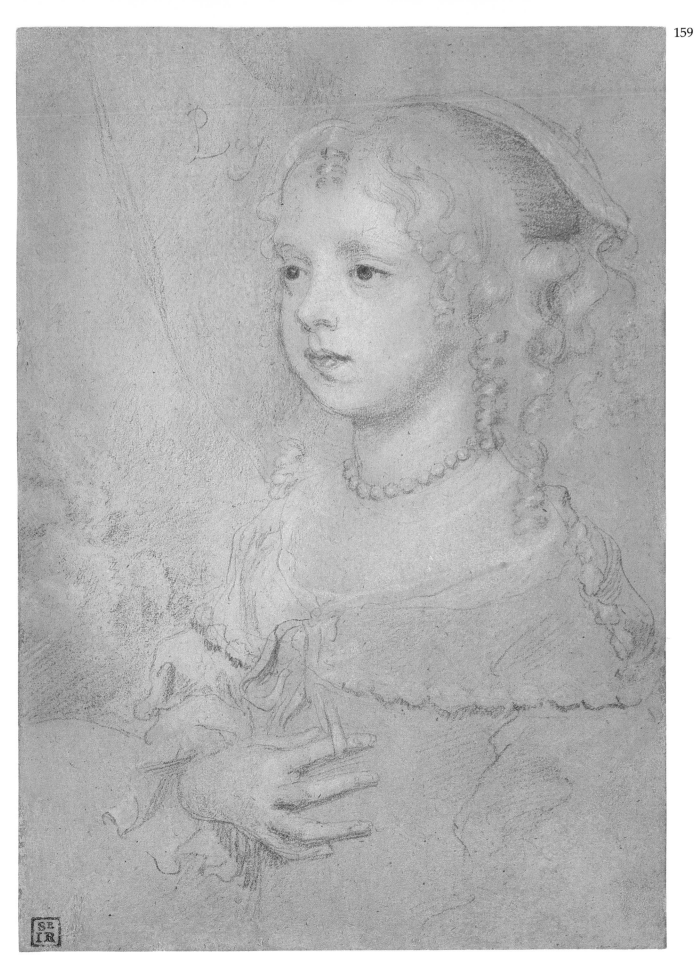

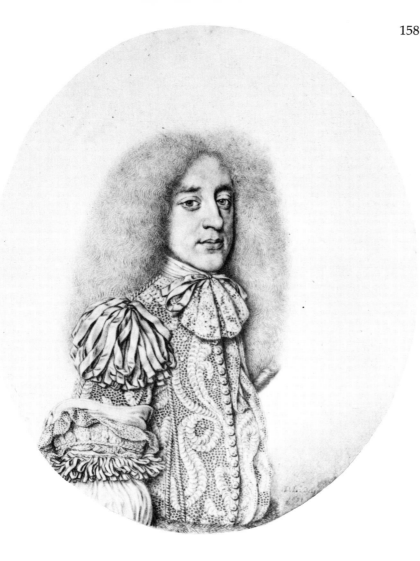

DAVID LOGGAN
1635-1692

158 *John Wilmot, 2nd Earl of Rochester (1647-1680),*
1671

Black lead with brown wash, on vellum; 13.8×11.8 cm (oval)
1903-3-9-1 Presented by Miss Adair

The sitter is traditionally identified as Lord Rochester, the
poet and intimate of Charles II, celebrated for his wit and
profligacy. Loggan's manner of drawing portraits in minia-
ture is derived from the Dutch and would have been learnt
during his years in Amsterdam during the 1650s.

SIR PETER LELY
1618-1680

159 *Portrait of a Girl*

Black and red chalk, heightened with white chalk, on buff
paper; 28.2×19.8 cm
1983-7-23-41

One of Lely's most tender studies, this highly-finished,
signed, portrait drawing is of the type which the artist made
as independent works of art: an inventory compiled at the
time of his death records that such 'Craions' still in his studio
were in ebony frames, suggesting that they were hung as if
they were paintings.

LEONARD KNYFF
1650-1722

160 *Hampton Court from the South*

Pen and brown ink with grey wash; 41.3×58.5 cm
1961-4-8-1

This drawing is probably connected with Knyff's series of
topographical views for Jan Kip's *Britannia Illustrata* (1707) in
which, however, the prospect of Hampton Court is from the
west. It is remarkable as a contemporary view made soon
after Wren's additions to the palace for William III and
Queen Anne, with the elaborate layout of the gardens in the
Franco-Dutch taste.

ALEXANDER COZENS
?1717-1786

161 *Landscape Composition*

Brush drawing in black ink; 15.6×19.3 cm
1888-1-16-8(10)

Cozens's 'blot' system for making ideal landscape drawings
was described in his *New Method of assisting the Invention in
drawing original Compositions of Landscape*, published shortly
before his death. Such compositions were to be made as
spontaneously as possible, the artist controlling the move-
ment of his hand only in accordance with some general idea
which he should first have in mind. This done, the accidental
shapes of the washes would suggest features to the artist
which he could then elaborate or suppress in a more finished
drawing. Although not strictly a 'blot', this drawing (like
others in the album) seems to have been conceived in much
the same way.

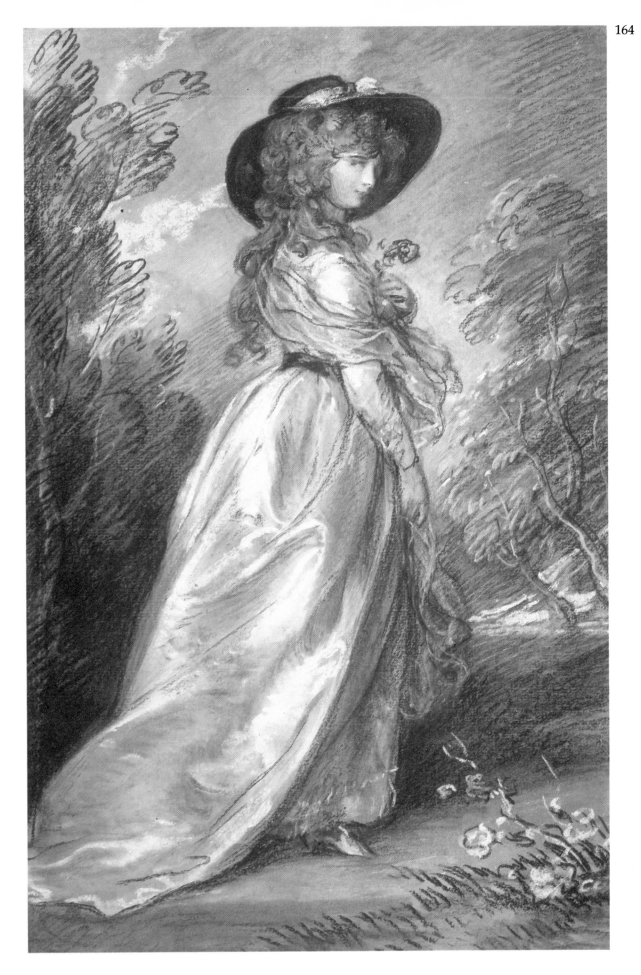

The bad Prentice at play in the church yard with Pickpokets

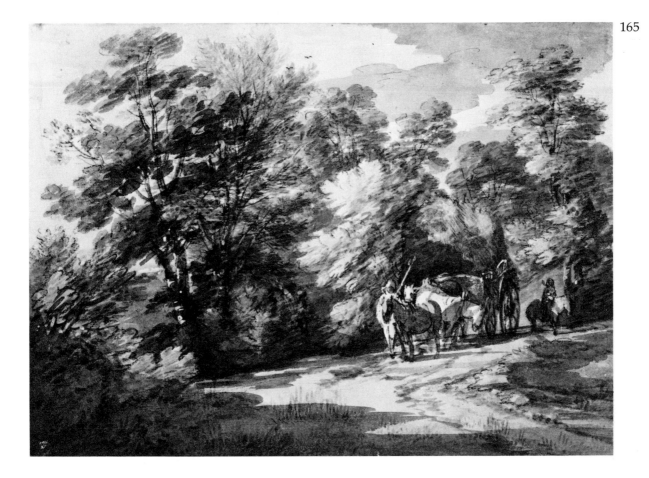

WILLIAM HOGARTH
1697-1764

162 *Finished drawing for Pl. 3 of 'Industry and
Idleness, 1747: The Idle 'Prentice at Play in the
Church Yard, during Divine Service'*

Pen and black and brown ink with grey wash, indented for
transfer; 27.2×35.1 cm
1896-7-10-7

Hogarth was not a prolific draughtsman and *Industry and
Idleness* is the only major project for which a number of
preliminary studies exists. This series of prints, aimed at a
popular market, was made directly from drawings rather
than being based on oil paintings as is the case with his other
Moral Progresses. The present drawing is developed from a
freer preliminary study. It shows the Idle 'Prentice and his
ruffianly friends gambling on a tombstone while (as is
shown in Plate 2 of the series) the Industrious 'Prentice and
their Master's daughter are attending the service within the
church.

PAUL SANDBY
1730-1809

163 *Windsor from Crown Corner*

Watercolour over pencil; 27.7×56.4 cm
1878-7-13-1280

Sandby developed the traditional topographical tinted
drawing, the freshness of his colouring playing an essential
rôle in conveying light and atmosphere. This early morning
scene is one of many views of Windsor where his brother
Thomas (1721-1798) was Deputy Ranger of the Forest.

THOMAS GAINSBOROUGH
1727-1788

164 *Study of a Woman, perhaps for 'The Richmond
Water-Walk', c.1785*

Black chalk and stump, heightened with white bodycolour
on buff paper; 49.5×31.4 cm
1910-2-12-250 George Salting Bequest

Dating from the mid-1780s, this figure study was probably
made in connection with a projected painting, *The Richmond
Water-Walk*, which was to be a companion to *The Mall* (The
Frick collection, New York). According to an inscription
formerly on the back of the frame, Gainsborough 'was much
struck with what he called "the fascinating leer" of the Lady
who is the subject of the drawing'.

THOMAS GAINSBOROUGH
1727-1788

165 *A Wooded Landscape with a Waggon in a Glade,
c.1765-67*

Watercolour heightened with white bodycolour, over indi-
cations of black chalk; 23.7×31.7 cm
1899-5-16-10

Unlike Sandby (no. 163), Gainsborough almost never con-
cerned himself with topographical views after his early years
in Suffolk. Increasingly, he developed an evocative interpre-
tation of nature. This watercolour, painted in the mid-1760s,
was probably based on rough sketches made in the country-
side around Bath. Like certain other drawings by Gains-
borough, this was stamped with his monogram in gold,
suggesting that it was intended for presentation to a friend
or patron.

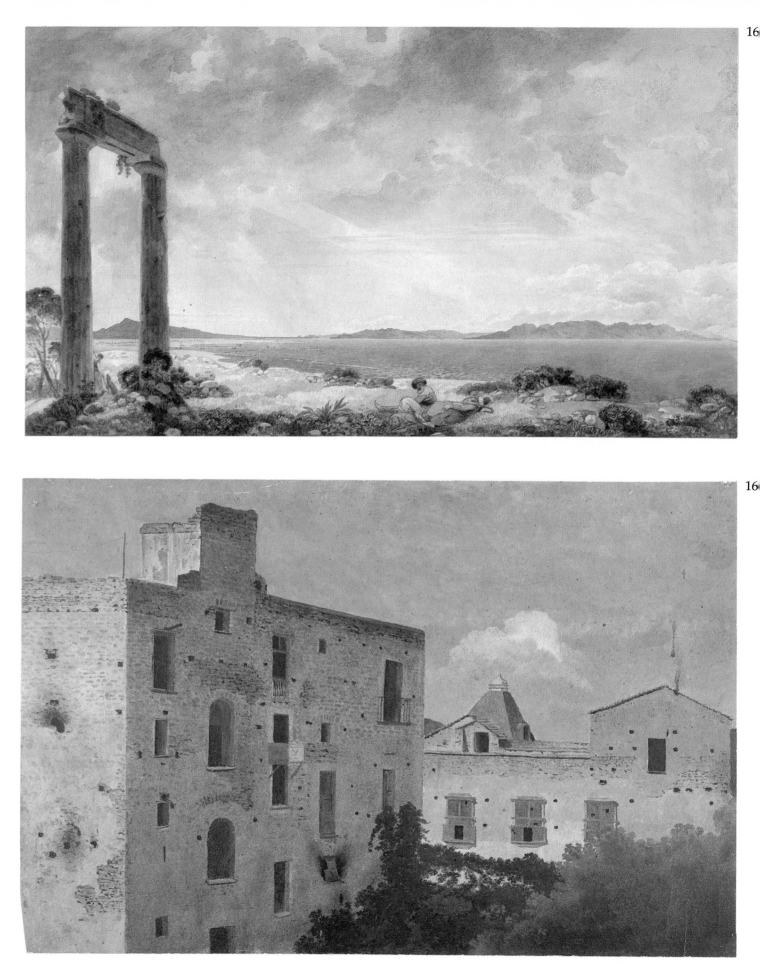

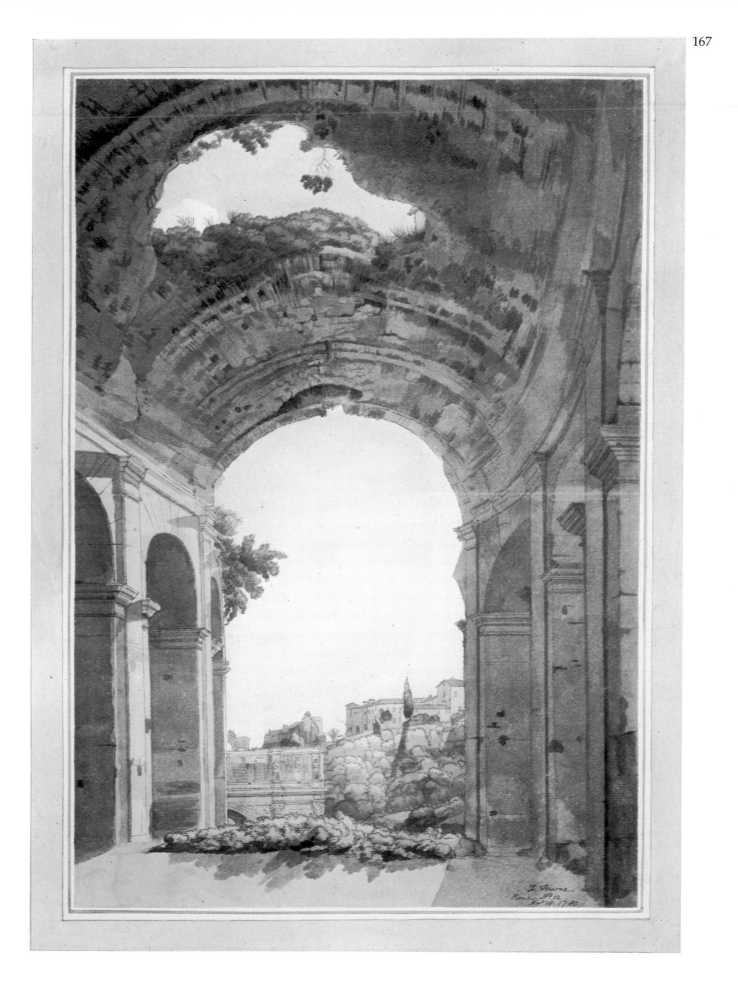

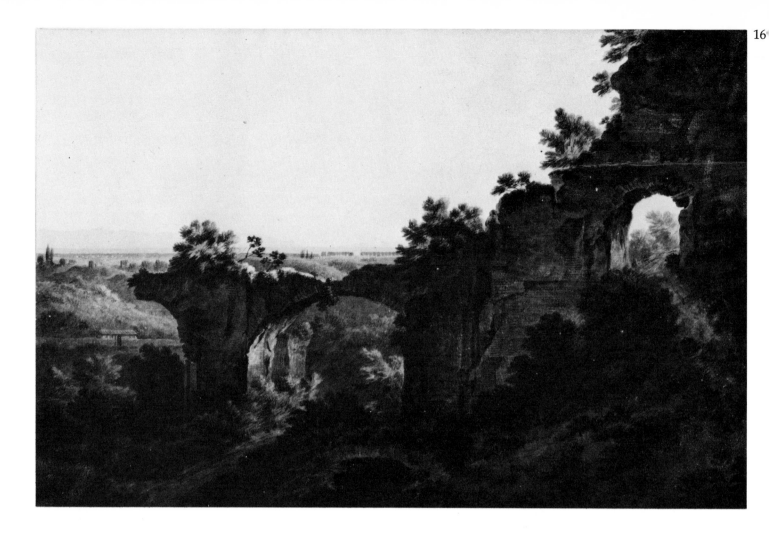

WILLIAM PARS
1742-1782

166 *Ruin near the Port of Aegina*

Watercolour with gum over pencil; 28.7×49 cm
Mm. 11-10 Presented by The Dilettanti Society

In 1764 Pars was commissioned by the Society of Dilettanti to accompany Chandler and Revett's expedition to Greece and Asia Minor, returning in 1766. The drawings made in connection with this journey were published in *Ionian Antiquities* (vol. I, 1769; vol. II, 1797); this view in the island of Aegina was engraved by William Byrne as Plate 1 in the second volume, and also as an aquatint by Paul Sandby.

FRANCIS TOWNE
1739/40-1816

167 *View through an Arch of the Colosseum, looking towards the Palatine, with the Arch of Constantine*

Watercolour with washes of ink and pen outlines;
47×31.5 cm
1972.u.729. Francis Towne Bequest, 1816

Among Towne's finest watercolours are those made in 1780 and 1781 during his visit to Italy and on his return journey through Switzerland. This drawing, in Towne's distinctive style, comes from one of the albums of Roman views bequeathed by the artist to the British Museum. According to an inscription on the *verso*, it was drawn on 18 November 1780, shortly after Towne arrived in the city.

THOMAS JONES
1742-1803

168 *Houses in Naples, 1782*

Oil on paper; 25.4×38.1 cm
1954-10-9-12 Purchased from the H. L. Florence Fund

Jones's Italian oil sketches, in particular those made in Naples between 1780 and 1783, are among the most original works by any British artist of the eighteenth century. While in Italy, Jones kept a journal (an invaluable source for the activities of his fellow British artists) which conveys much of the unaffected directness to be seen in sketches such as this view taken from the *lastrica* or rooftop of his lodgings in Naples during the summer of 1782.

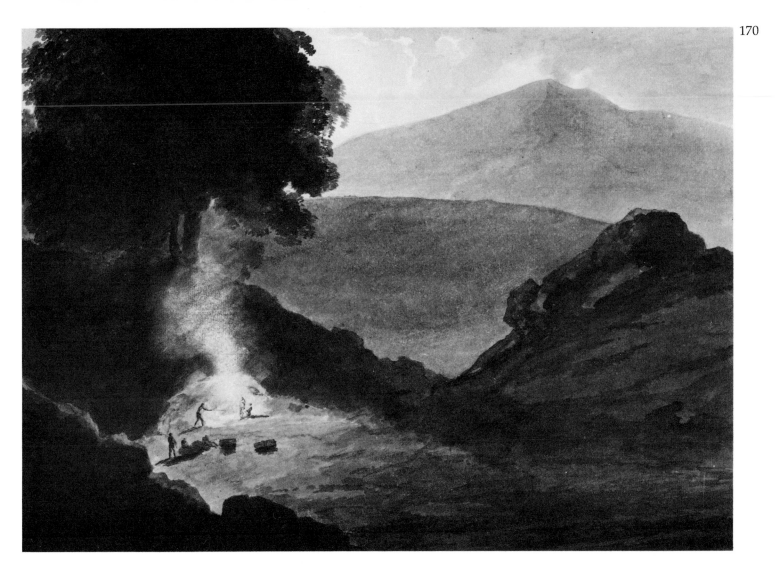

JOHN 'WARWICK' SMITH
1749-1831

169 *The Baths of Caracalla, Rome, 1781*

Watercolour and ink; 34.7×51.1 cm
1936-7-4-25

'Warwick' Smith (probably so-called after his patron, the Earl of Warwick) lived in Italy from 1776 to 1781. His most interesting drawings are those made on the spot, which are much more freely executed than his finished (and often poorly repeated) studio works. This is from a group of such studies apparently made in the company of Francis Towne (no. 167), with whom he made sketching expeditions in Italy in 1780-81 and in whose company he returned to England. A similar view of the Baths of Caracalla (though stylistically very different) by Francis Towne, dated January 1781, is also in the British Museum.

JOHN ROBERT COZENS
1752-1799

170 *Mount Etna, from the Grotta del Capro, 1777*

Watercolour and wash with scratching out, over pencil;
35.3×47.7 cm
Oo. 4-38 Richard Payne Knight Bequest, 1824

Based on a sketch by the amateur Charles Gore, who was a member of Payne Knight's expedition to Sicily in 1777, Cozens's watercolour shows the travellers' nocturnal halt in the Grotta del Capro during their ascent of Mount Etna. Cozens transformed the original, diminishing the scale of the figures in relation to the landscape, and dramatising the effect of the bonfire against the moonlit sky to haunting effect.

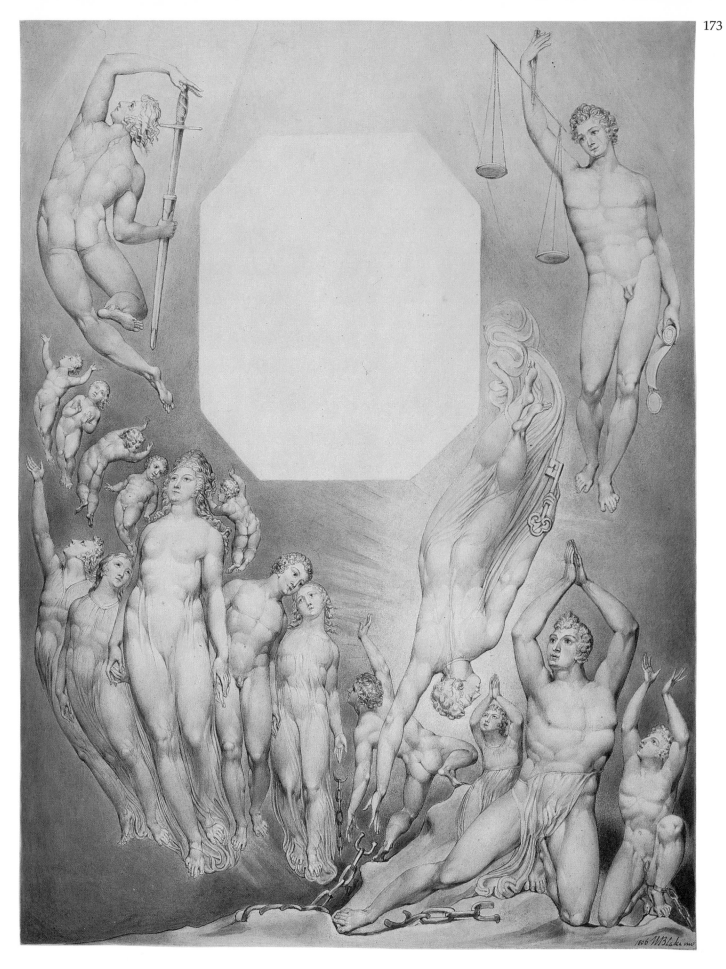

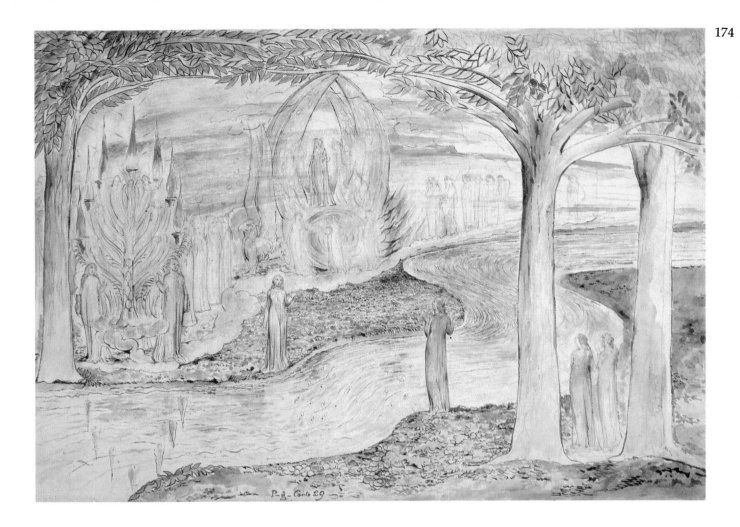

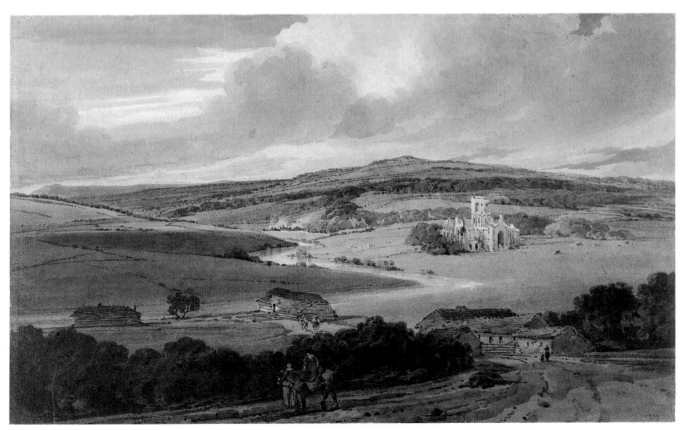

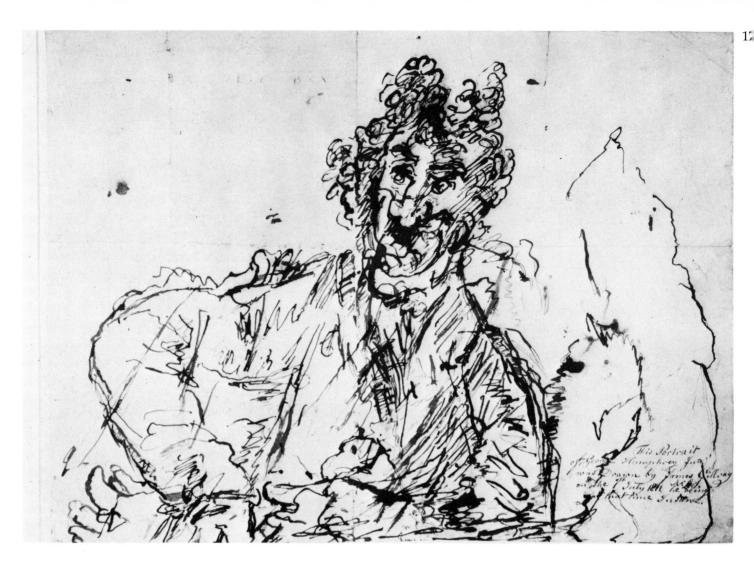

JAMES GILLRAY
1746-1815

171 *George Humphrey Jr*, 1811

Pen and brown ink; 37.1×49.3 cm
1853-1-12-112

Gillray's erratic line is expressive of his disturbed state of mind at the time of making this drawing. It is dated in the last year of his active career before he succumbed completely to insanity. The sitter, identified by the inscription, was the nephew of Gillray's publisher and landlady Hannah Humphrey.

JAMES BARRY
1741-1806

172 *Satan and his Legions hurling Defiance toward the Vault of Heaven*

Brush drawing in brown ink with grey wash over pencil; 68.9×49.4 cm
1868-6-12-2143 Presented by J. H. Anderdon

A signed study for an etching, intended as part of a series illustrating Milton's *Paradise Lost*. Barry worked intermittently on the project between 1792 and 1799, but failed to complete it, partly because he was often more interested in the intricate intellectual notions behind such ambitious schemes than in their execution.

WILLIAM BLAKE
1757-1827

173 *The Resurrection of the Dead*, 1806

Grey wash and watercolour over pencil; the outlines strengthened with pen and ink; 42.5×31 cm
1856-7-12-208

A finished watercolour, signed and dated 1806, apparently designed as a title-page for a new edition of Robert Blair's poem *The Grave*. However, it was not used and a suggestion has been made that Blake may have intended the drawing for inclusion in a portfolio of separate designs.

WILLIAM BLAKE
1757-1827

174 *Beatrice on the Car, Matilda and Dante*, 1824-7

Pen and watercolour over pencil; 36.7×52 cm
1918-4-13-5 Presented by the National Art-Collections Fund

An illustration to Dante's *Divine Comedy* (*Purgatorio*, xxix, 13-150). In the Earthly Paradise Matilda (probably the Grancontessa of Tuscany, supporter of Pope Gregory VII against the Holy Roman Empire) bids Dante heed the approaching procession, described with many allusions to the Bible, particularly the Book of Revelation, from which are taken the seven-branched candlestick, the four-and-twenty elders, and the chariot drawn by a gryphon. Virgil and Statius stand between the trees on the right.

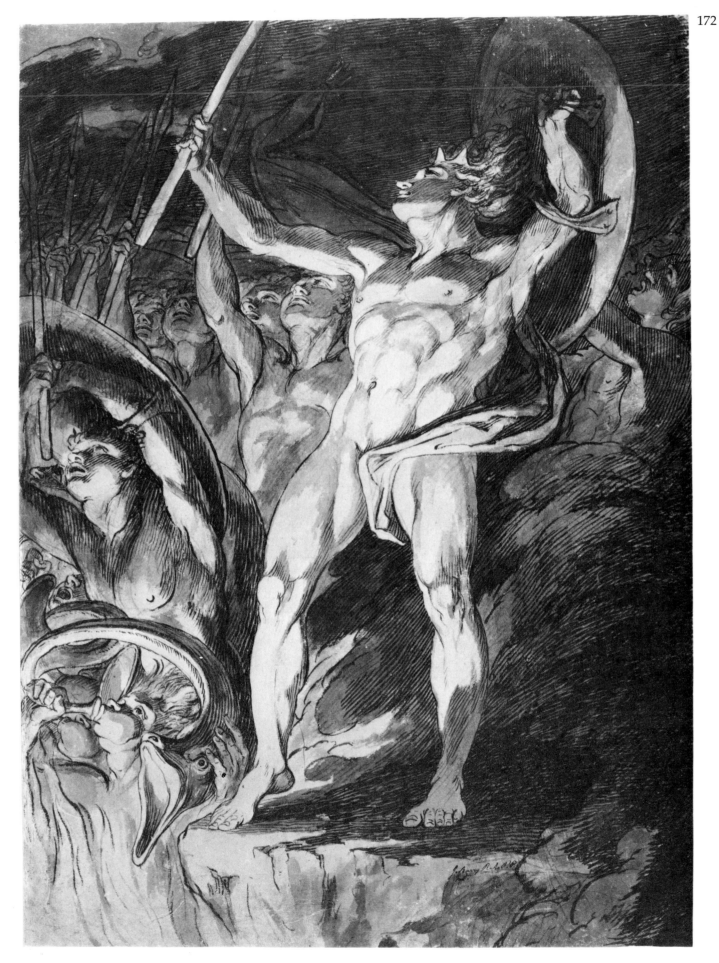

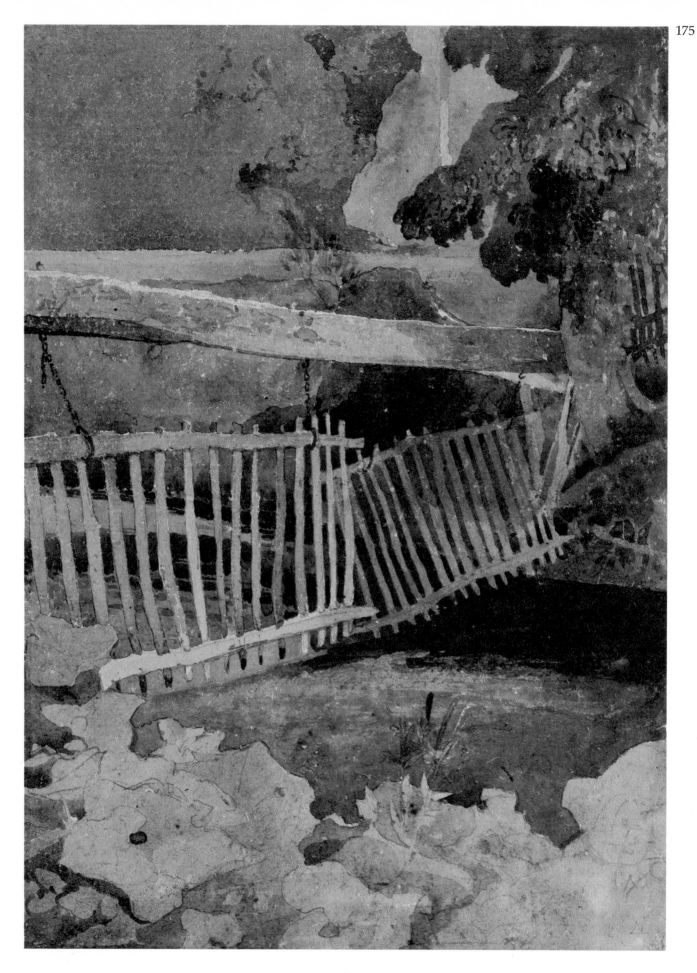

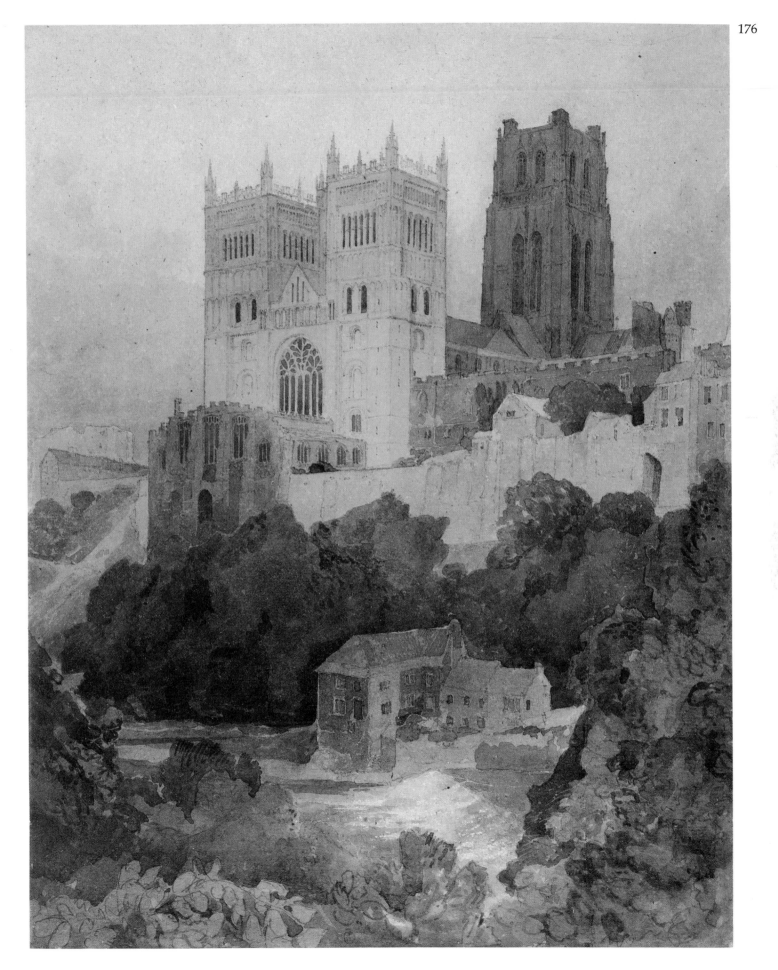

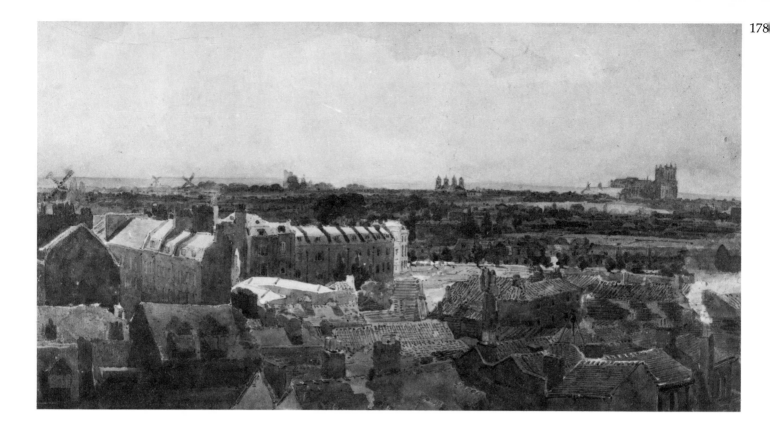

JOHN SELL COTMAN
1782-1842

175 *The Drop Gate, Duncombe Park, c.*1803-5

Watercolour over pencil; 33×23 cm
1902-5-14-14

If the traditional location of the Drop Gate at Duncombe Park, Yorkshire, is accepted, then this drawing would be connected with one of Cotman's visits there in 1803 and 1805. The concern with abstract patterning of tone and colour is characteristic of this early stage in his career.

JOHN SELL COTMAN
1782-1842

176 *Durham Cathedral from the South-East,* 1805-6

Watercolour over pencil; 43.6×33.1 cm
1859-5-28-119

Cotman spent a week or so in Durham in September 1805 and was impressed by the picturesque position of the Cathedral towering over the River Wear. This is the finest of five known drawings of the view and it was probably the one exhibited at the Royal Academy in 1806.

THOMAS GIRTIN
1775-1802

177 *Kirkstall Abbey, Yorkshire, c.*1800

Watercolour and black wash; 32×51.8 cm
1855-2-14-53 Presented by Chambers Hall

This is one of two late views of Kirkstall Abbey by Girtin (the other is in the Victoria and Albert Museum) belonging to a group of Yorkshire scenes which are among his finest achievements, monumental yet simple in mood.

THOMAS GIRTIN
1775-1802

178 *Westminster and Lambeth*

Watercolour over pencil; 29.1×52.5 cm
1855-2-14-23 Presented by Chambers Hall

One of six surviving studies for Girtin's *Eidometropolis,* an enormous circular panorama of London (probably painted in distemper on canvas), which was exhibited shortly before the artist's death. Taken from a point close to the south-west of Blackfriars Bridge, this view includes Lambeth Palace, St John's Smith Square and Westminster Hall and Abbey.

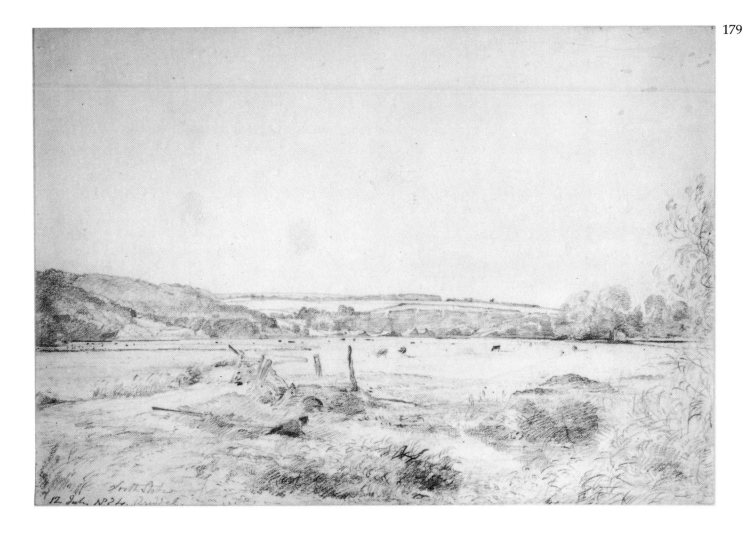

JOHN CONSTABLE
1776-1837

179 *North Stoke, Arundel*, 1834

Pencil; 26.5×37.5 cm
1888-2-15-66 Presented by Miss Isabel Constable

One of a group of drawings made during a week's stay in Arundel in July 1834. Four days after making the drawing which is dated July 12 Constable wrote . . . 'I never saw such beauty in *natural landscape* before. I wish it may influence what I do in future, for I have too much preferred the picturesque to the beautifull . . . The meadows are lovely, so is the delightfull river, and the old houses are rich beyond all things of the sort – but the trees above all.'

JOHN CONSTABLE
1776-1837

180 *London from Hampstead, with double Rainbow,* 1831

Watercolour with scraping out; 19.7×32.4 cm
1888-2-15-55 Presented by Miss Isabel Constable

A view over London presumably taken from a window of the house at 6 Well Walk which Constable first rented in the summer of 1827. He wrote in that year 'It is my wife's heart's content . . . and our little drawing room commands a view unequalled in Europe . . . The dome of St Paul's in the air, realizes Michael Angelo's idea on seeing that of the Pantheon – "I will build such a thing in the sky"'.

RICHARD PARKES BONINGTON
1802-1828

181 *The Château of the Duchesse de Berri, c.*1824-5

Watercolour and bodycolour; 20.3×27.2 cm
1910-2-12-223 George Salting Bequest

Bonington's short career was spent chiefly in France; he was one of the very few British artists to have exerted an important and almost immediate effect on his Continental contemporaries and immediate successors. His technique as a watercolourist (much admired by Delacroix) can be seen in this example, a composition which he also painted in oils.

JOSEPH MALLORD WILLIAM TURNER
1775-1851

182 *The Glacier des Bossons, c.*1836

Watercolour with scratching out; 23.2×33.5 cm
1915-3-13-49 The Rev. Charles John Sale Bequest

In 1836 Turner accompanied his friend and patron H.A.J. Munro of Novar on a tour through France, Switzerland and Northern Italy, a journey which re-awakened his interest in mountainous subjects. This view of the Glacier des Bossons (which Turner had drawn on his first Alpine tour in 1802) can be related to other watercolours made during or shortly after the 1836 tour. According to Munro, Turner worked in watercolour in the open air, rather than making rapid pencil sketches to be worked up at a later date.

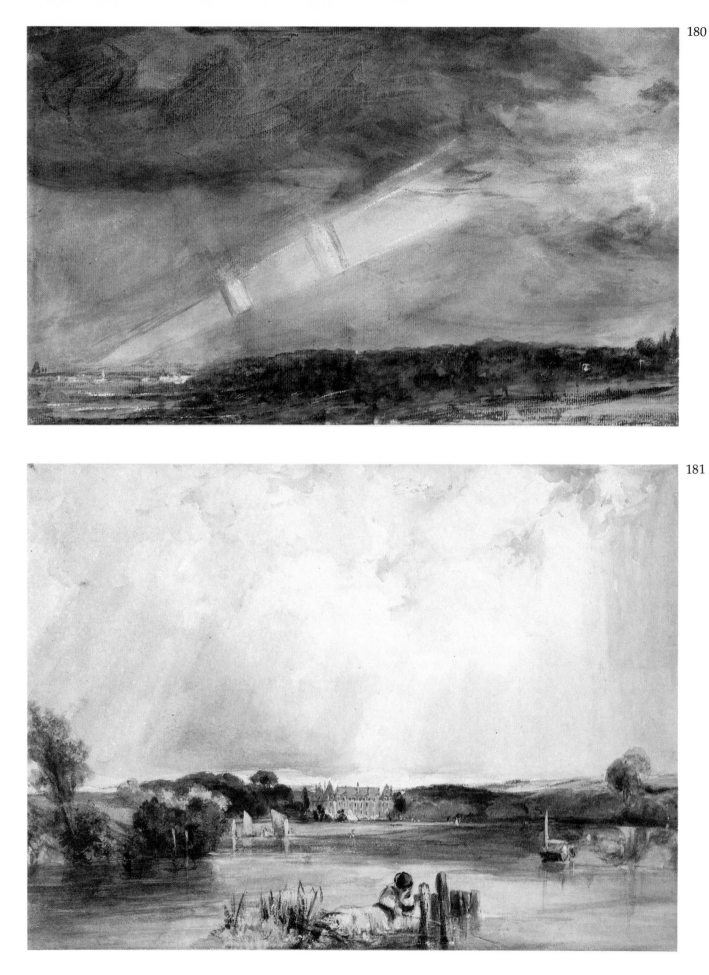

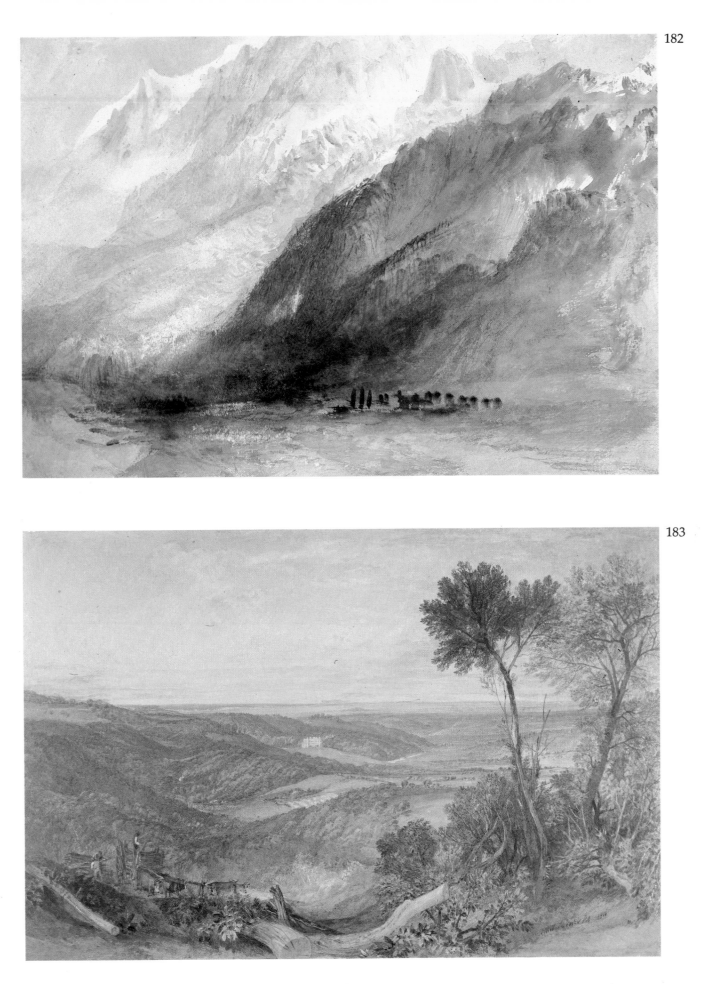

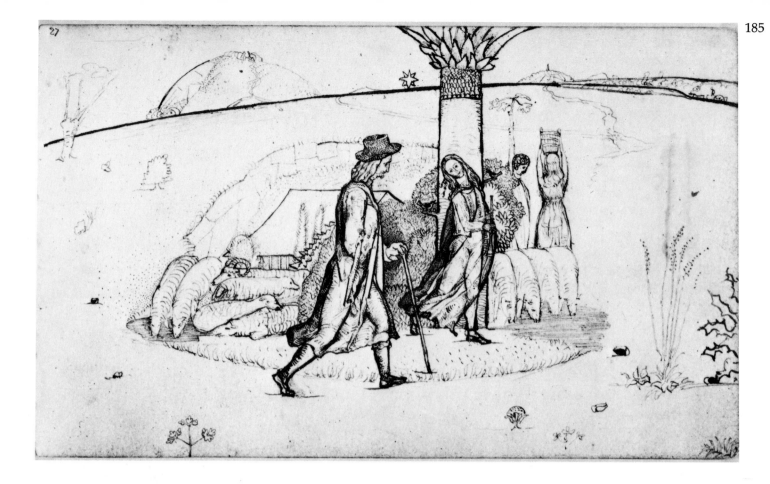

JOSEPH MALLORD WILLIAM TURNER
1775-1851

183 *The Vale of Ashburnham, 1816*

Watercolour; 37.9×56.3 cm
1910-2-12-272 George Salting Bequest

One of a group of watercolours depicting views in Sussex commissioned from Turner by John Fuller, M.P. for the county; he intended to have the series engraved, but only six (including this one) were published. This watercolour, Claude-like in its composition, was based on a drawing in the Vale of Heathfield sketchbook, T.B.CXXVII, 68v-69; Ashburnham House is in the mid-distance.

EDWARD CALVERT
1799-1883

184 *The Primitive City, 1822*

Pen and ink and watercolour; 6.8×10.2 cm
1947-2-17-1 Presented by the National Art-Collections Fund

Painted in 1822, four years before Calvert met Samuel Palmer, this watercolour, which resembles a mediaeval illuminated manuscript, shares much of the intensity that was to characterise the work of the Shoreham group in the late 1820s (including Calvert's own wood-engravings). However, while Palmer's vision was essentially based on Christian nature-mysticism, Calvert's largely derived from classical ideals – the figure on the left is based on the antique statue of Venus Callipyge.

SAMUEL PALMER
1805-1881

185 *A sheet from Samuel Palmer's 1824 sketchbook; perhaps Rebecca at the Well*

Pen and brown ink; 11.5×18.9 cm
1964-11-4-1(8)

A sheet from one of Palmer's two surviving sketchbooks, both of which are in the British Museum (the others were destroyed by the artist's son). The 1824 sketchbook includes almost all the motifs that were to recur in his most characteristic work, the paintings and drawings made chiefly at Shoreham between 1826 and 1834. Among the most powerful influences on Palmer's imagination at this period were the works of Dürer and Blake, echoes of whose styles can be seen in this drawing. The presence of a palm-tree suggests that this is an Old Testament subject.

SIR DAVID WILKIE
1785-1841

186 *Nude Woman on a Ladder, 1840*

Pencil and black and red chalks with grey wash, watercolour and oil; 33.2×22.8 cm
1885-7-11-302

One of a small number of female nude studies by Wilkie, which he seems to have conceived as independent compositions, quite separate from the immense number of preparatory drawings and sketches he made in connection with his paintings. The drawing is signed and dated July 18 1840; later in the year Wilkie left England to travel to the Holy Land, and died at sea during the return journey in 1841.

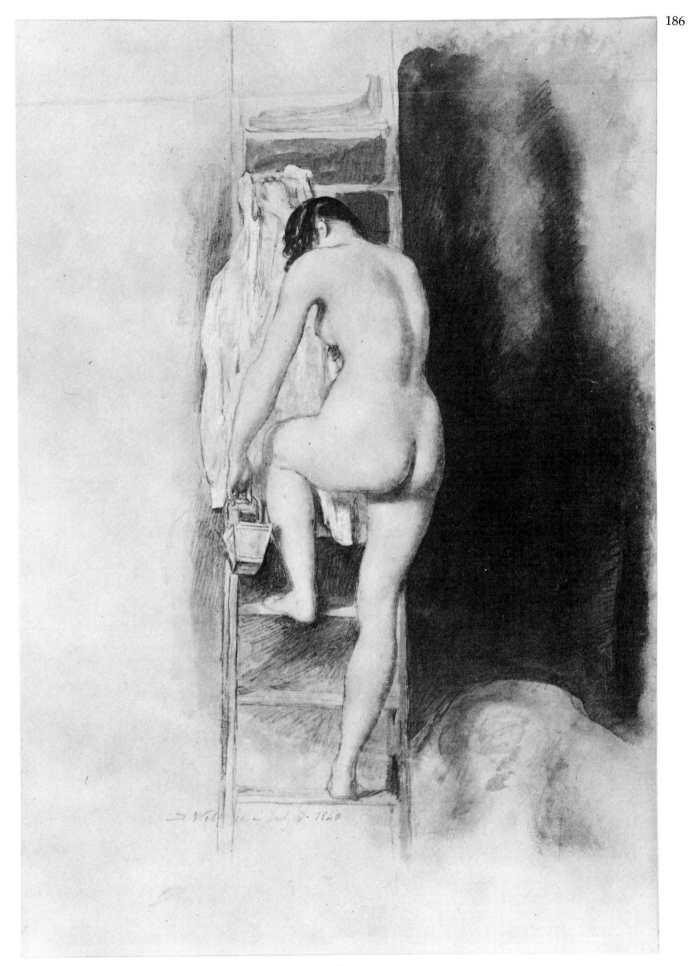

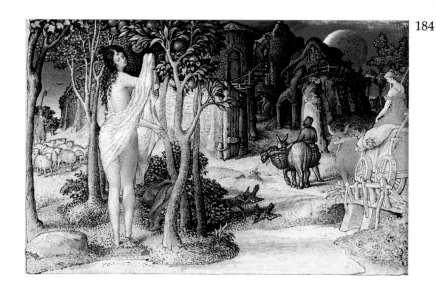

184

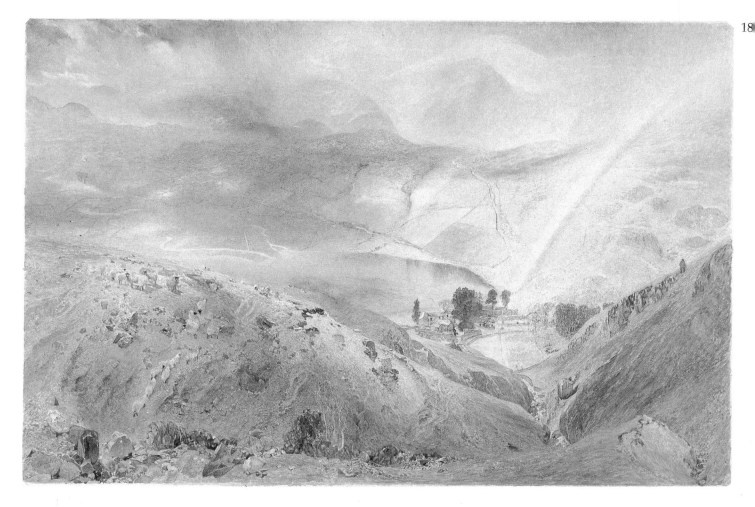

18

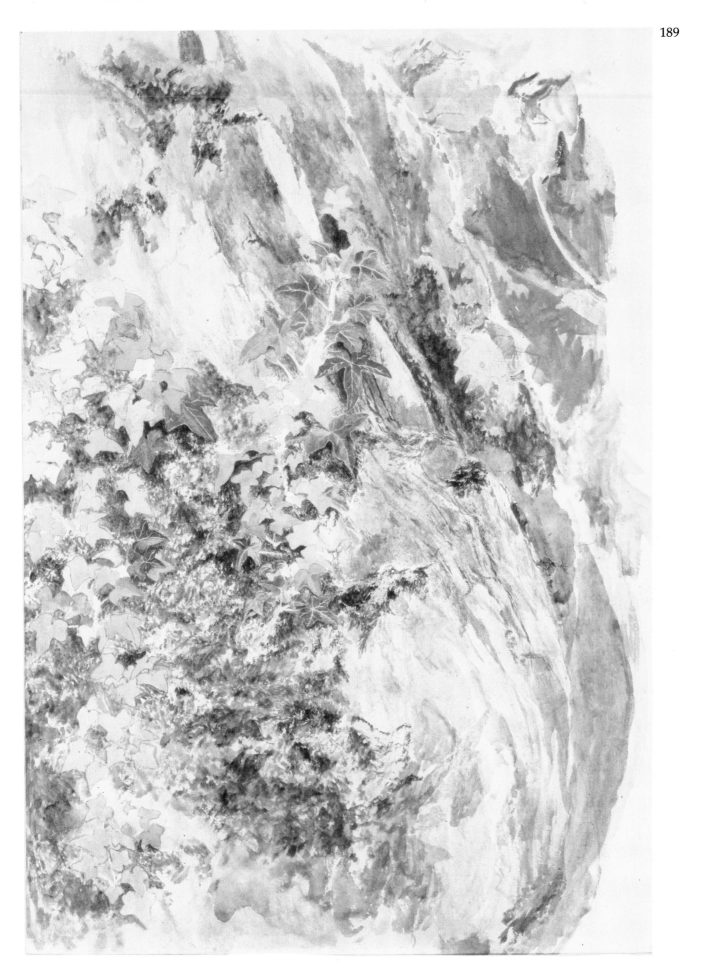

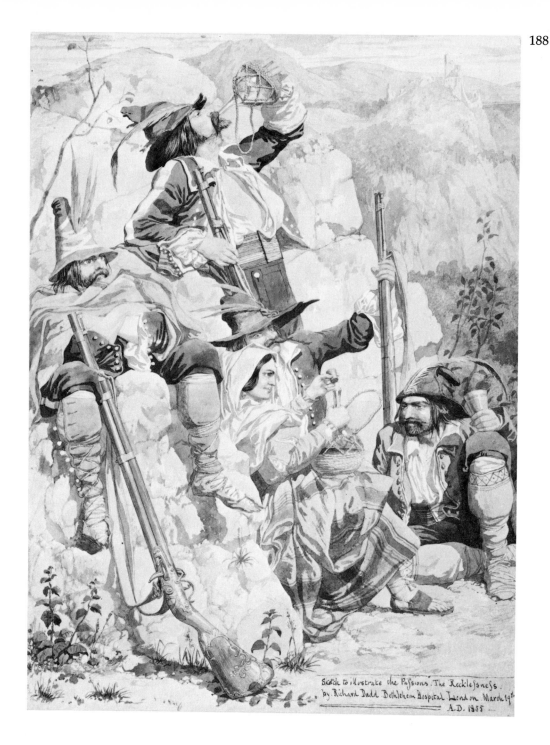

Sketch to illustrate the Passions. The Recklessness. by Richard Dadd Bethlehem Hospital London March 19th A.D. 1855

ALFRED WILLIAM HUNT
1830-1896

187 *The Tarn of Watendlath, between Derwentwater and Thirlmere,* 1858

Watercolour with bodycolour and scratching out;
32.2×49.2 cm
1969-9-20-1

Hunt did not become a professional artist until 1861, when his marriage to the novelist Margaret Raines meant the resignation of his Oxford Fellowship. However, he began to exhibit in 1854 and soon attracted Ruskin's praise. The formative influences on his style, as can be seen in this watercolour, were the Pre-Raphaelites and Turner.

RICHARD DADD
1817-1886

188 *Sketch to illustrate the Passions: Recklessness,* 1855

Watercolour; 35.7×25.7 cm
1876-5-10-683

Confined in 1844 to Bethlem, and subsequently to Broadmoor, for the murder of his father, Dadd was allowed to continue to paint. Almost all of his works are carefully signed and dated, frequently bearing long inscriptions describing the subjects: this watercolour is from an extensive series illustrating the Passions, a scheme perhaps suggested by the artist's physician, who owned a number of drawings from the series.

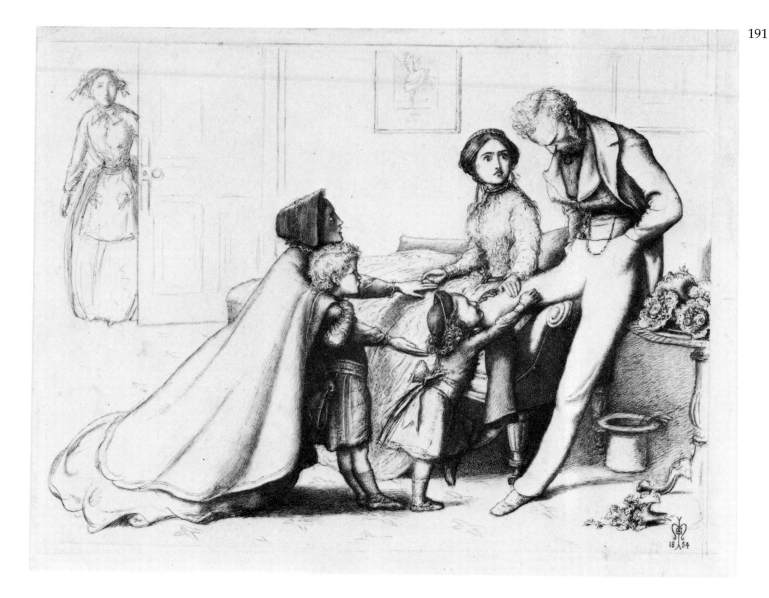

JOHN RUSKIN
1819-1900

189 *Study of Ivy (Hedera Helix)*

Watercolour over pencil; 40.3×27.1 cm
1979-1-27-11

Many of Ruskin's drawings are marked by a fanatical concern with precise, factual observation. He recounted in his autobiography how when making a study of ivy in May 1842 he proceeded 'carefully, as if it had been a bit of sculpture, liking it more and more as I drew. When it was done, I saw that . . . no one had ever told me to draw what was really there! All my time, I mean, given to drawing as an art; I had never seen the beauty of anything, not even of a stone – much less of a leaf.' The inscription on the *verso* of this drawing states that it was made at Coniston, presumably after 1872 when Ruskin bought a house at Brantwood on the lake.

DANTE GABRIEL ROSSETTI
1828-1882

190 *Sir Galahad, Sir Bors and Sir Percival receiving the Sanc Grael*, 1857

Pen with black and brown inks over pencil, with traces of red chalk; 25×35.1 cm
1910-12-10-3 William Gillum Bequest

In 1857 Rossetti, with six friends, undertook a decorative scheme for the hall of the Oxford Union Debating Society, planning to illustrate scenes from Malory's *Morte d'Arthur* in distemper. Such murals as were painted began almost immediately to deteriorate, and the project was left incomplete. Several of Rossetti's designs were committed to paper only, including this composition, which subsequently served as a study for a watercolour painted in 1864.

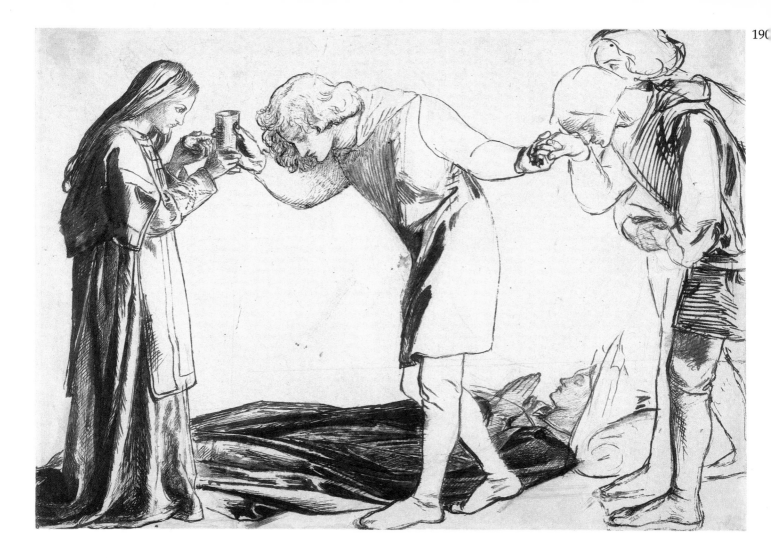

JOHN EVERETT MILLAIS
1829-1896

191 *Retribution* (also known as *The Man with Two Wives*), 1854

Pen and brown ink; 20.4×25.9 cm
1982-12-11-1

One of a number of drawings made by Millais in 1853-4 (this is dated 1854) dealing with the dramatic aspects of passion and reflecting the Pre-Raphaelite concern in the early 1850s with contemporary morals (for example, Rosetti's *Found* and Holman Hunt's *Awakening Conscience*). They were executed during a period of acute emotional disturbance for Millais, who found himself falling in love with Ruskin's wife, Effie: in April 1854 she left her husband, and married Millais in the following year.

AUBREY BEARDSLEY
1872-1898

192 *The Toilet of Salome*

Pen and brush with black ink; 22.7×16.2 cm
1919-4-12-1 Presented by the National Art-Collections Fund, in memory of Robert Ross

A design for the English edition of Oscar Wilde's *Salome*, translated by Lord Alfred Douglas, published in 1894. Beardsley's illustrations to *Salome* were among his most influential, summing up everything that is most distinctive about his graphic style – the exclusion of unnecessary detail, a powerful sense of abstract pattern and an atmosphere of menacing eroticism.

AUGUSTUS JOHN
1878-1961

193 *Gwen John, 1899*

Red chalk and grey wash with black chalk, pen and ink and touches of yellow chalk; 34.1×25 cm

1960-11-10-3 Bequeathed by Miss Judith Ellen Wilson

Gwen John (1876-1939), a highly gifted artist, entered the Slade School of Art in 1895, a year later than her brother. Some of Augustus John's most sensitive portraits were executed between 1897 and 1900.

WALTER SICKERT
1860-1942

194 *Woman at a mirror; Quai Voltaire, 1906*

Black chalk, pen and black ink, heightened with white on beige paper; 30.3×24.7 cm

1981-12-12-14

Sickert referred to a 'whole set of interiors in the hotel, mostly nudes', on which he was engaged during the autumn of 1906 when he resided at the Hotel du Quai Voltaire in Paris.

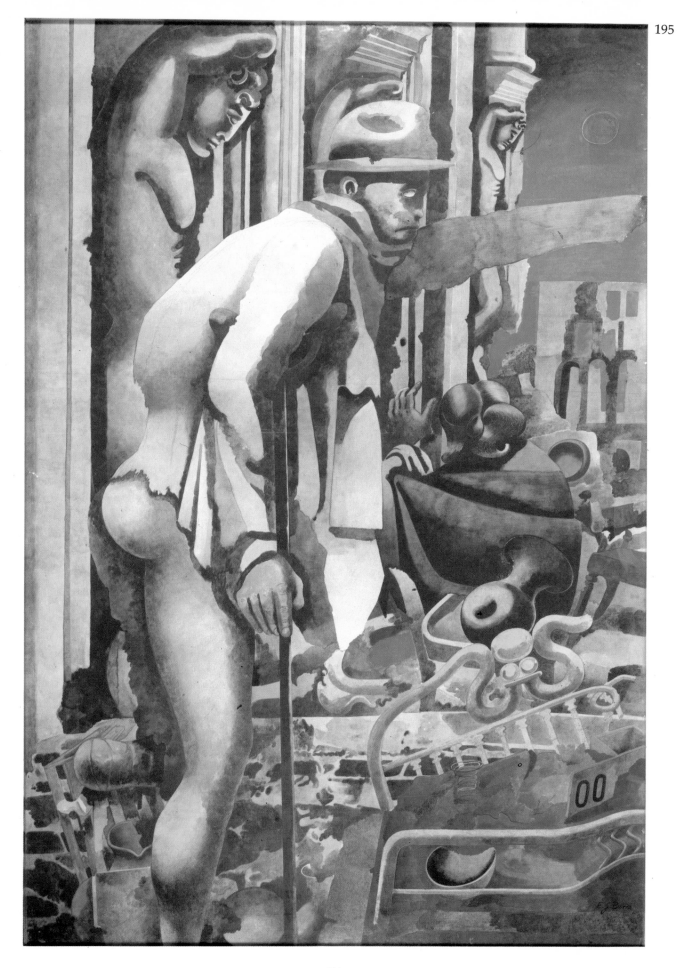

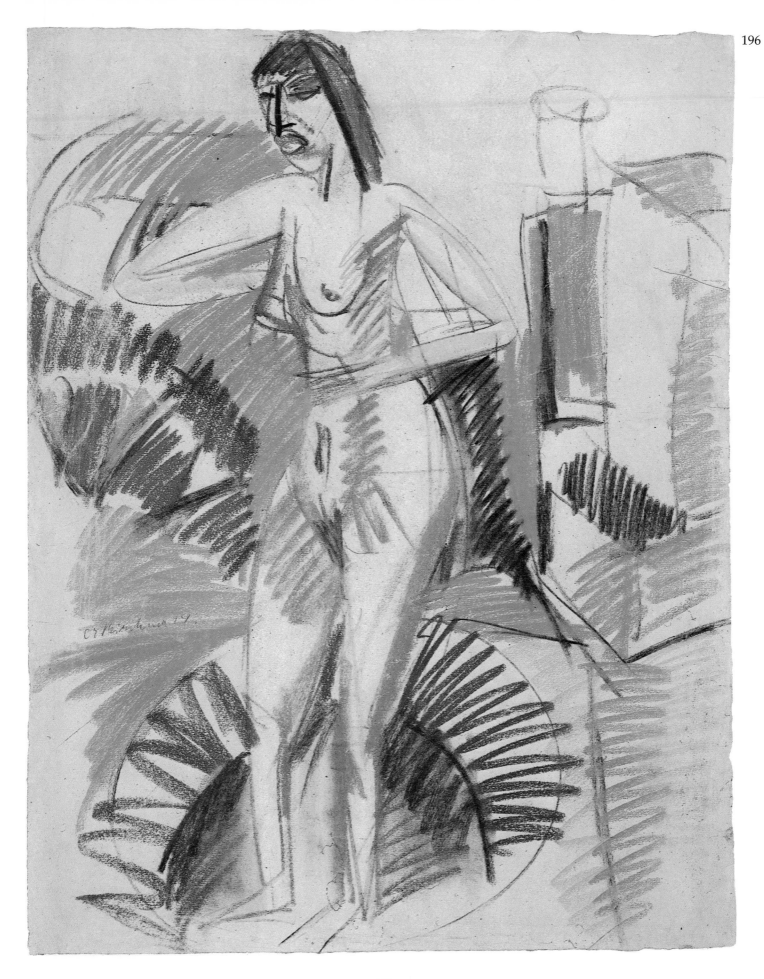

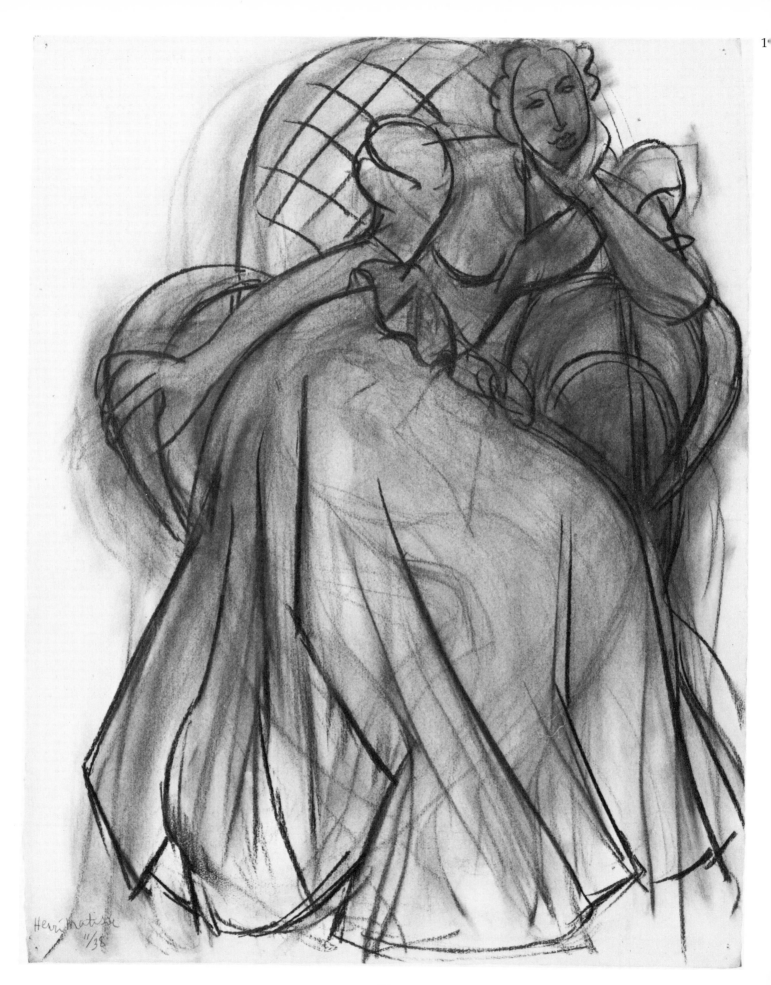

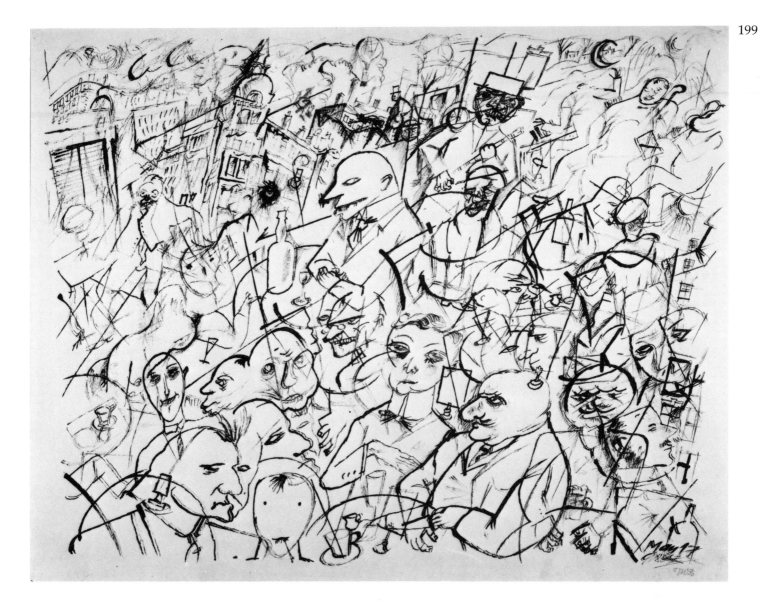

EDWARD BURRA
1905-1976

195 *Civilian Damage, Spanish Civil War*, 1938

Watercolour over pencil; 101×68 cm

1983-11-5-6

During 1937 and 1938 Burra produced a remarkable group of watercolours whose sense of sinister desolation amidst the ruins of classical architecture departs from the sardonic humour of his most popular depictions of the *demi-monde*. *Civilian Damage* is, however, alone among this group insofar as the artist makes specific reference to contemporary events. He had visited Spain in 1935 where he was profoundly disturbed by the sense of impending doom: 'It was terrifying: constant strikes, churches on fire, and pent-up hatred everywhere. Everybody knew that something appalling was about to happen.'

ERNST LUDWIG KIRCHNER
1880-1938

196 *A nude Woman standing in her Bath*, 1914

Pastel; 67.3×51.2 cm

1982-3-27-5

Kirchner produced some of his most striking compositions in pastel during his Berlin period; this drawing is the most highly finished of a number of studies he executed in his studio of women bathing.

HENRI MATISSE
1869-1954

197 *A seated Woman, wearing a taffeta Dress*, 1938

Charcoal; 66.3×50.5 cm

1979-12-15-17

One of a group of studies Matisse made between 1936 and 1938 of female models, principally Lydia Delectorskaya and Princess Elena Galitzin.

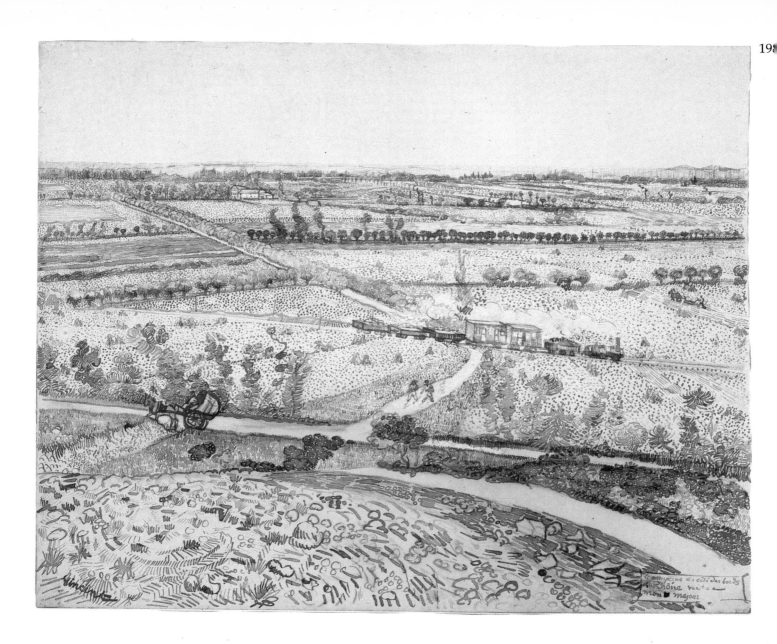

VINCENT VAN GOGH
1853-1890

198 *La Crau from Montmajour, 1888*

Reed and fine pen with brown ink over black chalk;
48.7×60.8 cm
1968-2-10-20 César Mange de Hauke Bequest

Van Gogh was particularly proud of this and one other,
similar, composition which he described in a letter to his
brother Theo, written in Arles, as 'the best things I have done
in pen and ink'. A more detailed description appears in a
letter to the painter Emile Bernard where the artist remarked:
'It does not have a Japanese look, and yet it is really the most
Japanese thing I have done; a microscopic figure of a
labourer, a little train running across the wheatfield – this is
all the animation there is in it.'

GEORGE GROSZ
1893-1959

199 *Men in a Café, 1917*

Pen, brush and black ink; 43.9×58.8 cm
1980-12-13-31

This drawing belongs to an intensely productive period of
Grosz's life, from 1916 to the middle of 1917, when he lived in
Berlin following his temporary discharge from the army. The
hectic compositions which emerged during this time were
profoundly expressive of the social and political disintegra-
tion threatening Germany: 'I drew men drunk, men vomit-
ing, men with clenched fists cursing the moon, men playing
cards on the coffins of the women they had murdered . . . I
drew lonely little men rushing insanely through empty
streets . . .' This drawing was originally owned by Richard
Huelsenbeck, one of the first Dadaists who introduced the
'art of the dustbin' to Berlin after the war.

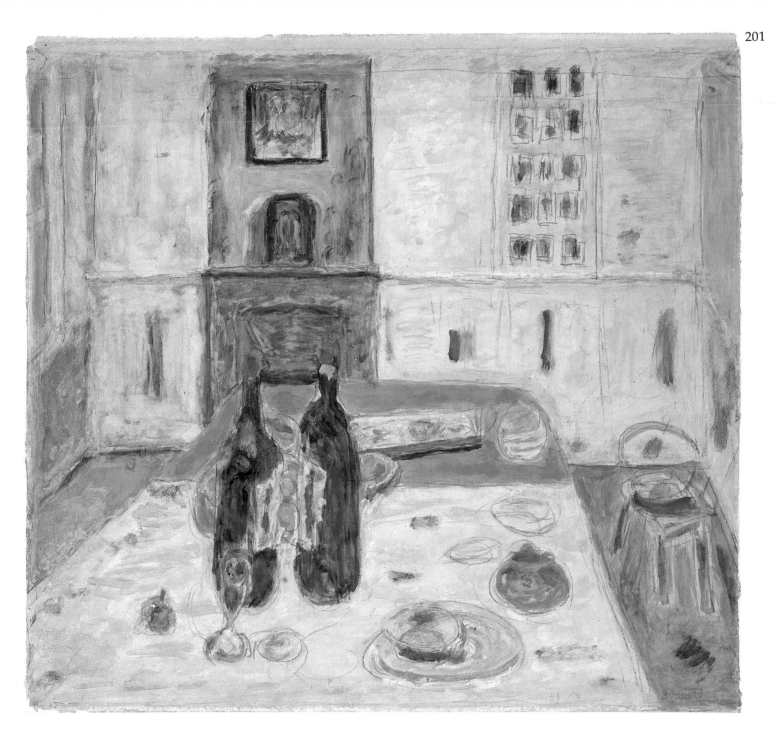

MAX BECKMANN
1884-1950

200 *Die Strasse (The Street)*, 1919

Charcoal on transfer paper; 67.5×52.5 cm
1983-3-5-55

The preparatory drawing used for plate 2 in the series of ten lithographs entitled *Die Hölle* (Hell), published in Berlin in 1919. This portfolio and the associated drawings, of which seven are known, are among the most compelling compositions of Beckmann's career; the immediate impetus for their mordant imagery came from the traumatic events ensuing from Germany's political collapse at the end of the First World War.

PIERRE BONNARD
1867-1947

201 *La salle à manger, Villa le Bosquet, le Cannet*

Watercolour, bodycolour and pencil; 46.5×48.7 cm
1981-2-21-1

Bonnard sustained his brilliance as a colourist to the end of his career. His watercolours date from the period 1925 when he bought the house 'Le Bosquet', near Cannes, which was to appear frequently in his work.

GIORGIO DE CHIRICO
1888-1978

202 *'Figure Metafisiche'*, 1918

Pencil; 31.4×21.8 cm
1982-3-27-4

De Chirico's mature style, *Arte Metafisica*, evolved between
1912-19, influenced by his stay in Paris, 1911-15, followed by
his return to Ferrara. The enigmatic quality of the work from
this period is particularly haunting in the refined pencil
drawings executed in 1917 and 1918, prior to de Chirico's
departure from Ferrara.

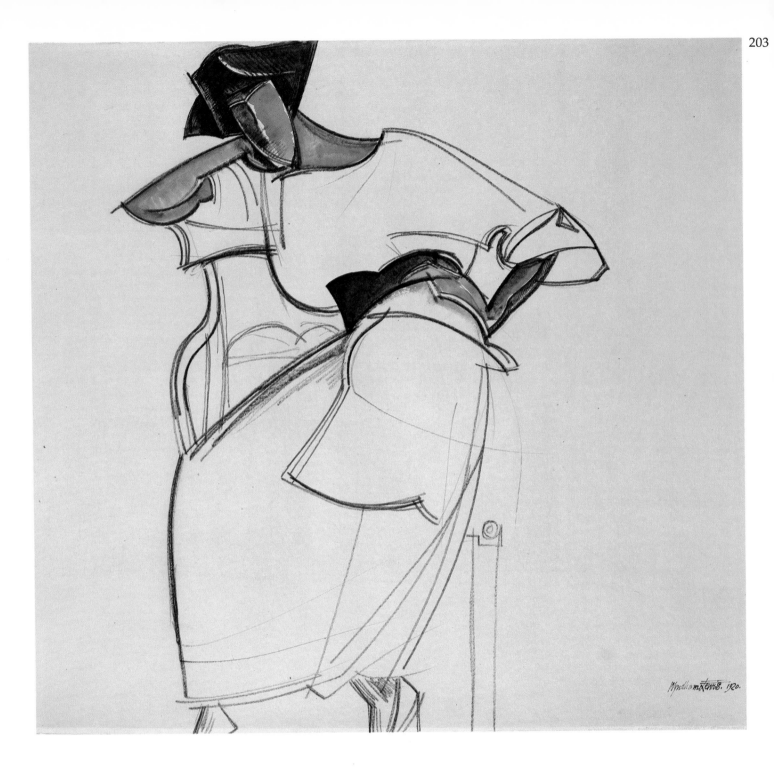

PERCY WYNDHAM LEWIS
1882-1957

203 *Woman with a Sash*, 1920

Pen and ink, crayon and watercolour; 38.1×39.1 cm
1983-4-16-4

Wyndham Lewis produced a particularly impressive series
of drawings of female sitters from 1919-21. The absence of
any features from the figure accentuates the hieratic quality
of the image; the spectator's attention is deliberately con-
centrated upon the articles of dress, with which the artist
retained his fascination until the end of his career.

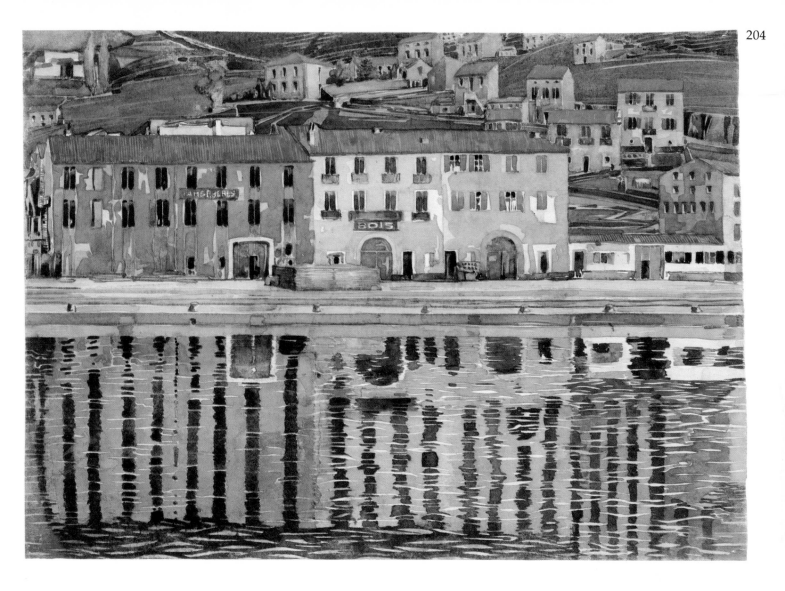

CHARLES RENNIE MACKINTOSH
1868-1929

204 *Port Vendres, c.1926-7*

Watercolour over pencil; 28×37.8 cm
1981-12-12-17

Mackintosh's large Mediterranean watercolours of 1923-7
concentrated upon rendering the landscape as a static,
almost two-dimensional pattern. The views of Port Vendres
were executed out-of-doors and he would often take at least
two or three weeks to finish a watercolour.

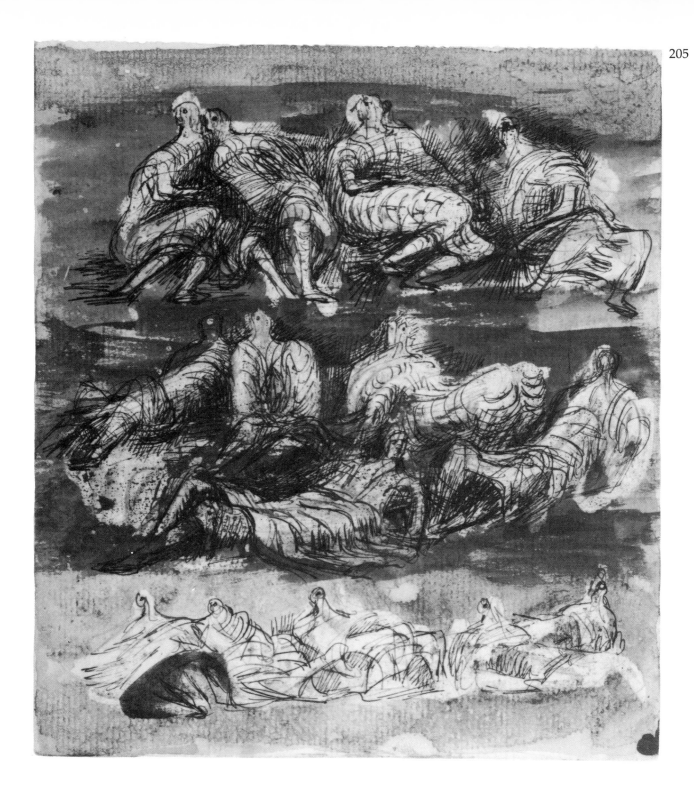

HENRY MOORE
b.1898

205 *Sleeping Figures*
Pen and ink over pencil, with washes of grey, blue-green and
pink; 18.9×16.5 cm
1977-4-2-13(57) Bequeathed by Lady Clark

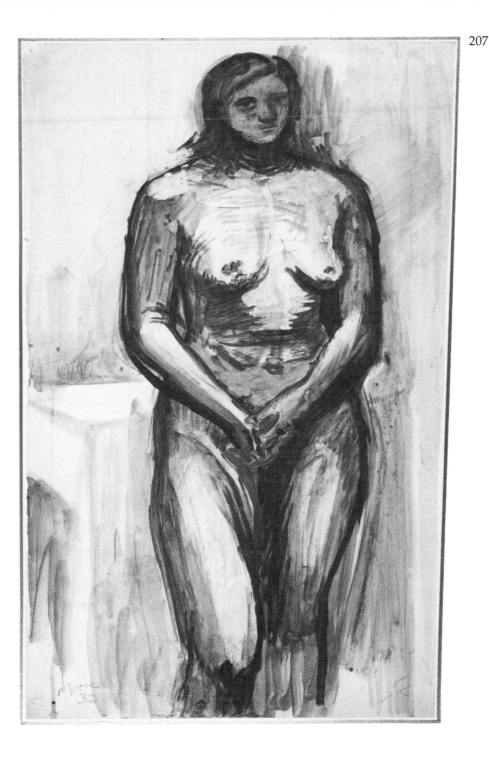

HENRY MOORE
b.1898

206 *Sleeping Figures*

Wax crayon with pen and ink and washes of grey, pink and yellow; 18.8×16.5 cm
1977-4-2-13(60) Bequeathed by Lady Clark

This and no. 205 are taken from the *First Shelter Sketchbook* of 1940 which contains a distillation of Moore's observations as a war artist, of life in the London Underground stations during the Blitz. The subject was particularly congenial to his artistic preoccupations: 'I saw hundreds of Henry Moore Reclining Figures stretched along the platforms.'

HENRY MOORE
b.1898

207 *Large standing nude Woman, 1932*

Black wash heightened with white over black chalk; 56×34 cm
1969-3-15-22 Presented by the artist

The life drawings produced between 1928 and 1935, many of them studies of the artist's wife, represent the culmination of Moore's efforts in this sphere. They were executed independently of his sculpture, although there was clearly a relationship between the two. It was the sale of drawings which provided Moore with one of his principal sources of income during this period.

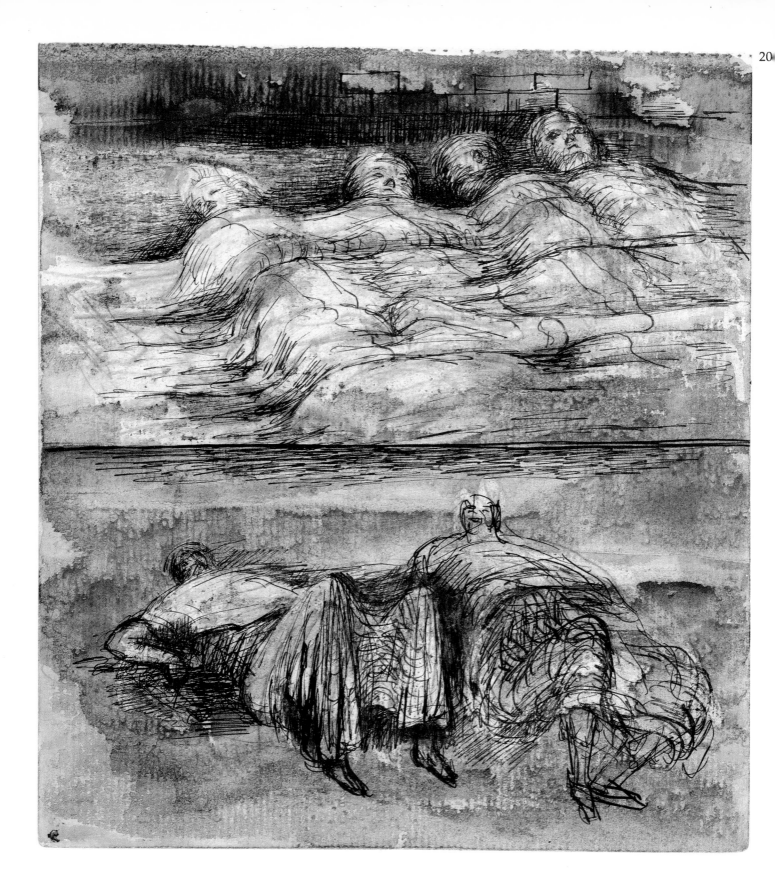

Index of artists